THE BLACK CIVIL WAR SOLDIER

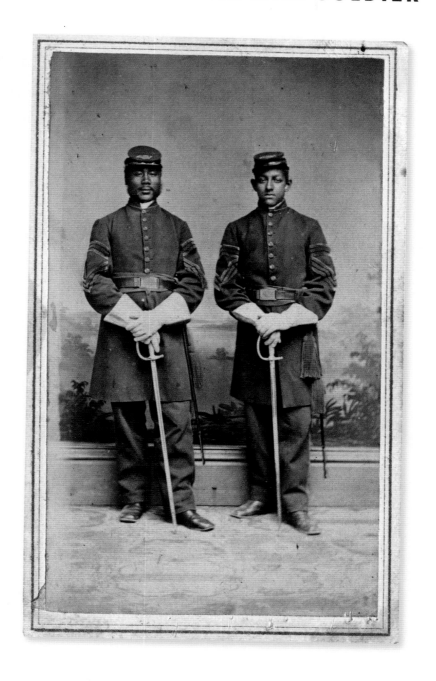

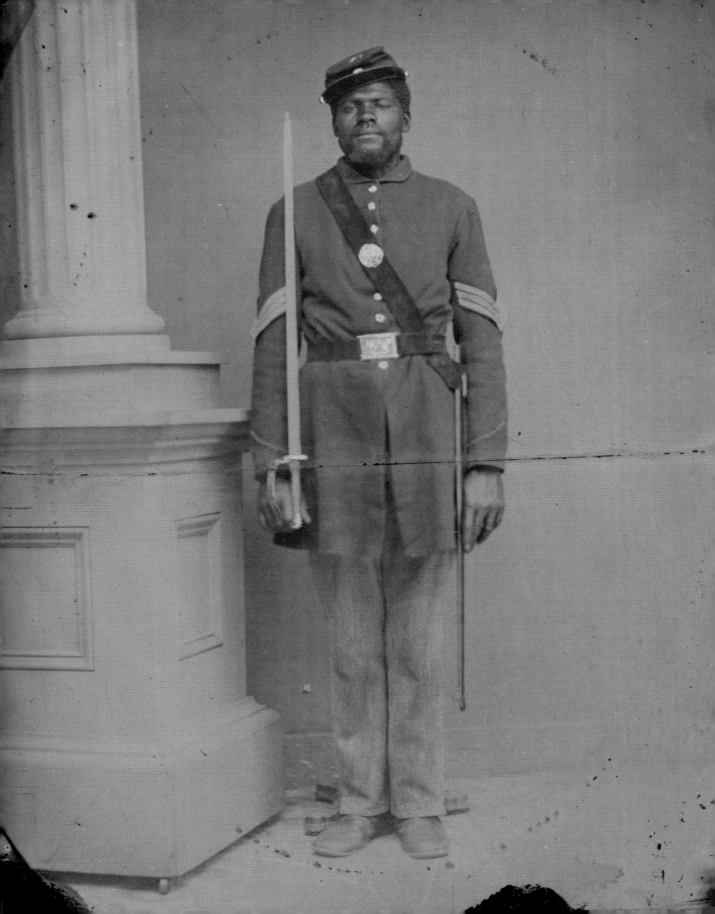

THE
BLACK
CIVIL WAR
SOLDIER

A VISUAL HISTORY OF
CONFLICT AND CITIZENSHIP

DEBORAH WILLIS

NEW YORK UNIVERSITY PRESS
NEW YORK

Half title art: Alexander Herritage Newton (*left*) as a quartermaster sergeant with the Twenty-Ninth Connecticut Infantry, ca. 1865. Standing next to him is Daniel S. Lathrop (1846-1924), who served at the same rank in the regiment. (Photographers: James Horace Wells and David C. Collins of New Haven, Connecticut; carte de visit; Beinecke Rare Book and Manuscript Library, Yale University)

Frontis: Sergeant Henry F. Steward, 1863. (Hand-colored ambrotype; from the 54th Massachusetts Volunteer Infantry Regiment photographs, Massachusetts Historical Society, photo 2.162)

NEW YORK UNIVERSITY PRESS
New York
www.nyupress.org

© 2021 by New York University
All rights reserved

References to Internet websites (URLs) were accurate at the time of writing. Neither the author nor New York University Press is responsible for URLs that may have expired or changed since the manuscript was prepared.

Library of Congress Cataloging-in-Publication Data
Names: Willis, Deborah, 1948- author.
Title: The Black Civil War Soldier : A Visual History of Conflict and Citizenship / Deborah Willis.
Description: New York : New York University Press, [2021] |
Series: NYU series in social and cultural analysis |
Includes bibliographical references and index.
Identifiers: LCCN 2020015037 (print) | LCCN 2020015038 (ebook) |
ISBN 9781479809004 (cloth) | ISBN 9781479826261 (ebook) |
ISBN 9781479827145 (ebook)
Subjects: LCSH: United States—History—Civil War, 1861-1865—Participation, African American. | United States—History—Civil War, 1861-1865—Participation, African American—Pictorial works. | African American soldiers—Biography. | African American soldiers—Portraits.
Classification: LCC E540.N3 W715 2021 (print) | LCC E540.N3 (ebook) |
DDC 973.7/415—dc23
LC record available at https://lccn.loc.gov/2020015037
LC ebook record available at https://lccn.loc.gov/2020015038

New York University Press books are printed on acid-free paper, and their binding materials are chosen for strength and durability. We strive to use environmentally responsible suppliers and materials to the greatest extent possible in publishing our books.

Book designed and typeset by Charles B. Hames

Manufactured in the United States of America

10 9 8 7 6 5 4 3 2 1

Also available as an ebook

CONTENTS

PREFACE

Memory, personal and public, as viewed through the experience of photography, shaped the history of the black Civil War soldier. This book synthesizes that history—both difficult and desired. We seek out memorials about slavery and the Civil War in the North and the South. We are engrossed in public debates about the relevance of monuments from Stone Mountain to Grant's Tomb. We visit historic sites such as Gettysburg, the African American Civil War Museum, and the Cyclorama in Atlanta, searching for new stories, and many people attend Civil War reenactments and Juneteenth celebrations. A number of films over the past few years—from *12 Years a Slave* and *Belle* to *Lincoln, Django Unchained*, and *Harriet*—have sought to tell an accurate story about slavery and freedom. Now that a large number of records are finally being digitized and becoming accessible, I believe it is important to reveal both the heroic and the horrific moments.

There is something about looking at images that forces me to question the narratives of the past. I have long been puzzled by the imagery of black peoples, and I have tried to make sense of the story that has been told. For decades, we have been taught to look at photographs as objects, but now, thanks to new scholarship, we are encouraged to consider the idea of postmemory and listening when we view photographs.[1] Images represent visual responses to what we may have been told about a period and prompt such questions as, How was black male identity formed by images of soldiers in uniform? In addition to reading images closely, I wanted this book

to include the invisible voices—arising from slave narratives and contemporary letters—of the people who are not typically researched. It was important for me to incorporate new voices and images in order to grapple with a history that is often exclusionary. Photographs and words function as a testimony that reflects people's bravery, pride, and determination and reminds us of the toll of war.

Photography first appeared in the United States in the 1840s, a time when images were more accessible than ever before. The photograph became the mechanical visual evidence that slavery existed, as did its resistance. Indeed, I believe the story of that resistance can be found in the photographs of black Civil War soldiers. That was the impetus for this book, which examines the public's memory of the Civil War and how the presence and lack of images of black soldiers influence our modern perceptions of the war in the archive. It weaves a narrative about the early years of American photography, focusing on iconic moments of the war and the role black Americans played in shaping the visual narrative of freedom. As the curator Okwui Enwezor asserts, "There is something to be said for historical returns, the way past events play on our memories,"[2] as we pay homage to historical and iconic images. What amazes me is the overlapping of historical narratives—from popular culture to literary texts—that make visible the racialized and gendered readings often depicted as "truths."

Unexpected and informative sources for my research include pension records and various periodicals whose focus was general interest, civil war, abolitionism, and religion. For example, a file in the pension records documents the story of Susan Brewster, wife of Henry, whose applications to receive her husband's pension were repeatedly denied. While giving a lecture at Carnegie-Mellon in Pittsburgh, I met the historian Millington Bergeson-Lockwood, who told me about his own research while using the pension records and introduced the complicated story of the Brewsters to me. In 1905, at the age of fifty-seven, Susan sent her only photograph of her husband along with her petition, requesting its return.[3] Sadly, the photograph is still filed at the US Department of the Interior, Bureau of Pensions, having never been returned. Henry Brewster was a blacksmith and a tailor; in the photograph, he holds a ruler and wears a long coat. Susan's story is long and complicated; she tried many times to prove her marriage to Henry and his service in the war. The following is her initial affidavit.

Original Petition for Pension
State of New York
Columbia County

Susan Brewster having been duly sworn deposes and says that she is the widow of Henry M. Brewster late private in Co. E 55 Mass. Vol. Infantry, that he enlisted under the name of Henry M. Forrest as a private at Newberryport Mass Feb 14, 1865. He was born in Lee, Mass. about 1835. His father's name was Fredrich Brewster. Henry M. Brewster was a colored man at the time he enlisted he was a blacksmith. After he left the army he did laboring work as long as he was able. My full name is Susan Brewster. My maiden name was Susan Whitford. I was married to the soldier at Pittsfield Mass. Dec 6, 1867 by the Rev. Mr Miller. we lived together from the time of our marriage to his death at Sommers, Ct. Lee, Mass, Hartford, conn. We had one daughter born at Hartford conn. April 18th 1883. He had lost the sight of his left eye & ?? of his right eye. He was troubled with his kidneys from the time he left the army to his death, which was from acute Bright's disease. He was discharged for disability at US Hospital Beaufort, S.C. July 10, 1865. He died April 19th 1899. Subscribed and

Signed: Susan Brewster
Dated: 26th Day of June 1905.
Harold Wilson Jr. Notary Public
Columbia County, New York[4]

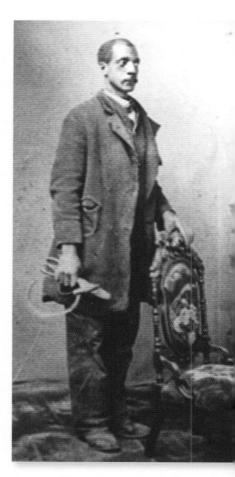

Portrait of Henry Brewster, ca. 1870s. (National Archives Pension Records)

Numerous women—mothers, wives, and daughters—believed in the fight for freedom as their sons, fathers, and husbands left the plantations all over the South. They recognized not only their sons' and husbands' role but also their own role in their quest. The historian Tera Hunter helps to visually frame the experiences of wives: "While women asserted claims of 'citizen wife' or 'soldier's wife,' they were not readily granted either. And yet their carefully chosen self-descriptions defined how they were at once vital to and undervalued by the Union. They spoke about their contributions and sacrifices as though they had, like their husbands, 'entered the army.'"[5] For example, Letty Barnes wrote to her husband, Joshua, of the Thirty-Eighth US Colored Infantry (USCI),

My dear husband

I have just this evening received your letter sent me by Fredrick Finich you can imagin how anxious and worry I had become about you. And so it seems that all can get home once in awhile to see and attend to their familey but you I do really think it looks hard your poor old Mother is hear delving and working like a dog to try to keep soul and body together and here am I with to little children and myself to support and not one soul or one dollar to help us I do think if your officers could see us they would certanly let you come home and bring us a little money.

I have sent you a little keepsake in this letter which you must prize for my sake it is a set of Shirt Bossom Buttons whenever you look at them think of me and know that I am always looking and wishing for you write to me as soon as you receive this let me know how you like them and when you are coming home and beleave me as ever

Your devoted wife

Letty Barnes

It appears from the records in the National Archives that Joshua Barnes received his buttons and was granted leave to visit his family.[6]

The archive speaks. If we search, if we listen, it can reveal worlds of brutality and kindness, of shame and glory. In this book, I want you to see and hear the world of the black soldiers and the wives and mothers of the Civil War.

INTRODUCTION

Once [you] let the black man get upon his person the brass letter, US, let him get an eagle on his button, and a musket on his shoulder, and bullets in his pocket; and there is no power on the earth, or under the earth, that can deny that he has earned the right to citizenship in the United States.

—Frederick Douglass, abolitionist and orator

I feel more inclined daily, to press the army on further and further; and, let my opposition be in life what it will, I do firmly vow, that I will fight as long as a star can be seen and if it should be my lot to be cut down in battle, I do believe . . . that my soul will be forever at rest.

—Sergeant Charles Brown, Union army

My position as an officer of the United States, entitles me to wear the insignia of my office, and if I am either afraid or ashamed to wear them, anywhere, I am not fit to hold my commission.

—Alexander T. Augusta, MD

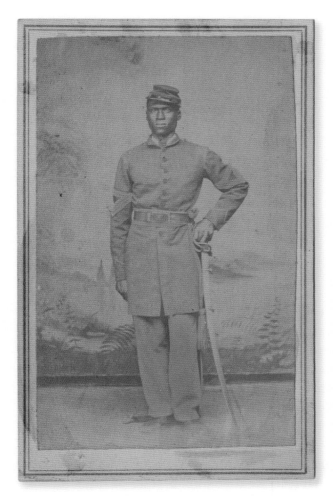

Portrait of Richard Eatheridge (hand-colored) and letter
(see facing page), ca. 1860s. (Carte de visite and letter;
Collection of Jacob Loewentheil and Stephan Loewentheil)

R. Co. 1 United 36. U.S. C. C.
Brazos Santiago
Aug 25th 1866

Major

I have the honor to hand here-
with my kind regards for your future
welfare trusting that in days to come the
enclosed likeness may be the means of
bringing to you pleasant recollections of days
past when you sacrificed all in your
power for the rights and elevation of the
Colored race and I trust that you may
receive your just reward in Heaven
is the constant prayer of
Your humble servant
Richard H. Etheridge
R. Co. 36. U.S. C. C.

To Bvt Maj Orange A Hendrick
36th U.S. C. C.

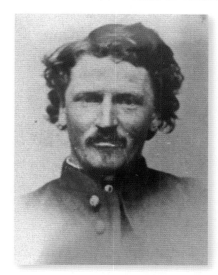

Portrait of Oren A. Hendrick (reproduction).
(Collection of Jacob Loewentheil and
Stephan Loewentheil)

Tintype with cover glass of an African American Union soldier with a mustache and beard, holding a pistol across his chest; in black thermoplastic case with brass hinges and red velvet liner, preserver and mat, brass decorated with eagle, two American flags, cannon, and "E Pluribus Unum" set in a red velvet liner. His buttons and belt buckle are hand-colored in gold paint.

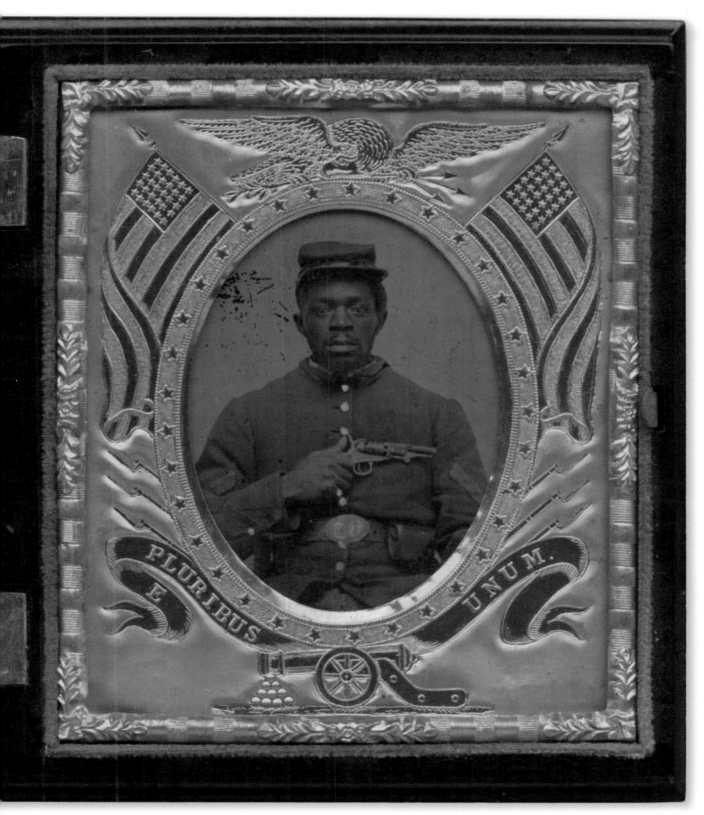

The hand-coloring on the buckle reads backward "SU," which when considered that the image is reversed, reads "US," the traditional inscription on Union Civil War belt buckles. (Collection of the Smithsonian National Museum of African American History and Culture, Gift from the Liljenquist Family Collection, 2011.51.12)

The epigraphs to this chapter, by Frederick Douglass, Sergeant Charles Brown, and Alexander T. Augusta, frame the black Civil War soldier in patriotism and manhood.[1] When we read text and images from the war in this way, we imagine in an instant the sense of bravery and pride that accompanied the very act of pinning and wearing that emblematic eagle and brass button. Portraits of black soldiers, whether taken in a photographic studio, on a battleground, or on a campground, are connected to the concept of democracy and citizenship expressed by Douglass. As the authors of *Picturing Frederick Douglass* explain, "It was the Civil War that inspired Douglass to write and speak on photography. . . . Like many Americans, he believed that photographs and pictures greatly contributed to secession and a war over slavery. During the Civil War years, Douglass penned four lectures on photography and 'picture-making.'"[2] Viewing photography as a form of activism, he connected the making of an image to the affirmation of humanity. "Douglass spoke about the transformative power of pictures to affect a new vision for the nation," asserts the art historian Sarah Lewis. "[He] argued that combat might end complete sectional disunion, but America's progress would require pictures because of the images they conjure[d] in one's imagination."[3]

With this book, I too seek to engage that sense of activism and highlight the various acts of courage by black men, both bonded and free, during the Civil War, as well as the rewards they received. Just as critical are the low points for those who fought in the war—from inequities in pay to discriminatory practices in the field to inadequate health services. These are experiences shared by all the soldiers, no matter their backgrounds. By examining diary pages, letters, and news items, I want to build on the stories that their portraits "tell"—to focus a lens on their hopefulness and the sense of what could be won from loss. These personal memories reach through the decades and centuries to tell us about individual feelings of love and longing, responsibility and fear, commitment and patriotism.

Black soldiers desired to communicate with their loved ones through letter writing as soon as their units were mustered into the army. Women like Frances Beecher and Susie King Taylor taught soldiers of color to "read and write while they were stationed at Beaufort and Jacksonville," Beecher said. A white woman, she was the wife of Colonel James Beecher, commander of the Thirty-Fifth US Colored Infantry. As she recalled,

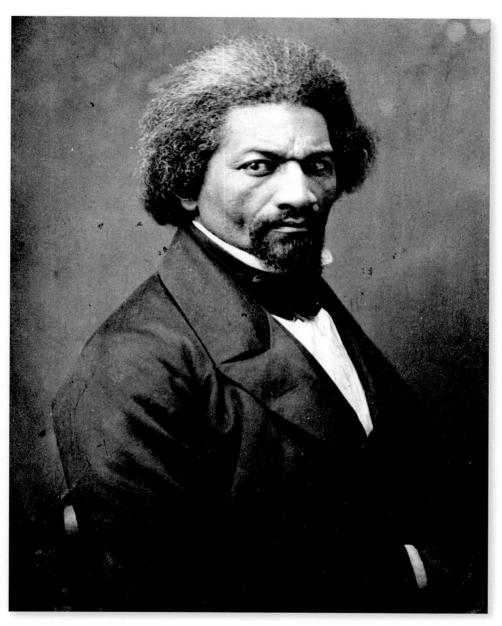

Half-length portrait of Frederick Douglass, ca. 1860s. (Unidentified photographer; Collection of the New-York Historical Society)

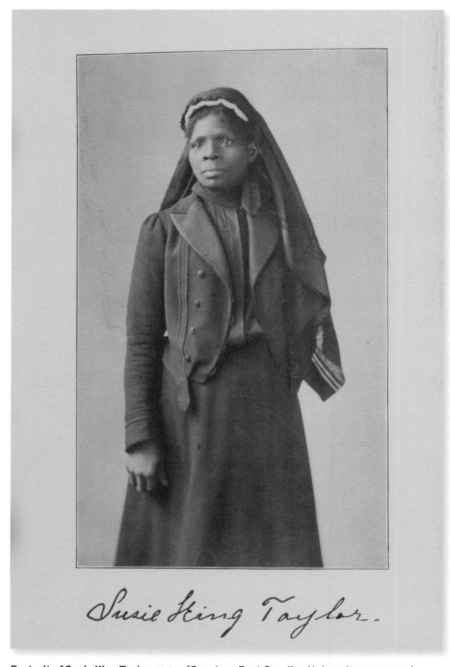

Susie King Taylor.

Portrait of Susie King Taylor, 1902. (Courtesy East Carolina University; 3a03574)

My mornings were spent in teaching the men of our regiment to read and write, and it became my pleasing duty and habit, wherever our moving tents were pitched, there to set up our school. Sometimes the chaplain assisted, and sometimes the officers; and the result was that when the men came to be mustered out each one of them could proudly sign his name to the pay-roll in a good legible hand. When enlisted, all but two or three of them were obliged to put a mark to their names as written by the paymaster . . . while their eagerness to learn and the difficulty that many found in learning were very touching. One bright mulatto man particularly worked at his letters for two years, and then could only write his own name; while others learned at once. Whenever they had a spare moment, out would come a spelling-book or a primer or Testament, and you would often see a group of heads around one book.[4]

Taylor, a black woman who had escaped from slavery, in 1862 lived on St. Simons Island, off the coast of Georgia, and found work as a nurse, laundress, teacher, and cook for the First South Carolina Volunteers. She taught children and adults how to read, using Bibles and other books sent from the North, and wrote about teaching black soldiers: "I taught a great many of the comrades in Company E to read and write, when they were off duty. Nearly all were anxious to learn. My husband taught some also when it was convenient for him."[5]

I learned about the reality of the Civil War from the letters of black soldiers and the photographs that frequently accompanied them. Black soldiers wrote to and received letters from black nurses and teachers, wives and mothers, girlfriends and daughters, and doctors (who supported and protested the war), as well as white officers and their wives. Some letters were written by the soldiers themselves; others were dictated to an unnamed scribe. They convey the importance of family and family ties, the urgent need to belong, losses caused by the war, and abuses inflicted on enslaved relatives left behind. "Through all their letters flows a current of dignity and pride," notes Edwin Redkey. "There is an unmistakable note of achievement and self-confidence."[6] Such letters, and pages from diaries, hold the legacy of African American resilience.

That people memorialized these experiences through photographs indicates the urgency of the moment. Having a photograph taken

was indeed a self-conscious act, one that shows the subjects were aware of the significance of the moment and sought to preserve it. Photographs were a luxury; their prevalence shows their importance as records of family, position, identity, and humanity, as status symbols. A soldier or a sailor who posed in front of a painted backdrop in a photo studio paid extra to have the flag carefully hand-colored. In the North, ambrotypes and tintypes cost from $0.25 for the smallest images to $2.50 for the largest—approximately $6 to $60 in today's dollars. In the South, black soldiers had few opportunities to

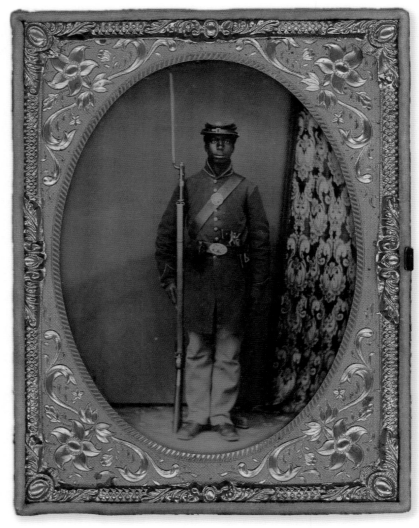

Portrait of a soldier with rifle, ca. 1860s. (Quarter-plate ambrotype; courtesy of Greg French and Collection of Greg French)

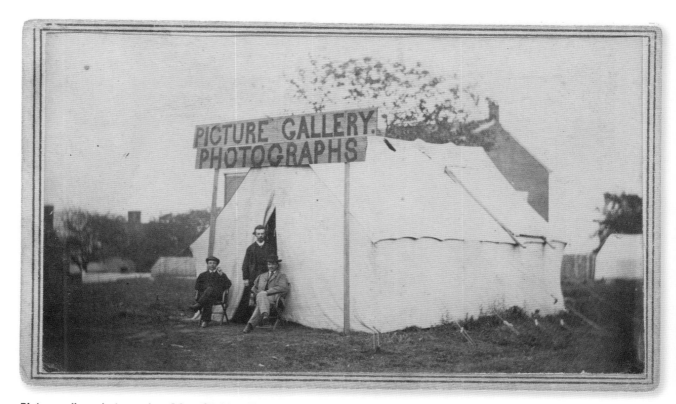

Picture gallery photographs, 1860s. (Unidentified artist; albumen silver print, carte de visite; The Metropolitan Museum of Art, New York purchase, Alfred Stieglitz Society Gifts, 2013; accession number 2013.57)

sit for a portrait. Commercial portrait photographers were few in the Confederate states, and photographic supplies were frequently not available. A limited number of Southern photographers held onto their businesses by raising prices to compensate for the high price of photographic supplies and the inflated Confederate dollar.[7]

In the 150-plus years since the end of the Civil War, books on the topic frequently have focused on the stories of politicians or landowners, the economy of slavery, or the reasoning that led to the war. Other books detail the tactics of the battles that took place in the North and the South or the strategies of the military leaders on both sides. Still others praise the heroism of the men who fought and, through extraordinary effort and determination, earned fame, glory, and monuments for themselves and their combat units. Some of these books overlook the contributions made by the black soldiers who fought and died for their own families and for freedom.

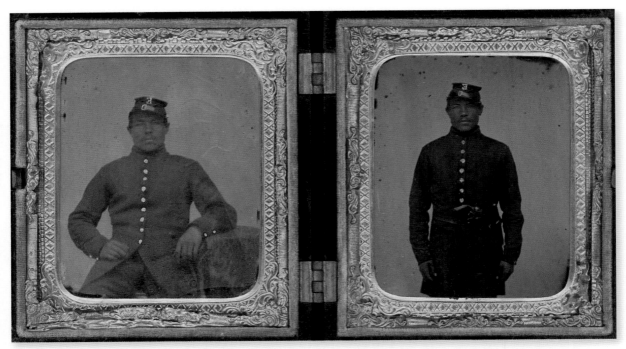

Double portrait of a Civil War soldier (seated and standing). (Plate ambrotypes; courtesy of Greg French and Collection of Greg French)

Quarters of Provost Marshall, Civil War, Port Hudson, Louisiana. (Louisiana Collection, State Library of Louisiana; Hp000582)

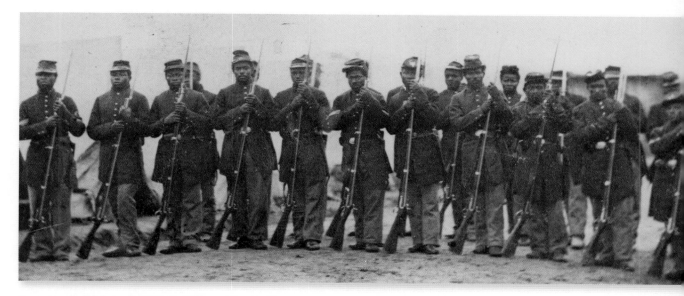

Group portrait of guard of US Civil War soldiers in Port Hudson, Louisiana. (Louisiana Collection, State Library of Louisiana; Hp001117)

Take, for example, the story of heroism and profound determination shown by Captain Andre Cailloux of the First Louisiana Native Guard, who died as he led his troops into battle at Port Hudson, Louisiana, on May 27, 1863 (one of the most important strategic battles of the war). His story is inspiring yet tragic, and his bravery and his death greatly affected people in his hometown, who gave him a public funeral. "Cailloux's death had a profound impact on people of color in New Orleans," writes Stephen J. Ochs. "To blacks, this funeral for one of their own attested to their capacity for patriotism, courage and martial valor. . . . Women of color donned crepe rosettes in mourning. . . . His body lay in state for four days in the hall of the Friends of the Order. . . . The coffin was draped with the American flag on which rested Cailloux's sword and belt, uniform coat and cap."[8]

Unfortunately, there are no known photographic portraits of Cailloux or his feats of heroism; however, descriptions of his bravery and achievements can be found in numerous articles and books, and his life has been reimagined through artist renderings. Using photographs to study the Civil War challenges the historical record in numerous ways. In searching for ways to include Cailloux's story in this book, beyond descriptions of his funeral by people who were there, I realized it was important to employ new methods, to use

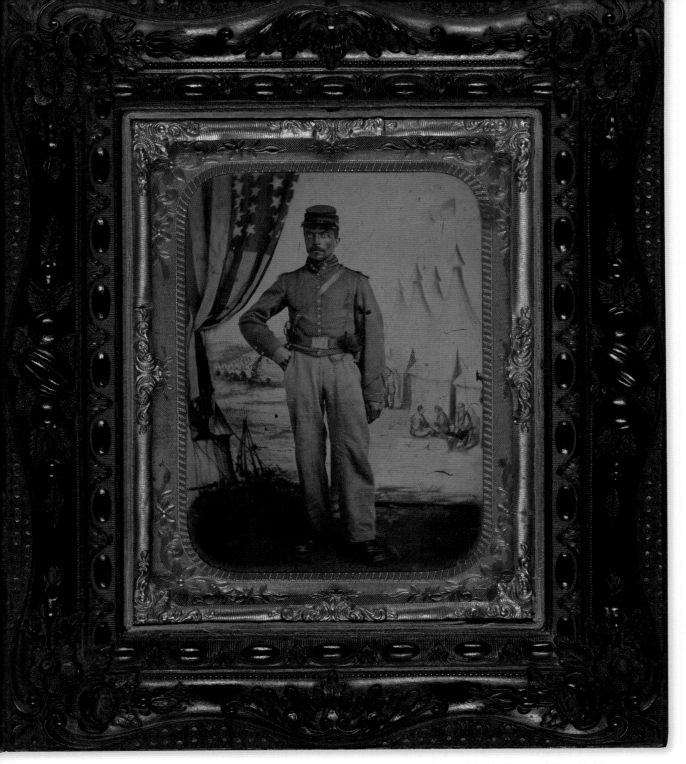

Portrait of an unidentified African American soldier in Union artillery shell jacket and shoulder scales in front of painted backdrop showing military camp with flag, 1861 and 1865. (Quarter-plate tintype, hand-colored; Library of Congress Prints and Photographs Division; LC-DIG-ppmsca-37532 LC-DIG-ppmsca-27532)

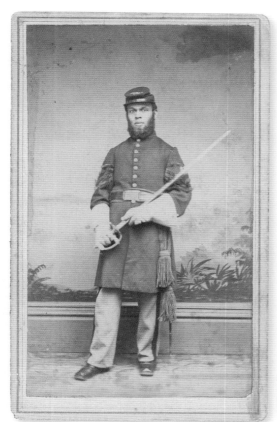 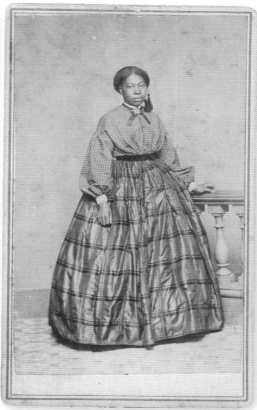

Double portraits of a Connecticut soldier and his wife. (Cartes de visite; courtesy of Greg French and Collection of Greg French)

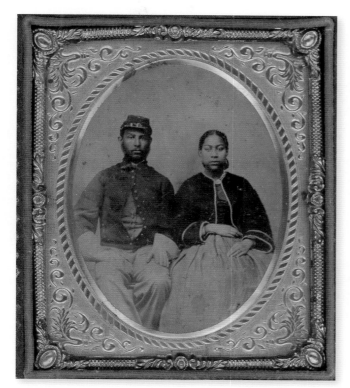

Portrait of husband and wife, ca. 1860s. (Tintype; courtesy of Greg French and Collection of Greg French)

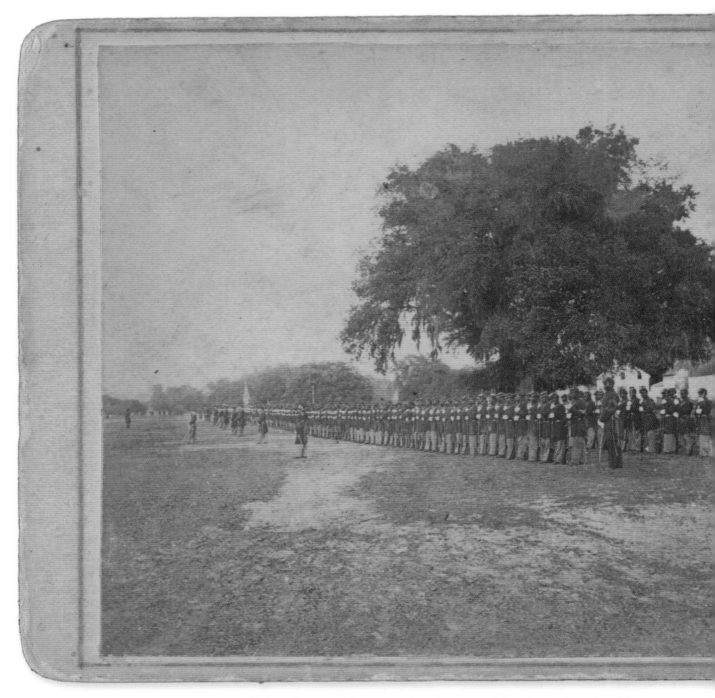

Tenth Army Corps, a Union army regiment composed of self-emancipated men, in formation, near Beaufort, South Carolina, 1863–64. (Photographer: Samuel A. Cooley; stereograph; Library of Congress, Prints and Photographs Division; LC-DIG-stereo-1s04441LOT 14110-5, no. 51 (H))

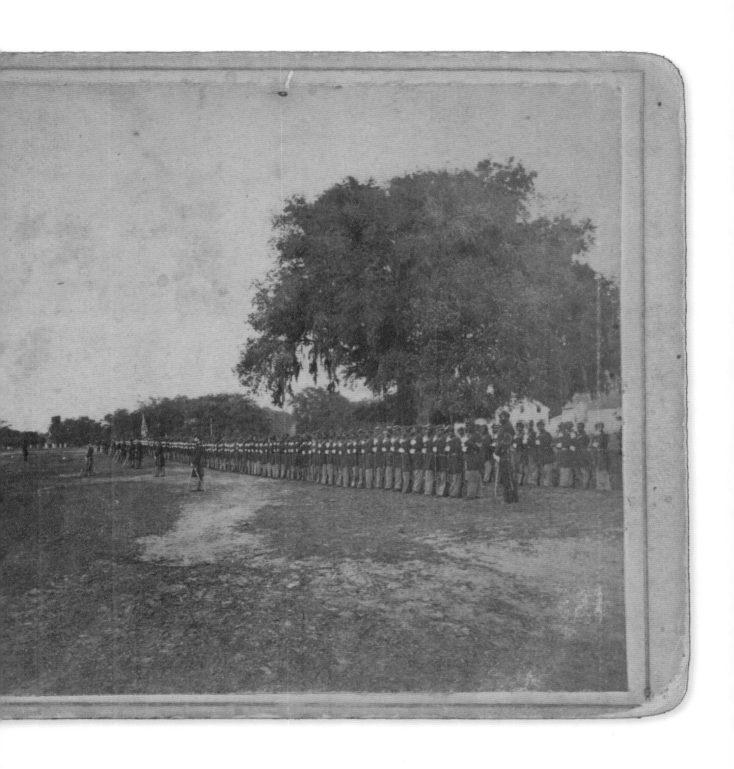

images of unidentified soldiers posing in uniforms and free and bonded women dressed fashionably and in work garments. In this way, I could complete the story of the importance of the clothed black body.

Since 2010, the United States has seen a boom in publishing, documentaries, and lectures on the Civil War; some of the works and presentations feature newly discovered photographs, many included in these pages. However, personal documents and photographs from that period do more than tell us about soldiers on the battlefield. These words and images also shape our ideas about black families and black identity during the Civil War and the years that followed. In the past twenty years, more and more researchers and scholars digging into Civil War archives have revealed alternative narratives about the experiences of the black men who fought the battles, worked the camps, built the bunkers, suffered the wounds, and died on a daily basis on hundreds of battlefields. The Library of Congress, the Smithsonian Institution, the Schomburg Center for Research in Black Culture, Howard University's Moorland Spingarn Research Center, the Charles L. Blockson Afro American Collection at Temple University, Yale University, and the National Archives are just a few of the important resources for researching the history of photography and the Civil War, as is the scholarship conducted using their collections. For example, the wartime and postwar experiences of wives, children, and surviving soldiers come alive in the letters and photographs that form the Pension Fund records at the National Archives and in images from W. E. B. Du Bois's 1900 Paris exhibition *A Small Nation of People*, now part of the collections at the Library of Congress.

This book returns the voices to these men and women, whose lives in some cases had long been forgotten, whose bodies lie unidentified, and whose voices have been silenced for decades. Letters between loved ones, friends, foes, and fellow soldiers help us to resurrect their views about the war and the circumstances in which they found themselves.

1860-61

THE WAR BEGINS

There were debates about the need for political change and quietly spoken rumors of war in the United States during the autumn of 1860. The controversy surrounding the presidential election of 1860 brought much of the discussion out into the open. Although the black population in the United States has rarely been recognized as a participant in the conversations, there was much discussion in the cotton fields, plantation houses, tobacco barns, churches, and masonic halls. I imagine that enslaved blacks overheard the feverish political discussions among whites, passed information on to other blacks, and became pro-Lincoln very early, associating him with their freedom. Many enslaved blacks and servants were united in their opinion—they associated war with emancipation. When Abraham Lincoln won the election, black people listened intently for the next development. This is found in the letters that black men and women wrote directly to President Lincoln. The decisions made in Washington, DC, and on the battlefields during the Civil War had a major impact on their daily lives.

On December 21, 1860, as a direct consequence of Abraham Lincoln's election as president, the state of South Carolina formally seceded from the Union—an act that ignited the flame that would become the War between the States. Seven states joined South Carolina to form the Confederacy; four more states seceded after the war began in April 1861. President Lincoln called for seventy-five thousand new troops for the Union army; however, African American men were

excluded from this initial call-up. Many who eventually fought for the Union had to protest to the government to allow them to serve. Before the war, a large number of free black people—journalists, farmers, religious leaders, abolitionists—had advocated for black participation in the military. They understood that it was vital for black people to be engaged fully and that the armed services provided a direct route to that goal. Even though that call did not come until 1863, the inclusion of black servicemen had a direct impact on everyone.

In my search for details about the 1860-61 period, I turned to correspondence and other accounts from white officers and surgeons and letters that black people sent to editors of newspapers sympathetic to the abolitionist cause. Now housed in archives or documented in books, newspapers, and journals, these are fascinating descriptions of the early days of the Civil War. Blacks sought their freedom and freedom for others. Black people were often endangered by both armies and were vulnerable as they left plantations and homes without weapons or shelter of any kind. Traveling through swamps, over dusty trails, and across rivers, families seeking freedom carried all of their possessions, clothing, food, and other items in sacks, on their backs, or in wagons following Union troops or to escape their plight. Although the Union Army did not initially welcome black people, that attitude had changed as early as May 1861. By January 1862, the Lincoln administration was already engaging black people to support the war effort in many ways.

There was no ambiguity in the war's beginning. Two Southern men, one representing the Confederacy and the other representing the Union, exchanged three courteous and respectful letters: the first, an invitation/demand; the second, a rejection of that invitation; the third, an attack. General P. G. T. Beauregard, of the Confederate States of America, announced the precise date, time, and place of the beginning of the war when he composed the third letter to Major Robert Anderson of the United States.

> To: Maj. Robert Anderson
> Commanding at Fort Sumter
>
> April 11, 1861
> Dear Sir,
> I am ordered by the Government of the Confederate States to demand the evacuation of Fort Sumter. My aides, Colonel Chesnut and

Captain Lee, are authorized to make such demand of you. All proper facilities will be afforded for the removal of yourself and command, together with company arms and property, and all private property, to any post in the United States which you may select. The flag which you have upheld so long and with so much fortitude, under the most trying circumstances, may be saluted by you on taking it down. Colonel Chesnut and Captain Lee will, for a reasonable time, await your answer. I am, sir, very respectfully, your obedient servant.

G. T. Beauregard
Brigadier-General, Commanding
Headquarters Provisional Army, CSA
Charleston, SC

To: G. T. Beauregard
Brigadier-General, Commanding
Headquarters Provisional Army, CSA
Charleston, SC

April 11, 1861

General:

I have the honor to acknowledge the receipt of your communication demanding the evacuation of this fort, and to say, in reply thereto, that it is a demand with which I regret that my sense of honor, and of my obligations to my Government, prevent my compliance. Thanking you for the fair, manly, and courteous terms proposed, and for the high compliment paid me, I am, general, very respectfully, your obedient servant,

Robert Anderson
Major, First Artillery, Commanding
Fort Sumter, SC

April 12, 1861, 3.20 a.m.

Sir:

By authority of Brigadier-General Beauregard, Commanding the Provisional Forces of the Confederate States, we have the honor to notify you that he will open the fire of his batteries on Fort Sumter in one hour from this time. We have the honor to be, very respectfully, your obedient servants,

James Chesnut, Jr., Aide-de-Camp
Stephen D. Lee, Captain, C.S. Army, Aide-de-Camp[1]

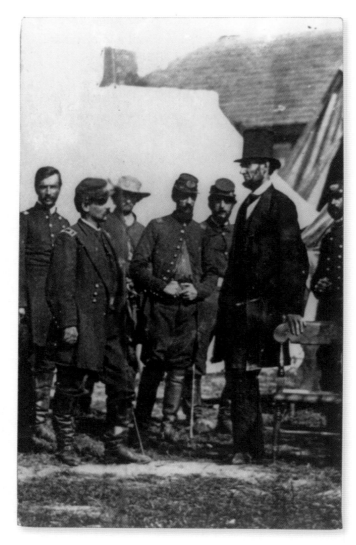

Abraham Lincoln with, from left, Colonel Alexander S. Webb, Chief of Staff, Fifth Corps; General George B. McClellan; Scout Adams; Dr. Jonathan Letterman, Army Medical Director; an unidentified person; and standing behind Lincoln, General Henry J. Hunt. (Photographer: Alexander Gardner, 1862; Library of Congress Prints and Photographs Division, PRES FILE—Lincoln, Abraham—Portraits—Meserve no. 44, LC-USZ62-2276)

During the period leading up to this exchange between the commanders of the opposing forces in Charleston Harbor, hundreds of black men were working as laborers for each side. They repaired the structures at Fort Sumter for the federal government and upgraded and expanded the facilities at Fort Moultrie and Castle Pinckney for the Confederate army.

The war formally started on April 12, 1861, with that attack on Fort Sumter. Lincoln realized that the Confederates' next target would be the Capitol, the seat of the federal government and the Union itself. Seventy-five thousand men—the maximum number the Constitution allowed federal authorities seeking to put down a rebellion—were formally called on April 15, 1861, by the secretary of war, for a ninety-day enlistment in the Union army. Each state's armed forces provided its quota, and the troops moved south to defend the nation. On April 18, 1861, five volunteer militia companies from Pennsylvania marched through the city of Baltimore on the way to defend the Capitol in Washington, DC. These soldiers were attacked by a mob of local citizens who were sympathetic to the Confederate cause. A sixty-five-year-old black soldier, Nicholas Biddle (ca. 1796–1876), the apparent target of the attack, was hit in the face with a brick, and someone in the crowd yelled derogatory epithets because he was a black man wearing a uniform. Bloodied but not otherwise seriously injured, Biddle was helped to his feet by white soldiers and continued the march to Washington, DC, where the regiment camped and waited for further orders. Biddle was reportedly the first man to shed blood during the Civil War. Four men from Pennsylvania were also attacked.

> When the soldiers at last arrived at Camden Station [in Baltimore], violence erupted. They were pelted with stones, bricks, bottles, and whatever else the vehement mob could find; some were even clubbed and knocked down by a few well-landed punches. A few more determined Confederate sympathizers lunged at the unarmed Pennsylvanians with knives and drawn pistols. "Powder had been sprinkled by the mob on the floor of the [railroad] cars," wrote First Defender Heber S. Thompson (1840–1911) of Pottsville, "in the hope that a soldier carelessly striking a match in the darkened interior of the car might blow himself and his comrades to perdition." . . . For the idealistic volunteers from

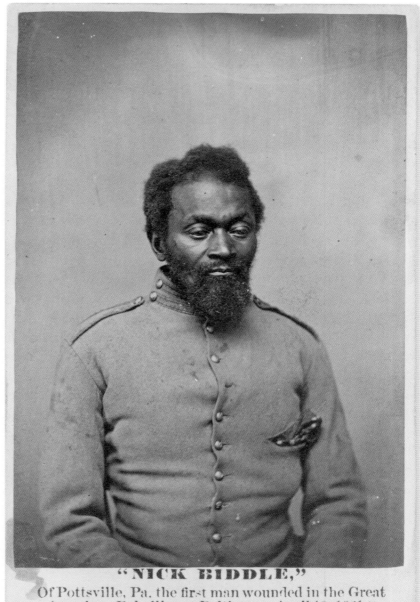

"NICK BIDDLE,"
Of Pottsville, Pa. the first man wounded in the Great
American Rebellion, "Baltimore, April 18, 1861."
Published by W. R. Mortimer, Pottsville, Schuylkill Co., Pa.

Nicholas Biddle, "the first man wounded in the Great American Rebellion,"
Baltimore, April 18, 1861. (Carte de visite; Charles L. Blockson Collection,
Temple University Libraries)

Pottsville, Allentown, Reading, and Lewistown, it was a trying ordeal and one that diminished the romanticized notion of the glories of soldiering. Soon, all the men were boarded and the train sped south toward Washington. Of all the injuries sustained during the harrowing ordeal, the most serious was Biddle's. Because he was Black, Biddle was prevented from being mustered in as a soldier. Not to be deterred, however, he [had] marched off to war as the orderly (an attendant to an officer) of Captain James Wren (1825–1901), the commanding officer of the Washington Artillery. Biddle had been associated with the company since its formation in 1840 and was so highly regarded by Wren and the members of the Washington Artillery that he was considered one of their own and even permitted to wear the company's uniform.[2]

According to numerous historical accounts, President Lincoln and others from his Cabinet greeted the soldiers on Capitol Hill and noticed the injured Biddle among the other soldiers the following day.

The next day, April 19, 1861, a troop train carrying the Sixth Massachusetts Infantry regiment on the way to Washington was attacked by another Baltimore mob, larger this time and armed with guns. Having heard an account of the attack on the Pennsylvania Militia that had taken place the previous day, Colonel Edward F. Jones, the commander of the Sixth Massachusetts Infantry, had fully armed his regiment and prepared the men for the inevitable encounter with a Baltimore mob. His official report on the events of the nineteenth follows.

> Report of Col. Edward F. Jones, Sixth Massachusetts Militia.
> Hdqrs. 6th Regiment, 3d Brig., 2d Div., M.V.M., Capitol,
> Washington, April 22, 1861.
> In accordance with Special Orders, No. 6, I proceeded with my command towards the city of Washington, leaving Boston on the evening of the 17th April, arrived in New York on the morning of the 18th, and proceeded to Philadelphia, reaching that place on the same evening. After leaving Philadelphia I received intimation that our passage through the city of Baltimore would be resisted. I caused ammunition to be distributed and arms loaded, and went personally through the cars, and issued the following order:

"The regiment will march through Baltimore in column of sections, arms at will. You will undoubtedly be insulted, abused, and, perhaps, assaulted, to which you must pay no attention whatever, but march with your faces square to the front, and pay no attention to the mob, even if they throw stones, bricks, or other missiles; but if you are fired upon and any one of you is hit, your officers will order you to fire. Do not fire into any promiscuous crowds, but select any man whom you may see aiming at you, and be sure you drop him."[3]

Four soldiers were shot and killed. The soldiers were ordered to open fire, and in the ensuing fight, several Baltimore citizens were killed as well. Led by the city's mayor and chief of police, the Union soldiers fought their way through the streets of Baltimore and on to Washington, DC. The incident came to be known as the Baltimore Riots.

From the earliest days of the war, black men strived to prove their worthiness as soldiers and fighters. A primary way to accomplish this was to stand in front of a camera and be photographed, to be depicted as men who had made a choice to be free. As soon as they were given their gear—from uniforms to forage caps to weapons—they posed for photographs, holding their weapons as if they were props that signified the future. Standing alone or in groups, they held flags, rifles, and banners and looked directly into the camera lens, sending a message of undeniable patriotism, commitment, and courage.

A letter written by a black soldier, William Henry Johnson, helps us envision a significant battle in Virginia. Johnson's letter was one of several that he published in 1861 in a weekly newspaper, the *Pine and Palm*, whose front-page banner promoted its mission: "Devoted to the interests of freedom, and of the colored races in America." The *Pine and Palm*'s editors—the white abolitionists James Redpath, G. Lawrence Jr., and R. J. Hinton—were based in Boston and focused their interests on the concept of freedom. Redpath's goal was to convince the US government to abolish slavery and embrace Haiti, the first black-ruled nation in the Western Hemisphere. He promised his readers they would be enlightened by his newspaper, which was published in English and French.

We do not believe in a distinctive Nationality, founded on the preservation of any race, as a *finality*. We believe in Humanity, not in Black men or White men; for the fusion of the human races is the destiny of the future. We stand by man as man; not by the Saxon because we are Saxon; nor by the Negro because we are an Abolitionist. What we assert, as our belief, is this only—that, at this stage of the world's progress, the fact of a powerful Negro Nation is a lesson imperatively needed in order that the African race, wherever it exists, may be respected as the natural equal of other families of man. We do not believe that the inculcation of the doctrine of fraternity alone will accomplish this result; for without a physical basis, this class of truths require centuries for their universal acceptance.[4]

Born a free man, William Henry Johnson was the war correspondent of the *Pine and Palm* during the first year of the Civil War—initially with the Army of the Potomac during the three-month campaign. He had been forced to leave Philadelphia in 1859 to escape imprisonment for having assisted self-emancipated men, women, and children to escape to the North. He moved to Norwich, Connecticut, and was a resident there when the war broke out. Not being allowed to enlist as a soldier because he was black, he joined a Connecticut regiment as an independent man. The regiment, unable to formally enlist him, allowed him to arm himself and accompany the regiment to the front. He then joined the Burnside Expedition and served in North Carolina.[5]

> [From] William H. Johnson
> 2nd Connecticut Infantry
> Washington, DC

July 24, 1861

We have met the enemy in this pro-slavery war—we have fought two great battles—one of the longest and most sanguinary ever fought in America. The first, on the 18th, lasted from 11½ a.m. until 5 p.m., and our loss was great. The second, on Sunday the 21st, was commenced at 8 in the morning, and we were defeated, routed and driven from the field before 1 p.m. We lost everything— *life, ammunition, and honor.* We were driven like so many sheep

into Washington, disgraced and humiliated. One week ago we marched into Virginia with the Stars and Stripes proudly floating in the breeze, and our bands playing Yankee Doodle. We had but one thought, and that was of success.

What! 50,000 brave and Union-loving men get beaten? No, it could not be. No one would have believed it for a moment, who saw the firm and soldierly tread of Uncle Sam's men, and the glittering of their bayonets as they moved onward and passed through Fairfax Court House, and tore down the Secession flag, and hoisted the Stars and Stripes in its place. No one would have believed it who saw the burning of Germantown, and the general havoc made along the line of march, and saw the backs of the fleeing reels, as they went pell-mell before our advance guards. But we were all disappointed and the under-rated enemy proved too much for us.

It was not alone the white man's victory for it was won by slaves. Yes, the Confederates had three regiments of blacks in the field, and they maneuvered like veterans, and beat the Union men back. This is not guessing, but it is a fact. It has angered our men, and they say there must be retaliation. There is much talk in high places and by leading men, of a call being made for the blacks of the North; for Africa to stretch forth her dusky arms, and to enter the army against the Southern slaves, and by opposing, free them. Shall we do it? Not until our rights as men are acknowledged by the government in good faith. We desire to free the slaves, and to build up a negro Nationality in Hayti; but we must bide our own time, and choose the manner by which it shall be accomplished.[6]

The following account from an enslaved man who was forced into service was recorded by a reporter, writing for the *Reading (PA) Journal,* and sections were later published in *Douglass' Monthly* in March 1862. The man describes how he helped to load a Confederate artillery battery at Bull Run and later gave the Union army information about the locations of Confederate soldiers in Virginia:

My name is John Parker, I was born in King and Queen's county Virginia, I do not know my age. My master's name was Benjamin Wilson; he failed in business, and when he broke up they seized 130

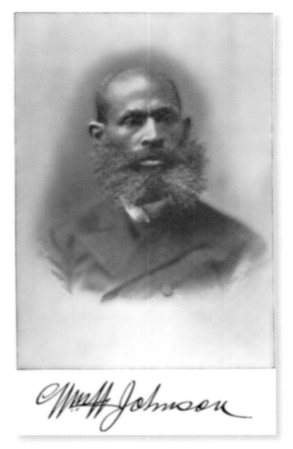

William Henry Johnson. (John Muller, "Dr. William Henry Johnson: Albany [NY] Correspondent of *The North Star*," *The Lion of Anacostia* [blog], April 16, 2018, https://thelionofanacostia.wordpress.com/2018/04/16/dr-william-henry-johnson-albany-ny-correspondent-of-the-north-star/)

Negroes—of which I am one—and sold them at auction market in Richmond. I was bought by Thomas Griggs, a Colonel in the Rebel army for $1000. I stayed with my new master until war broke out, then he and his sons went away to the war, leaving an overseer to manage us. In two weeks our overseer also went to the war. We had good times then, and eat up everything we could get. Not long after, our mistress and her two daughters packed up and went off. Our master had told us to stay at the plantation until he came back, and that if any d—d Yankees showed themselves in his absence, to

shoot them. Our master had also before this sent us to Winchester and Fredericksburg to work upon the batteries and assist at the trenches. Ten of us then went to Richmond and worked for a considerable length of time upon the batteries and breastworks on James River. When they were done with us we returned to the farm and found our overseer at home. We worked on smoothly until the excitement about the expected battle at Bull Run arose. They said that all the colored people must then come and fight. I arrived at Junction two days before the action commenced. They immediately placed me in one of the batteries.

There were four colored men in our battery, I don't know how many there were in the others. We opened fire about ten o'clock on the morning of Sunday the 21st; couldn't see the Yankees at all and only fired at random. Sometimes they were concealed in the woods and then we guessed our aim. My work was to hand the balls and swab out the cannon; in this we took turns. The officers aimed this gun; we fired grape shot. The balls from the Yankee guns fell thick all around.

In one battery a shell burst and killed twenty, the rest ran. I felt bad all the time, and thought every minute my time would come; I felt so excited that I hardly knew what I was about, and felt worse than dead. We wish to our hearts that the Yankees would whip, and we would have run over to their side but our officers would have shot us if we had made the attempt. I stayed at my place till the order came for all to retreat, then everyone ran thinking that the Yankees were close upon our heels. I followed the retreat a good piece, but as soon as our officers found out that the Yankees were also running as fast as we were, they ordered a halt, and the Black Horse Cavalry (which lost a great number in the fight) stopped all the fugitives and turned in pursuit of the United States troops but the general was a little "skittish" about following him, and they didn't care to press forward upon them very sharply. . . . I stayed about here for two weeks, we worked until the next Friday burying the dead—we did not bury the Yankees and our men in the same hole, we generally dug a long hole 8 or 9 feet deep and threw in a hundred in each pit. We were afraid of another attack from the Yankees, and prepared ourselves as well as we could to meet them again, but they didn't come. I then left . . . with six of my master's men to go home. . . .

When we got back we found all the cattle and mules gone, and corn all grown up with weeds, but we didn't care for that, all we wanted was a chance to escape. There were officers prowling round the neighborhood in search of all the Negroes, but we dodged round so smartly, they didn't catch us. . . . I staid with my wife from Saturday night until Monday morning, and then returned to my master's; I was afraid to stay long in the neighborhood for fear of the officers, so I left and came nearer the American lines. I found the U.S. soldiers at Alexandria, who gave me two papers, one for myself and one for my wife; they asked me whether I could get my wife, I said I would try. I then went back, and finding her, I gave her the paper and told her to come to the Chain Bridge at a certain time and I would meet her, but I found out they wouldn't allow me to pass over there, so I fixed another plan to get to my wife over, I was to meet her in a canoe and ferry her across, but I missed her though, and I think she must have gone too high up the river. When I had given her up I went along up the river and came up with some of the pickets in Gen. Banks' division, near Frederick, Md. I was afraid, but they welcomed me and shouted, "Come on! Don't hurt him!" Some of the pickets were on horseback, they gave me a suit of clothes and plenty to eat, and treated me well. They wanted me to stay and go down into Virginia and tell them all about where the batteries were, but I was afraid to try that country again, and said that I was bound for the North, I told them all I knew about the position of the other army, about the powder mill on the Rappahannock river, &c. They let me go. . . . I left at night and travelled for the star, I was afraid of the Secessionists in Maryland, and I only walked at night. I came to Gettysburg in a week, and I thought when I saw the *big barns*, that I was in another country. . . . I am going from here to New York where I hope to meet my wife, she has two girls with her; one of my boys is with my master, and the other, who is 14 years old, I think was taken to Louisiana. My wife and I are going to travel from New York to Canada.[7]

Black soldiers expressed in their own words their desire to fight for the Union. Alexander Herritage Newton wanted to fight as much as any volunteer in the ranks. Not legally permitted to join the army in 1861 because he was a black man, he went on his

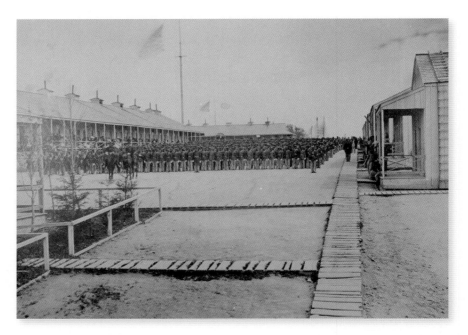

The Twenty-Sixth US Colored Volunteer Infantry on parade, Camp William Penn, PA, 1865. The camp, which was fully operational by July 4, 1863, served as the training ground for eleven regiments comprising nearly eleven thousand men in its two years of existence. (Charles L. Blockson Afro-American Collection, Temple University Libraries)

own accord. "I engaged myself for the great Civil War, the War of the Rebellion," he wrote, adding, "I went into the company of the Thirteenth Regiment, of Brooklyn. I went to the front, as the United States was not taking Negro troops." Newton knew firsthand the plight of men and women of African descent. "Although free born, I was born under the curse of slavery, surrounded by the thorns and briars of prejudice, hatred, persecution and the suffering incident to this fearful regime." He faced the stark realities of racism in New Bern, North Carolina.[8]

Newton left the South at age nineteen in 1857. He worked his way as a ship's cook to New York. In Brooklyn, he reunited with his mother, Mary, who had moved there earlier in the decade. She contacted abolitionists who helped her buy the freedom of her husband, Thadde. As a teenager, Newton participated in the Underground Railroad movement. "I was, of course, deeply interested in this means of travel," he wrote, "and tried to get all the passengers for this railroad that I could find." He writes, "My boss-foreman, H. E. Bryan, had disobeyed his master and was threatened to be whipped.

Alexander Herritage Newton (*left*) as a quartermaster sergeant with the Twenty-Ninth Connecticut Infantry, ca. 1865. Standing next to him is Daniel S. Lathrop (1846–1924), who served at the same rank in the regiment. (Photographers: James Horace Wells and David C. Collins of New Haven, Connecticut; carte de visit; Beinecke Rare Book and Manuscript Library, Yale University)

I assisted him to a place of safety. In all the slave holders' dwellings, slaves were employed in the house." Newton devised a ruse to dress him in women's clothing and hid him in the kitchen of the house, which was rarely searched. A reward was posted for the capture of Bryan, but he was never found. Newton later explained, "At last things quieted down and we found opportunity to put him on this mystic train and send him to a clime where he enjoyed his freedom. This was indeed a daring attempt of mine, but it was in me to do it with a great deal of delight. And from that day to this, I have been proud of this one feat of my boyhood life which was on the side of right and humanity."

Laws prohibited the enlistment of blacks; however, Newton attached himself to the Brooklyn Thirteenth. He did not note his exact role. The regiment made it as far as Annapolis, Maryland, when authorities ordered it to Baltimore, where citizens had recently rioted against Union troops passing through the city. Its three-month term of enlistment ended in August 1861. The federal government activated the Thirteenth again for brief stints in 1862 and 1863. It appears that Newton accompanied the regiment both times. The latter mobilization, organized to resist the Confederate invasion of the North that culminated in the Battle of Gettysburg in 1863, ended after state officials recalled the regiment to quell draft riots in New York. The Thirteenth arrived a day after the angry mobs were broken up. Newton got caught in the lingering violence. He married in 1859 and started a family that grew to include a son and daughter. "Newton rejoiced at the election of Lincoln in 1860 and welcomed war. 'I had no ill feeling for the Southern white people, some of them had been my best friends; but this was not a personal matter, but a question of national issue, involving the welfare of millions, and my soul was on fire for the question, Slavery or No Slavery, to be forever settled and that too as soon as possible.'"[9]

Men like William H. Johnson, John V. Givens (a black activist from New York City), and Alexander Herritage Newton found ways to join the Union army and sent letters to black newspapers describing the impact that the war had on migrating black families in the war zones.[10] Givens had been active in the city's Masonic Mount Olive Lodge and lectured for the Masons in Connecticut. In 1863, he became a recruiter of black soldiers and an officer in the city's Loyal League.[11] At the beginning of the war, it was the policy of the Lincoln

administration to return all "fugitive slaves" either directly to the plantations or to professional slave catchers. Givens worked with a New York regiment to get into the field, where he could oppose this policy. Givens, like Johnson, used his position to rescue formerly enslaved people, who were known as "contraband."[12] He reported on his contraband rescues and military activities in Virginia and Maryland at a meeting at New York's Shiloh Presbyterian Church, then ministered by Henry Highland Garnet.[13] He later worked with the New York State Militia. Givens wrote the following letter to the *New York Weekly Anglo-African*.

[From] John V. Givens to Thomas Hamilton
Headquarters of the 9th Regt., N.Y.S.M.
[New York State Militia]
Gen. Bank's Division

[October 12, 1861]
Mr. Editor:
I need not tell you of our march through Maryland and into Virginia, nor of the devastation that met the eye at every point, nor of our long and tiresome marches of days and nights, of our surprises, skirmishes and so on, but that more directly concerns you and I, and our people everywhere.

After leaving Camp Cameron in Washington, on the 11th of June, we took up our line of march for the Potomac and Monocacy Junction. About every other house on our line of march we found deserted. But what struck me most was to see the singular conduct of the slaves towards us, they ran from us as though we were the plague—but I have since ascertained that their owners have instructed them that the Northerners came to take them and sell them for their own benefit. And some of the slaves believed their masters; but there were others that did not, and those would follow the regiment until they got a birth as cook or officer's servant.

The colored churches on the whole line of our march were closed with the exception of Quin's Chapel, (Methodist,) in Frederick. They had orders to discontinue their services, but as the Union troops occupy Frederick, they have not obeyed the orders but continue their services.

The colored people of Frederick have more advantages of education than they do in any part of Maryland, Baltimore not

excepted. They have eight colored churches, Baptist, Methodist, Presbyterian and a great number of them belong to the Catholic church. But still slavery casts her dark and gloomy mantel over all of this.

After six weeks marching and camping we arrived at Sandy Hook, opposite Harpers Ferry, and there we lost our first men in a skirmish. The rebels had evacuated Harpers Ferry five days before we got there. But they left a picket guard behind them, but they also left in double quick as they saw our troops advancing. We continued our line of march on the Maryland side of the Potomac to Williamsport, and from there, on the 14th of July we crossed the Potomac into Virginia. We were then under that rebel General [Robert] Patterson. And let me remark here that the Wisconsin regiment was two miles in the advance of the New York Ninth, when they fell in with the rear guard of the rebels retreating towards Martinsburg. They had a fight at the falls—and with the rebel prisoners they took fourteen colored men in uniform, and armed to the teeth, fighting the Union troops, one they killed outright and three others were wounded. They were not slaves but free black men that were pressed into the rebel service; and before we got to Martinsburg we got forty colored men who had deserted from the rebel ranks and came over to us. Some were barbers, shoemakers, carpenters, and waiters, and were forced to leave their families and join the rebel ranks—many of them left at the first opportunity and come to us, but how disappointed they were when they found that they could not fight in our ranks against their oppressors!

When we entered the city of Martinsburg we saw that desolation had spread its broad hands over everything and everywhere—famine, pestilence and death walked boldly from house to house. The Union troops entered Martinsburg twenty-five thousand strong, and occupied the city for a week, we then took up our line of march for Bunker Hill, and there I commenced my work. We left Bunker Hill for Charleston, and whilst on our march the rebels passed us on a road running parallel with ours, but General Patterson would not let us give them battle. So, as you know, General [Joseph E.] Johnston passed us without either of us striking a blow. We entered Charleston and what a sight presented itself, hundreds of colored men and women in the streets

with their children; some in their mother's arms, some of the men armed and shouting and thanking God that we had come at last to free them. Most of their masters had ran off at our approach and left all behind them. The slaves had helped themselves, and now stood ready with open arms and shouts to receive their deliverers, who they believed had come for the sole purpose of freeing them. But what pen can describe the revulsion of their feelings when they were told that we came "not to free the slaves, but to preserve the Union as it was, with its millions of suffering slaves!" why, Mr. Editor, when the slaves heard that they cursed the Union troops in their hearts, and some with tears in their eyes begged us not go away for now they had committed themselves against their masters—and if we went away their masters would come again and do worse than kill them; I could not bear the sight of their disappointment, so left them and visited the Court House where that murderous crew tried the noble John Brown; I visited the prison that held the hero, and looked at the old gallows in the prison yard that was honored by having so illustrious a charter die upon it— and visited the very spot that the hero was hung upon. I thought the shade of that venerable hero stood beside me and said, "the hand of Providence appears to move slowly but it moves; so wait patiently, the clouds are lifting, the signs are standing forth in bold relief." Here let me add, that the land they hung him on belonged to an old colored man named John Welcome, and this same John Welcome owned the horses and the cart that the hero rode upon to that fatal tree; and I also add that this same John Welcome drove the horse and cart himself to the murdering. The only piece of cannon they had on that memorable day, is now in Philadelphia, in possession of the Pennsylvania Regiment of three months volunteers. They captured it the day we entered Charlestown and have since left and returned home bearing the cannon with them as a trophy. We left Charlestown after campaigning for a week and then entered Harpers Ferry, remained there two weeks and again crossed the Potomac and entered Sandy Hook. Nothing worthy of note occurred until I reached Buckiestown. There two slaveholders entered the 29th Regiment of Pennsylvania Volunteers and gave Sergeant Stark of Company G and Corporal Harry Millard, five dollars each to catch two slaves for them that were then in the camp cooking; they succeeded in doing so, when the colored

men interfered, but were driven off with the swords and pistols of the captains.

I shall in my next letter, give the condition of our people here.

John V. Givens[14]

As revealed in the letters from men like Johnson and Givens during the early months of the war, free black men in the North became increasingly aware of the plight of the enslaved and sought ways to join the Union army, to report on and come to the aid of this vulnerable population of brave men and women desperately seeking freedom.

This is the letter General Benjamin Butler, commanding officer at Fort Monroe in Virginia, sent to General Winfield Scott, commanding general of the Union army, explaining how to respond to enslaved men, children, and women when encountering them on plantations; Butler sent the letter before the first major battle of the war, the First Battle of Bull Run:

Commander of the
Department of Virginia to the
General-in- Chief of the Army
[Fortress Monroe, Va.]

May 27, 1861
Sir:
Since I wrote my last dispatch the question in regard to slave property is becoming one of very serious magnitude. The inhabitants of Virginia are using their negroes in the batteries, and are preparing to send the women and children South. The escapes from them are very numerous, and a squad has come in this morning to my pickets bringing with them their women and children. Of course these cannot be dealt with upon the theory on which I designed to treat the services of able-bodied men and women who might come within my lines, and of which I gave you a detailed account in my last dispatch. I am in the utmost doubt what to do with this species of property. Up to this time I have had come within my lines men and women with their children—entire families—each family belonging to the same owner. I have therefore determined to employ, as I can do very profitably, the able-bodied persons in the party, issuing proper food for the support

of all, and charging against their services the expense of care and sustenance of the non-laborers, keeping a strict and accurate account as well of the services as of the expenditure, having the worth of the services and the cost of the expenditures determined by a board of survey, hereafter to be detailed. I know of no other manner in which to dispose of this subject and the questions connected therewith. As a matter of property to the insurgents it will be of very great moment, the number I now have amounting, as I am informed, to what in good times would be of the value of $60,000. Twelve of these negroes, I am informed, have escaped from the erection of the batteries on Sewall's Point, which this morning fired upon my expedition as it passed by out of range. As a means of offense, therefore, in the enemy's hands, these negroes, when able-bodied, are of the last importance. Without them the batteries could not have been erected, at least for many weeks. As a military question, it would seem to be a measure of necessity to deprive their masters of their services. How can this be done? As a political question and a question of humanity, can I receive the services of a father and a mother and not take the children? Of the humanitarian aspect I have no doubt. Of the political one I have no right to judge. I therefore submit all this to your better judgement; and as these questions have a political aspect, I have ventured—and I trust I am not wrong in so doing—to duplicate the parts of my dispatch relating to this subject, and forward them to the Secretary of War.

Benj. F. Butler[15]

Three days earlier, General Butler had informed General Scott that three enslaved men belonging to one Colonel Mallory, commander of Confederate forces in the district, had "delivered themselves up" to his picket guards. Butler had interviewed the three personally and found that they were about to be taken south for Confederate service: "I determined, . . . as these men were very serviceable, and I had great need of labor in my quartermaster's department, to avail myself of their services." Questioned about this decision by another officer, Butler offered to return the men if Mallory would swear an oath of allegiance to the federal government.[16] Aware that this was only one instance of many that would follow, Butler asked Scott for a statement of general

policy: "Shall they [the Confederates] be allowed the use of this property against the United States, and we not be allowed its use in aid of the United States?"[17] In endorsements, Scott found "much to praise . . . and nothing to condemn" in Butler's action, and Secretary of War Simon Cameron concurred.[18] Butler put his idea into practice, treating the enslaved people who entered his camp as "contraband of war" and refusing to return them to slave owners. When the plantation owners discovered this, they approached Fort Monroe, demanding that their human property be returned to them. Considering enslaved people to be contraband had a profound impact on black people and influenced their feelings about the Union army for the remainder of the Civil War. Eventually, Butler's actions contributed substantially toward the defeat of the Confederates, who were unable to use enslaved labor to build their forts. Some of these men escaped and found work as servants, cooks, and laborers with Union military units as they passed through on their way south. John Boston was one such man. In the following letter to his wife, he expresses his freedom with a mixture of joy, relief, and sadness.

[From] Uptown Hill [Virginia]
January the 12 1862

My Dear Wife

It is with grate joy I take this time to let you know Whare I am. I am now in Safety in the 14the Regiment of Brooklyn. Th Day I can Adress you thank god as a free man. I had a little truble in getting away. But as the lord led the Children of Isrel to the land of Canon, So he led me to a land Whare freedom will rain in spite of earth and hell.

Dear, you must make your Self content. I am free from al the Slavers Lash and as you have chose to Wise plan of Serving the lord I hope you Will pray Much and I will try by the help of god To Serv him With all my hart. I am With a very nice man and have All that hart Can Wish But My Dear I cant express my grate desire that I Have to See you.

I trust the time Will come When we Shal meet again. And if We don't meet on earth, We Will Meet in heven Whare Jesas ranes. Dear Elizabethe tell Mrs. Ow[e]n[s] that I trust that She Will Continue her Kindess to you and that god Will Bless her on

earth and Save her in grate eternity. My Acomplemnts to Mr. Owens and her Children, may They Prosper through life. I never Shall forgit her kindess to me. Dear Wife, I must Close, rest yourself. Contented, I am free. I Want you to rite to me Soon as you Can Without Delay. Direct your letter to the 14th Regiment, New York State Militia, Uptowns Hill, Virginia. In Care of Mr. Cranford Comary. Write my Dear, Soon as you C

Your Affectionate Husban. Kiss Daniel For me.

John Boston[19]

Other enslaved men often had to make a difficult decision when they became self-emancipators; they had to leave their families in what could perhaps be years of enslavement and brutal torture. John Boston fled slavery in Maryland and joined a New York regiment of the Union army, as described in the letter to his wife previously mentioned.

In letters, black men also told the government about their desire to fight for the Union army.

[From William A. Jones
To the Secretary of War]
Oberlin, O[hio] Nov. 27th 1861

Sir:— Very many of the colored citizens of Ohio and other states have had a great desire to assist the government in putting down this injurious rebellion.

Since they have heard that the rebels are forming regiments of the free blacks and compelling them to fight against the Union as well as their Slaves. They have urged me to write and beg that you will receive one or more regiments (or companies) of the colored of the free States to counterbalance those employed against the Union by Rebels.

We are partly drilled and would wish to enter active service amediately. We behold your sick list each day and Sympathize with the Soldiers and the government. We are confident of our ability to stand the hard Ships of the field and the climate So unhealthy to the Soldiers of the *North* To prove our attachment and our will to defend the government we only ask a trial I have the honor to remain your humble Servant.

Wm. A. Jones[20]

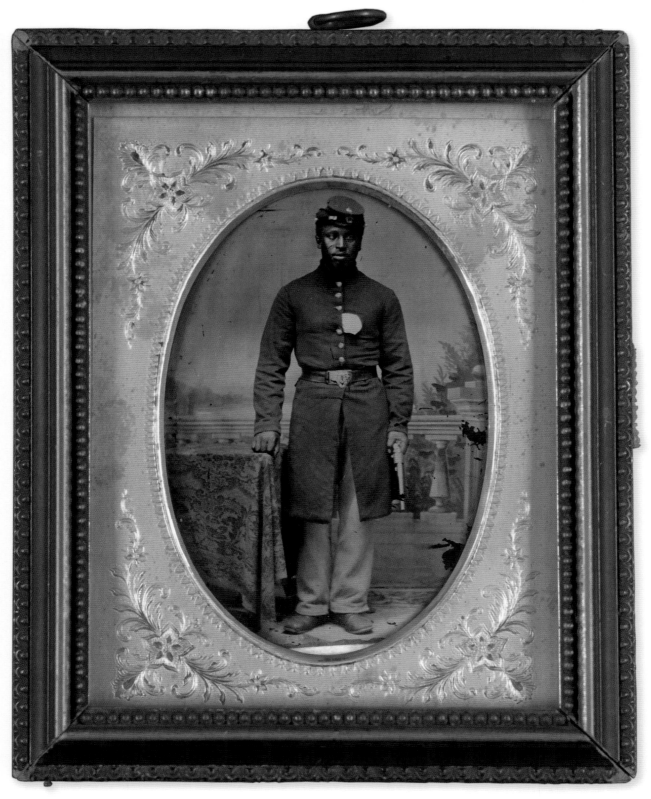

Portrait of Sergeant Tom Strawn of Company B, Third US Colored Troops Heavy Artillery Regiment. (Library of Congress Prints and Photographs Division; LC-DIG-ppmsca-32668)

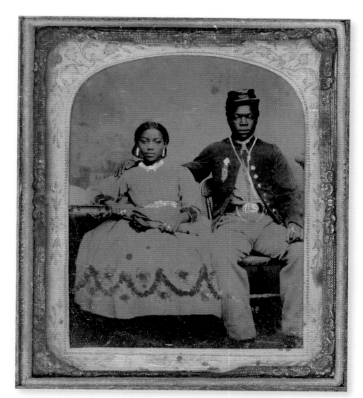

Portrait of a soldier and his wife, ca. 1860s. (Courtesy of Greg French and Collection of Greg French)

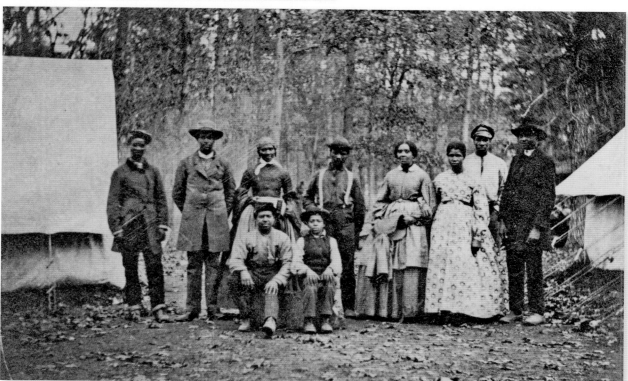

"Contraband" who served with the Thirteenth Massachusetts Infantry, ca. 1863-65. (Courtesy Massachusetts Commandery Military Order of the Loyal Legion and the US Military History Institute)

There also was a black presence and participation in the Confederate army, although that history is, of course, a much more nuanced and complex story. "Thousands of slaves served their masters and masters' sons in the Confederate Army," writes the Civil War historian Ronald Coddington, "before and after the 'Black Republican' in the White House, as some referred to President Abraham Lincoln, issued the Emancipation Proclamation. Many remained with their owners throughout the war."[21] The perplexing relationships between slave masters and enslaved soldiers reflect the mystery of the human condition in this period. Some black soldiers fought for and along with the sons of their owners, while others stood guard to protect white men from Union soldiers.

Portraits of Southern black servants and soldiers tell us a great deal. Take, for example, a photograph of two men—Silas Chandler and the Confederate soldier Sergeant Andrew Martin Chandler, Company F, Forty-Fourth Mississippi Infantry—probably taken in 1861. A tintype portrait of the two men shows Silas seated on a lower chair and Andrew sitting a head taller. Their positions make it clear that Silas's status is inferior. However, both appear well armed for battle. Seventeen-year-old Andrew proudly holds a small pistol in his left hand, a Colt Single Action Army is tucked into his belt, and a short sword is in his right hand. Silas's gaze is focused on the lens; he holds a musket in his left hand and a Bowie knife in his right, and a percussion single-shot pistol has been slipped between the buttons of his jacket. The tintype represents both the complexity of relationships during this period and the conflicted loyalty between the two men.

Silas, fifteen years old at the time, received his free papers just before the fighting began but chose to stay with his friend and follow him to war. After the Battle of Shiloh, Andrew was thrown into a Union prison in Ohio. Silas ran back and forth from the prison to the Chandler homestead in Palo Alto, Mississippi, seeing to Andrew's essentials. The boy was soon released, and the two were excited to rejoin their outfit. During the fighting at Chickamauga, Andrew was wounded on his leg, which the surgeons were ready to amputate. But Silas pulled out a gold coin that the boys had saved to buy some whiskey. Bribing the doctors to let Andrew go, Silas carried the injured boy on his back to the

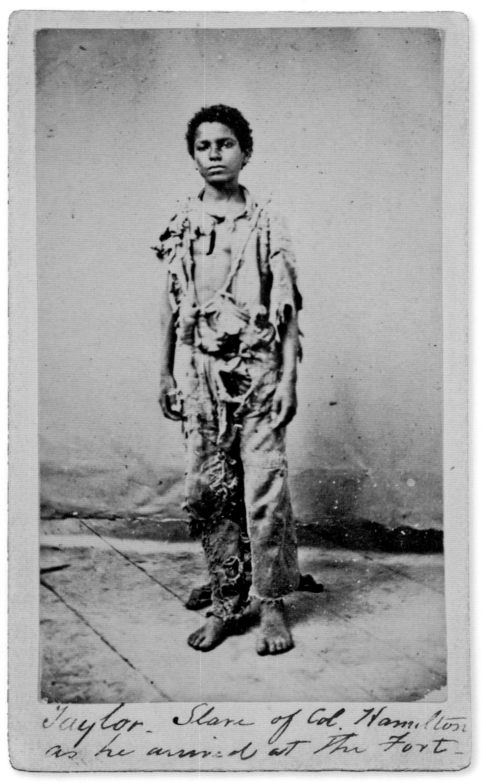

Full-length portrait of a young boy standing barefoot, clothes in tatters. Beneath photograph is written, "Taylor. Slave of Col. Hamilton as he arrived at the Fort." (Yale University Library Beinecke Rare Book & Manuscript Library, Item #D-48 Randolph Linsly Simpson Collection, ca. 1862)

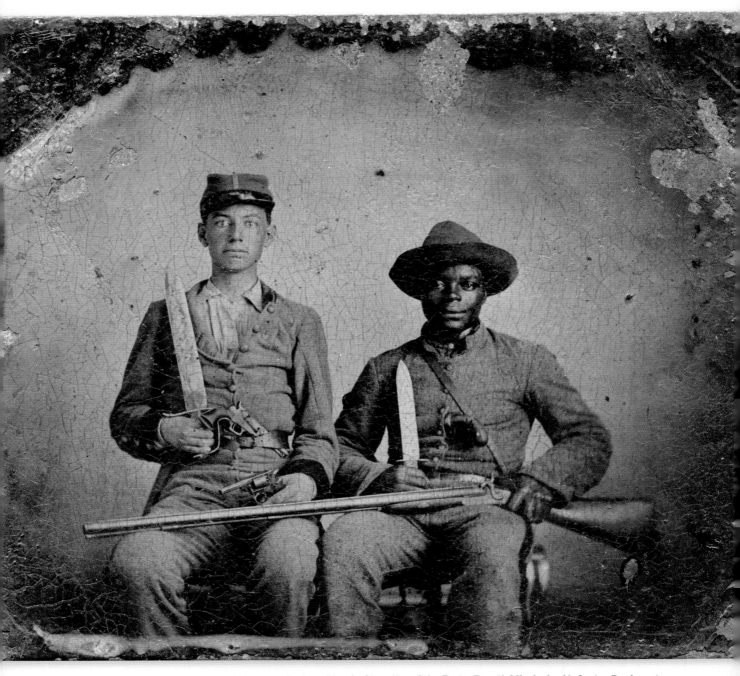

Sergeant Andrew Martin Chandler of the Forty-Fourth Mississippi Infantry Regiment, Company F, and Silas Chandler, servant, with Bowie knives, revolvers, pepper-box, shotgun, and canteen. (Library of Congress, Prints and Photographs Division, Digital ID: ppss 00834 LC-DIG-ppmsca-40073)

African American hospital workers, including nurses, at a hospital in Nashville, Tennessee, July 1863. (Courtesy National Archives)

nearest train. They rode all the way to Atlanta in a boxcar. Once there, the hospital doctors saved the boy's leg and his life. Soon after, Silas and Andrew returned home to Palo Alto, where they continued their friendship until they died. Andrew gave Silas land to build a church for the black community and saw that his friend got a Confederate veteran's pension in 1878.[22]

1861-62

VISUALIZING THE PLAN FOR VICTORY

The Lincoln administration devised a war strategy for what it hoped would lead to a quick and successful end to the war. The plan was designed by General Winfield Scott, commanding general of the Union army. The goal, to isolate and cut off all international trade between the rebellious states and their European customers, was to be accomplished by setting up a naval blockade of all ships entering or leaving the Confederate ports along the Atlantic Ocean and the Gulf of Mexico. To accomplish this, the Union navy would be augmented by the use of privateers in international waters, and sixty thousand Union soldiers would be deployed to control the Atlantic and Gulf coastlines from Virginia to New Orleans. A similar blockade would be set up along the length of the Mississippi River to isolate the rebels from the Confederate states west of the Mississippi.

When General Scott retired after the defeat of the Union troops by the Confederates at the First Battle of Bull Run, command of the Union army was passed on to General George McClellan,[1] who approved the deployment of a joint expedition headed by Admiral Samuel Francis Du Pont, commanding the navy warships, and General Thomas W. Sherman, commanding the army troops. The goal of this expedition was to capture Port Royal and the Sea Islands south of Charleston, South Carolina. The sound at Port Royal, South Carolina, was both deep and wide enough to support a naval base for even the largest Union warships and was also ideally suited to control sea traffic into and out of the harbors at both

Charleston and Savannah. Control of this single port could result in the disruption of imports and exports from the two major Southern Atlantic seaports.

Twelve thousand soldiers under the command of General Sherman were assigned to sail with Admiral Du Pont's fleet of warships to launch the land invasion. This fleet sailed from Hampton Roads on October 29, 1861, dropping anchor off Hilton Head Island in South Carolina on November 6 of that year.

General McClellan extended the scope of the plan by approving an expedition by Major General Benjamin Butler, whom he reassigned from his post as commanding general of Fort Monroe in Virginia. Butler would lead a military troop-ship convoy around the tip of Florida into the Gulf of Mexico to rendezvous with a fleet

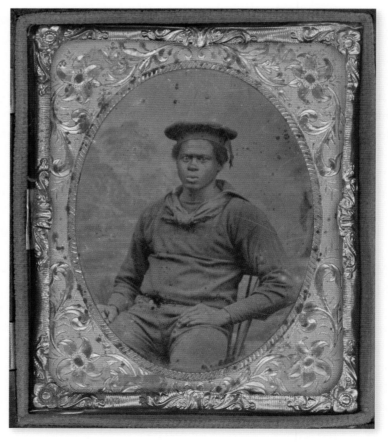

Portrait of Aaron Carter Joseph, US Navy. (Courtesy of Greg French and Collection of Greg French)

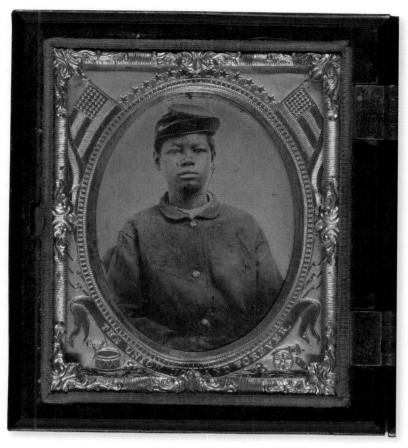

Portrait of unidentified young African American soldier in Union uniform with forage cap, ca. 1860s. (Tintype; Library of Congress, Prints and Photographs Division, LC-DIG-ppmsca-37079)

of Union warships under the command of Admiral David Farragut and take the Gulf ports controlled by the Confederates, including Mobile, Alabama, and the city of New Orleans.

THE BURNSIDE EXPEDITION

Major General Ambrose Burnside proposed to launch an expedition along the Atlantic coast to take the ports at Roanoke Island and New Berne, North Carolina.[2] When McClellan approved the plan, Burnside set up offices in New York City and Rhode Island to outfit the ships and recruit the manpower to undertake the expedition.

After the Battle of Bull Run, William Henry Johnson left the army, in August 1862. It was the end of his initial ninety-day enlistment period, and he returned to his home in Connecticut. Prior to the war, Johnson had been a correspondent for several newspapers, including Frederick Douglass's *North Star*, James Redpath's *Pine and Palm*, and the AME Church's *Christian Recorder*, all of which printed several of his letters. A few months later, in October 1862, having heard that Burnside was planning to outfit an expedition to the coast of North Carolina, Johnson volunteered again to travel with the army, this time with the Eighth Connecticut Infantry Regiment and what would become the Burnside Expedition. As he had done at the Battle of Bull Run, he planned to write letters to the *Palm and Pine* detailing the progress of the military action and the impact of the war on fugitive and contraband enslaved people along the North Carolina coast.[3]

In the following letters, Johnson describes how a group of black men found ways to attach themselves to the Connecticut regiment.

Pine and Palm, November 23, 1861
[From] William H. Johnson
8th Connecticut Infantry
Annapolis, Maryland

November 11, 1861

I am again in the seat of war, and again preparing for active service. Our regiment (the 8th C.V.) is in General (Ambrose E.) Burnside's Division, and our destination is said to be South Carolina, and we shall in all probability reinforce General (Thomas W.) Sherman. Annapolis has been chosen as a place of rendezvous, because it is a first class shipping port; it is located on the banks of the Chesapeake Bay, and its facilities for camping purposes most complete. There are now at this port, and attached to his Division, the 21st, 25th, 27th Massachusetts, 51st New York, and the 8th and 10th Connecticut regiments, numbering about 6,000 men. There are to be six other regiments joined to the Division, which will augment the number to 12,000 or 13,000. We expect to sail from here about the 25th inst.

The election here last week, whilst it resulted in a Union victory, demonstrated the fact that Annapolis is not quite free from secesh yet, and the process of purging it must still go on.

The proscribed Americans (and there are many) attached to this regiment have, since their encampment here, formed

themselves into a defensive association. They propose to culti-
vate a correct Knowledge of the manual of arms and military evo-
lutions, with a view to self-protection.

The association is based upon the principles of military disci-
pline, morality and literature; and they hope by a strict observance
of the rules and regulations they have adopted, to do credit to their
people, and honor to themselves. The name of the association is
Self-Defenders of Connecticut, and their officers are:— Wm. H.
Johnson, Norwich, Conn., first officer; Frederick C. Cross, Hartford,
second officer; Prince Robinson, Norwalk, Third officer. In forming
this association, we have been actuated by the conviction that the
time is not far distant when the black man of this country will be
summoned to show his hand in this struggle for liberty.

> "Attack on Roanoke Island, North Carolina,"
> *Pine and Palm*, February 27, 1862
> [From] William H. Johnson
> 8th Connecticut Infantry
> Pamlico Sound, North Carolina

February 9, 1862
Federal Troops defeated the rebel defenders on February 7 and 8,
1862. The Burnside Expedition has been gloriously successful. The
rebels have been defeated, and driven from Roanoke Island. On
Friday, our fleet came to anchor at Albemarle Sound, at ten o'clock
a.m. The rebels fired into the fleet from a battery on shore. The gun-
boats responded with vigor.

> 4 p.m.—The bombardment is progressing with great
> fury.
> 5 p.m.—We are gaining upon the rebels; our troops are
> being landed in small boats, in the face of the enemy's
> batteries.
> 9 p.m.—We are on the Island; the enemy is held in check;
> hostilities have ceased for the night.
> Saturday, 10 a.m.—The battle has been resumed; the
> rebel land battery is being engaged by our troops; the
> bombardment is still going on.
> 1:30 p.m.—The rebels have been driven from the batteries
> at the point of the bayonet. The field is ours; and we
> are pursuing the rebels.

11 p.m.—Two thousand rebels have unconditionally surrendered. It is the end of one of the bloodiest battles of the campaign.

Our victory has indeed been brilliant, but we have paid dearly for it. Our loss is about thirty killed, among whom is a Colonel and a Lieutenant-Colonel, and a number of line officers. We have in the hospital between 75 and 80 wounded; they are all doing well. The enemy's loss I have not ascertained, but it has been considerable. I counted ten dead in one battery, myself. O. Jennings Wise, son of Gen. (Henry A.) Wise is one of our prisoners, and he is mortally wounded.

Pine and Palm, February 27, 1862
[From] William H. Johnson
8th Connecticut Infantry
Roanoke Island, North Carolina

February 10, 1862
Since Saturday, everybody here has been in a perfect state of excitement, and up to this morning I have not had an opportunity to examine the field of battle, and its surroundings; but now that I have done so, I will endeavor to give you a faint idea of things as they are here, and then you will be able to appreciate the importance of our victory. The enemy was attacked at two different points at the same time. The gunboats engaged the enemy's Fort No. 1, which is situated on a point of land commanding the main channel, and mounts twelve 32-pound guns, whilst our forces drove, at the point of the bayonet, the rebels from their inland battery No. 1, which is situated about one mile from the southern extremity of the Island, and commands the main and only road across it. This battery mounts 3 12-pounders.

When the rebels were beaten out of these fortifications, they unconditionally surrendered themselves, and gave up two other forts, and one other battery, without discharging their guns; also very extensive barracks, capable of accommodating 20,000 troops, together with forage sufficient for their accommodation for thirty days. This is a valuable acquisition. The Island is twelve miles in length, and two miles wide. Its natural defenses are almost complete, and it is the key to all the most important points in the State, and enables us to place a strong Union force behind

the rebels at Richmond. The rebels had a force here of 35,000, consisting of Infantry and Artillery. They commanded three forts with twenty-eight 32-pound guns, and two inland batteries of five 12-pound guns, making a grand total of thirty-three guns, of the most approved style. These forts and batteries (were built) by the blacks, who have been brought here in large numbers, and are now jubilant at the success of the Stars and Stripes. They informed us, (and their statements have been confirmed by the native whites,) that the rebels did not intend to give us any quarter, had their arms proved victorious.

Feb. 11—The Victory is complete. Elizabeth City, twelve miles above here, was attacked by our fleet yesterday, and after a sharp and bloody engagement, the rebels burned the city, and ingloriously fled, leaving us in full possession of the burnt city, some heavy guns, three gunboats, and two schooners. The Captain of the rebel Navy, and sixteen soldiers, surrendered. Guns are now being fired, in honor of the victory.

> *Pine and Palm*, March 27, 1862
> [From] William H. Johnson
> 8th Connecticut Infantry
> Albemarle Sound, North Carolina

March 9, 1862

My last letter to you was written after our first victory, and I had just overlooked the field of our operations. We had, in two days, reduced the enemy's fortifications, beaten him in a land engagement, 2,000 of his best troops were ours, and we were masters of Roanoke Island.

You can estimate something of the importance of our victory, by a recent speech made by the rebel President, Jeff. Davis, in which he said that if he was defeated at Manassas, at Richmond, and elsewhere, he would fall back upon Roanoke Island, and hold it, against the combined forces of the world. And well might he say so, for it was a strong position, and determined troops, in a good cause, would have baffled us for weeks—yes, I may say for months; but their cause was that of the *Devil*, and they themselves were cowards—hence, our success is not to be marveled at.

We are now on the eve of departure for new conquests; we hope to meet the enemy again, fight, conquer him, end the rebellion,

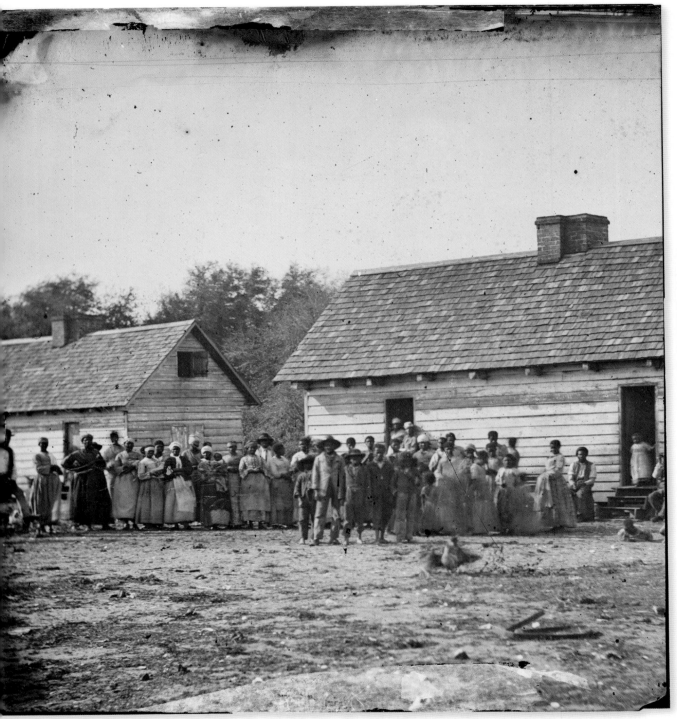

Enslaved men, women, and children standing in front of buildings on Smith's Plantation, Beaufort, South Carolina. (Library of Congress, Prints and Photographs Division, cph 3b15290 \LC-USZ62-67819)

and then come home to our Northern people, to freemen who look South with joyous hearts, and behold not a single Slave State—but only free territory, from Maryland to Texas. Our armies will defeat the rebels, and hang slavery; a just Administration will execute the monster, and the good news and glad tidings will be borne by the many gallant ones to all parts of the Christian world; but the glory will belong to God!

The abolition of slavery is rapidly progressing South—it is in the natural course of events, and must be; for wherever the federal Army goes, the so-called master dies, and the slaves, once chattels, are transformed into men! We have especial cause to be pleased with our commander—Gen. Burnside. In answer to a Union pretender (and all who are beaten immediately profess to become lovers of this glorious Union, when they have anything to gain by coming into our lines), who came to the Island the other day, and demanded the General to surrender to him several slaves who had sought safety under the Stars and Stripes, the General looked the fellow full in the face, and delivered himself thus: "Sir, you misunderstand my mission—I am not here to bag slaves for their owners. No, sir! I am here to teach rebels their duty to their Government, and, with the help of god, I will do it!" The fellow seceded, and the scene closed.

This is just what we want; let commanders of [the] Divisions look out for traitors, and the slaves will take care of themselves, to be cared for by their friends.

Quite a large number of contrabands have already congregated on the Island, who are free to go or stay—no one being authorized to hinder them. Many go North, in every Northern-bound vessel, whilst others prefer to follow the Army.

The sanitary condition of this Division is good, notwithstanding the hardships we are subjected to, in being exposed to the inclement weather, night after night, with no covering save the canopy of heaven. It rains on the Island, as a general thing, four days in the week, and during the other three, the sun refuses to shine upon [us].

Disease proved to be more lethal than all the Civil War battles, and thousands of soldiers died from dysentery, diarrhea, and other

illnesses. But Johnson survived and settled in Albany, New York, where he later recruited black soldiers for the Union army.

> *Pine and Palm*, June 19, 1862
> [From] William H. Johnson
> Albany, New York

June 2, 1862

I write to inform you that whilst I am not at the seat of war, I am in the land of the living. I am still afflicted with the rheumatism—not badly, but so as to render it unsafe for me to return to the field again for the present. [Abolitionist] Dr. M[artin] R. Delany has been lecturing here with good effect. His subject has been Africa. He has very ably set forth the advantages to be derived by us, as a people, in emigrating. The doctor is liberal. I think that he is right. He is for Africa first, "but any country," says he, "where a negro nationality can be established is far better than remaining here." So say I.

When the proposition is fully endorsed by our people, and I think that it will shortly be, I hesitate not to say that the good people of Albany will turn their steps to Hayti.

Johnson, like other Union soldiers, desired to offer an accurate description of life on the battlefield. John V. Givens, for example, wrote to the *New York Weekly Anglo-African*, while William Jones sent a letter directly to the secretary of war. In the months before black men joined the Union army, formerly enslaved men were sometimes able to join local regiments. The Fifty-Fourth Regiment Massachusetts Volunteer Infantry is a case in point. Massachusetts did not have a large population of African American males, so Frederick Douglass put out a call for black men to join the ranks. Posters offered $100 at the end of one's service, pay of $13 a month, and state aid to black families. Some men made the journey to Massachusetts to join the regiment; others enlisted where they lived or made their way to neighboring states.

White masters and Confederate soldiers were outraged when they encountered self-emancipated men, who might have been their own brothers or offspring. For example, in the early days of the war, Benjamin Bronson was so furious when he saw his slave Calvin on a New Orleans street that he wrote a letter of complaint to the commander of the Union regiment occupying the city.

Portrait of Harriet Tubman, 1868–69. (Photographer: Benjamin Powelson; carte de visite, albumen and silver on photographic paper on card mount; Collection of the Smithsonian National Museum of African American History and Culture, 2017_30_47_001)

Colonel F. S. Nickerson
Fourteenth Maine Regiment,
USA [US Army]
Lafayette Square

[June 23, 1862]

Dear Sir,

My slave Calvin, a light mulatto, absconded last Friday, 16th inst. On Saturday, as I was passing by Lafayette Square, I found the said slave, with a United States uniform on, standing guard just above the Brooks House on Camp Street, enlisted as a United States soldier, assuming to be a white man; and I have the documents to prove him a slave. I lay these facts before you, trusting you will give me every assistance to recover my lawful property. Very respectfully,

B. Bronson,

Per E. W. Herrick, Carriage Repository,

74 Carondelet Street

The above slave being a very light color, it would be difficult matter for a stranger to recognize him as a colored man.

B. Bronson, Per E. W. Herrick[4]

In *A History of the Negro Troops in the War of the Rebellion, 1861-1865*, the noted historian George Washington Williams writes, "Having examined the case, General Butler issued the subjoined order."

Headquarters,
Department of the Gulf,
New Orleans, July 7, 1862

Colonel Nickerson, Fourteenth Maine Regiment:

Sir, It having been represented to the General Commanding that you have enlisted a slave (nearly white) by the name of Calvin, the property of B. Bronson, Esq., who will be recognized and pointed out by Mr. E. W. Herrick, you will forthwith discharge him. This by order of the General Commanding.

By order of

Major-General B. F. Butler.

G. Weitzel, Lieut. U.S. Eng. and Asst. Military Commander

Portrait of a woman in a bonnet standing beside a man in uniform with a bayonet and hand-colored buttons. (Stephan Loewentheil History of Photography Collection, Kroch Library, Cornell University, Box Number: IV-26, Folder Number: 1)

Williams adds that in cases like this one, "the rebel slave-holders . . . dragged their human chattels from before the guns of the Union army!"—notwithstanding Secretary of State William Seward's 1861 order stating that "persons thus employed and escaping are received into military protection of the United States, and their arrest as fugitives from service or labor should be immediately followed by the military arrest of the parties making the seizure."[5]

THE EXPEDITION TO PORT ROYAL AND THE SOUTH CAROLINA SEA ISLANDS

The federal government promptly designated the black people who lived on confiscated land as well as the plantations in Beaufort and all other property of the former inhabitants as "contraband of war."[6] There was immediate interest by many entrepreneurs in the North to develop a plan to manage the great resources of the Port Royal area for the benefit of the federal government. An excerpt of the official report prepared by Commanding General T. W. Sherman describes the scene in this way: "The effect of this victory is startling. Every white inhabitant has left the island. The wealthy islands of Saint Helena, Ladies, and most of Port Royal are abandoned by the whites, and the beautiful estates of the planters, with all their immense property, left to the pillage of hordes of apparently disaffected blacks, and the indications are that the panic has extended to the fort on the north end of Reynolds' Island commanding the fine anchorage of Saint Helene sound."[7]

Frederick Law Olmsted, who had recently codesigned New York City's Central Park and was serving as executive secretary of the United States Sanitary Commission, wrote in early 1862, "The opportunity of proving to the South, the economic mistake of Slavery, which is offered us at Port Royal, is indeed invaluable."[8]

It is important to note that Olmsted had written about the viability of slavery in his book *A Journey in the Seaboard Slave States*, and in early 1862, he crafted a bill about Port Royal for Senator Lafayette S. Foster that would set up a plan for running the plantations in addition to deciding the fate of the lives of the black men, children, and women who were still living on the plantations. The bill was introduced by Foster into Congress. Aware of the significance of the Sea Islands to the economy, Secretary

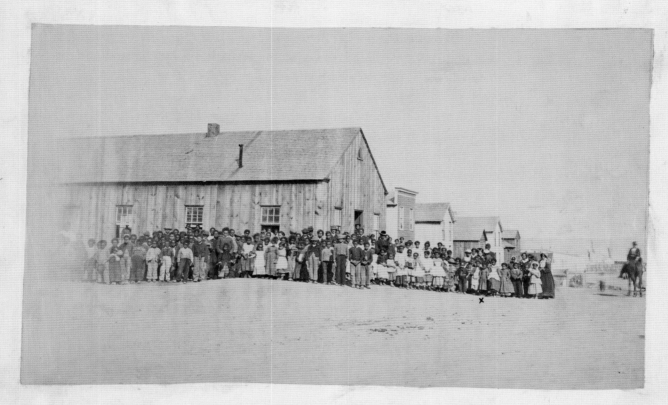

Coloured school at Alexandria Va 1864 taught by Harriet Jacobs & daughter agents of New York Friends

x H Jacobs an Ex Slave

"Coloured school at Alexandria, VA, 1864." The school was taught by Harriet Jacobs and her daughter, agents of New York Friends. (Courtesy Rose Library: Robert Langmuir African American Photographs, Emory University, MSS1218_B048_1005 MARBL)

of the Treasury Salmon P. Chase and the Treasury Department had the responsibility to receive all confiscated property, human or otherwise, and organize a plan. This included thousands of black people who had been designated as human property, over two hundred plantations, and numerous cotton crops and other produce estimated to be in the millions. They needed doctors to attended to the sick and wounded. The food stores that had been

set aside on plantations for the next year were being consumed by the Union army.

In October 1862, at the age of twenty-five, Philadelphia-born Charlotte Forten (1837–1914) became the first black teacher from the North to arrive in the Sea Islands. Her diary pages provide a unique perspective and a compelling description of the land and the newly freed people whom she encountered.

Little colored children of every hue were playing about the streets, looking as merry and happy as children ought to look,—now that the evil shadow of Slavery no longer hangs over them. Some of the officers we met did not impress us favorably. They talked flippantly, and sneeringly of the negroes, whom they found we had come down to teach, using an epithet more offensive than gentlemanly. They assured us that there was great danger of Rebel attacks, that the yellow fever prevailed to an alarming extent, and that, indeed, the manufacture of coffins was the only business that was at all flourishing at present. Although by no means daunted by these alarming stories, we were glad when the announcement of our boat relieved us from their edifying conversation. We rowed across to Ladies Island, which adjoins St. Helena, through the splendors of a grand Southern sunset. The gorgeous clouds of crimson and gold were reflected as in a mirror in the smooth, clear waters below. As we glided along, the rich tones of the Negro boatmen broke upon the evening stillness,—sweet, strange, and solemn—"Jesus make de blind to see, Jesus make de cripple walk, Jesus make de deaf to hear. Walk in, kind Jesus! No man can bender me."

It was nearly dark when we reached the island, and then we had a three-miles' drive through the lonely roads to the house of the superintendent. We thought how easy it would be for a band of guerrillas, had they chanced that way, to seize and hang us; but we were in that excited, jubilant state of mind which makes fear impossible, and sang "John Brown" with a will, as we drove through the pines and palmettos. Oh, it was good to sing that song in the very heart of Rebeldom! Harry, our driver, amused us much. He was surprised to find that we had not heard of him before. "Why, I thought eberybody at de Nort had heard o' me he said, very innocently. We learned afterward that Mrs. F., who made the tour of the islands last summer, had publicly mentioned Harry. Someone had

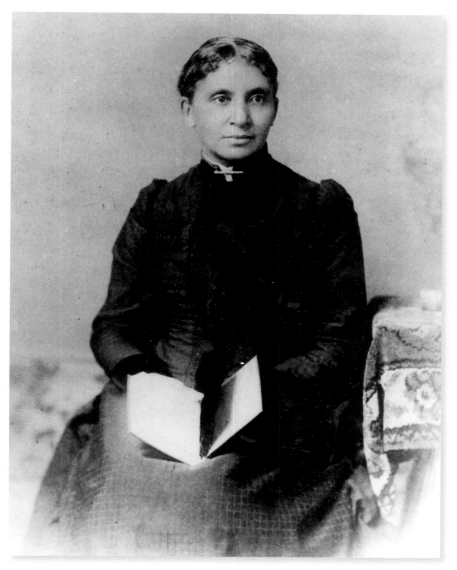

Portrait of Charlotte L. Forten. (Charles L. Blockson Collection, Temple University Libraries)

told him of it, and he of course imagined that he had become quite famous. Notwithstanding this little touch of vanity, Harry is one of the best and smartest men on the island.

Gates occurred, it seemed to us, at every few yards' distance, made in the oddest fashion, opening in the middle, like folding-doors, for the accommodation of horsemen. The little boy who accompanied us as gate-opener answered to the the name of Cupid.

Arrived at the headquarters of the general superintendent, Mr. S., we were kindly received by him and the ladies, and shown into a large parlor, where a cheerful wood-fire glowed in the grate. It had a home-like look; but still there was a sense of unreality about everything, and I felt that nothing less than a vigorous "shaking-up," such as Grandfather Smallweed daily experienced, would arouse me thoroughly to the fact that I was in South Carolina.

The next morning L. and I were awakened by the cheerful voices of men and women, children and chickens, in the yard below. We ran to the window, and looked out. Women in bright-colored handkerchiefs, some carrying pails on their heads, were crossing the yard, busy with their morning work; children were playing, and tumbling around them. On every face there was a look of serenity and cheerfulness. My heart gave a great throb of happiness as I looked at them, and thought, "They are free! so long down-trodden, so long crushed to the earth, but now in their old homes, forever free!" And I thanked God that I had lived to see this day. . . .

During the week we moved to Oaklands, our future home. The house was of one story, with a low-roofed piazza running the whole length. The interior had been thoroughly scrubbed and white-washed; the exterior was guiltless of white-wash or paint. There were five rooms, all quite small, and several dark little entries, in one of which we found shelves lined with old medicine-bottles. These were a part of the possessions of the former owner, a Rebel physician, Dr. Sams by name. Some of them were still filled with his nostrums. Our furniture consisted of a bedstead, two bureaus, three small pine tables, and two chairs, one of which had a broken back. These were lent to us by the people. The masters, in their hasty flight from the islands, left nearly all their furniture; but much of it was destroyed or taken by the soldiers who came first, and what they left was removed by the people to their own houses. Certainly, they have the best right to it. We had made up our minds to dispense with all luxuries and even many conveniences; but it was rather distressing to have no fire, and nothing to eat. Mr. H. had already appropriated a room for the store which he was going to open for the benefit of the freed people, and was superintending the removal of his goods. So L. and I were left to our own resources. But Cupid the elder came to the rescue,—Cupid, who, we were told, was to be our right-hand man, and who very graciously informed us

that he would take care of us; which he at once proceeded to do by bringing in some wood, and busying himself in making a fire in the open fireplace. While he is thus engaged, I will try to describe him. A small, wiry figure, stockingless, shoeless, out at the knees and elbows, and wearing the remnant of an old straw hat, which looked as if it might have done good service in scaring the crows from a cornfield. The face nearly black, very ugly, but with the shrewdest expression I ever saw, and the brightest, most humorous twinkle in the eyes. One glance at Cupid's face showed that he was not a person to be imposed upon, and that he was abundantly able to take care of himself, as well as of us. The chimney obstinately refused to draw, in spite of the original and very uncomplimentary epithets which Cupid heaped upon it, while we stood by, listening to him in amusement, although nearly suffocated by the smoke. At last, perseverance conquered, and the fire began to burn cheerily. Then Amaretta, our cook,—a neat-looking black woman, adorned with the gayest of head-handkerchiefs, made her appearance with some eggs and hominy, after partaking of which we proceeded to arrange our scanty furniture, which was soon done. In a few days we began to look civilized, having made a table-cover of some red and yellow handkerchiefs which we found among the store-goods,—a carpet of red and black woollen plaid, originally intended for frocks and shirts,—a cushion, stuffed with corn-husks and covered with calico, for a lounge which Ben, the carpenter, had made for us of pine boards,—and lastly some corn-husk beds, which were an unspeakable luxury, after having endured agonies for several nights, sleeping on the slats of a bedstead. It is true, the said slats were covered with blankets, but these might as well have been sheets of paper for all the good they did us. What a resting-place it was! Compared to it, the gridiron of St. Lawrence—fire excepted—was as a bed of roses.

The first day at school was rather trying. Most of my children were very small, and consequently restless. Some were too young to learn the alphabet. These little ones were brought to school because the older children—in whose care their parents leave them while at work—could not come without them. We were therefore willing to have them come, although they seemed to have discovered the secret of perpetual motion, and tried one's patience sadly. But after some days of positive, though not severe treatment, order was brought out of chaos, and I found but little difficulty

in managing and quieting the tiniest and most restless spirits. I never before saw children so eager to learn, although I had several years' experience in New-England schools. Coming to school is a constant delight and recreation to them. They come here as other children go to play. The older ones, during the summer, work in the fields from early morning until eleven or twelve o'clock, and then come into school, after their hard toil in the hot sun, as bright and as anxious to learn as ever.

Of course, there are some stupid ones, but these are the minority. The majority learn with wonderful rapidity. Many of the grown people are desirous of learning to read. It is wonderful how a people who have been so long crushed to the earth, so imbruted as these have been,—and they are said to be among the most degraded Negroes of the South,—can have so great a desire for knowledge, and such a capability for attaining it. One cannot believe that the haughty Anglo-Saxon race, after centuries of such an experience as these people have had, would be very much superior to them. And one's indignation increases against those who, North as well as South, taunt the colored race with inferiority while they themselves use every means in their power to crush and degrade them, denying them every right and privilege, closing against them every avenue of elevation and improvement. Were they, under such circumstances, intellectual and refined, they would certainly be vastly superior to any other race that ever existed.[9]

General Saxton, quartermaster for the Port Royal expedition, was given an assignment by Commanding General Thomas Sherman to organize a regiment of black men for the defense of the Port Royal colonies. Saxton wrote to Colonel Thomas Wentworth Higginson to offer the position. Higginson was a steadfast abolitionist who had supported John Brown and had provided financing for Brown's [Harpers Ferry] raid. Colonel Higginson kept a diary of his experiences in the Sea Islands as he organized the first regiments of black troops and led them on their first combat mission in the islands. A reflection of this experience is found in the first pages of his diary.

These pages record some of the adventures of the First South Carolina Volunteers, the first slave regiment mustered into the

service of the United States during the late civil war. It was, indeed, the first colored regiment of any kind so mustered, except a portion of the troops raised by Major-General Butler at New Orleans. These scarcely belonged to the same class, however, being recruited from the free colored population of that city, a comparatively self-reliant and educated race.

One day in November, 1862, I was sitting at dinner with my lieutenants, John Goodell and Luther Bigelow, in the barracks of the Fifty-First Massachusetts, when the following letter was put into my hands:

BEAUFORT, S. C., November 5, 1862. MY DEAR SIR.

I am organizing the First Regiment of South Carolina Volunteers, with every prospect of success. Your name has been spoken of, in connection with the command of this regiment, by some friends in whose judgment I have confidence. I take great pleasure in offering you the position of Colonel in it, and hope that you may be induced to accept. I shall not fill the place until I hear from you, or sufficient time shall have passed for me to receive your reply. Should you accept, I enclose a pass for Port Royal, of which I trust you will feel disposed to avail yourself at once. I am, with sincere regard, yours truly,

R. SAXTON, Brig.-Genl, Mil. Gov.[10]

By late November 1862, Higginson had resigned his previous post and was on the way to Port Royal. His diary chronicles his organization of the first black regiment that would serve in the Union army in the Civil War.

Of discipline there was great need, that is, of order and regular instruction. Some of the men had already been under fire, but they were very ignorant of drill and camp duty. The officers, being appointed from a dozen different States, and more than as many regiments, infantry, cavalry, artillery, and engineers, had all that diversity of methods which so confused our army in those early days. The first need, therefore, was of an unbroken interval of training. During this period, which fortunately lasted nearly two months, I rarely left the camp, and got occasional leisure moments for a fragmentary journal, to send home, recording the many odd or novel aspects of the new experience. . . .

The shores were low and wooded, like any New England shore; there were a few gunboats, twenty schooners, and some steamers, among them the famous "Planter," which Robert Smalls, the slave, presented to the nation. . . . Then we saw on a picturesque point an old plantation, with stately magnolia avenue, decaying house, and tiny church amid the woods, reminding me of Virginia; behind it stood a neat encampment of white tents, "and there," said my companion, "is your future regiment."

Three miles farther brought us to the pretty town of Beaufort, with its stately houses amid Southern foliage. Reporting to General Saxton, I had the luck to encounter a company of my destined command, marched in to be mustered into the United States service. They were unarmed, and all looked as thoroughly black as the most faithful philanthropist could desire; there did not seem to be so much as a mulatto among them. Their coloring suited me, were clad in a lively scarlet, as intolerable to my eyes as if I had been a turkey. I saw them mustered; General Saxton talked to them a little, in his direct, manly way; they gave close attention, though their faces looked impenetrable. Then I conversed with some of them. The first to whom I spoke had been wounded in a small expedition after lumber, from which a party had just returned, and in which they had been under fire and had done very well. I said, pointing to his lame arm, "Did you think that was more than you bargained for, my man?"

His answer came promptly and stoutly,

"I been a-tinking, Mas'r, dot's jess what I went for."

I thought this did well enough for my very first interchange of dialogue with my recruits.

November 27, 1862.

Thanksgiving-Day; it is the first moment I have had for writing during these three days, which have installed me into a new mode of life so thoroughly that they seem three years. Scarcely pausing in New York or in Beaufort, there seems to have been for me but one step from the camp of a Massachusetts regiment to this, and that step over leagues of waves.

It is a holiday wherever General Saxton's proclamation reaches. The chilly sunshine and the pale blue river seems like New England, but those alone. The air is full of noisy drumming, and of gunshots;

for the prize-shooting is our great celebration of the day, and the drumming is chronic. My young barbarians are all at play. I look out from the broken windows of this forlorn plantation-house, through avenues of great live-oaks, with their hard, shining leaves, and their branches hung with a universal drapery of soft, long moss, like fringe-trees struck with grayness. Below, the sandy soil, scantly covered with coarse grass, bristles with sharp palmettoes and aloes; all the vegetation is stiff, shining, semi-tropical, with nothing soft or delicate in its texture. Numerous plantation-buildings totter around, all slovenly and unattractive, while the interspaces are filled with all manner of wreck and refuse, pigs, fowls, dogs, and omnipresent Ethiopian infancy. All this is the universal Southern panorama; but five minutes' walk beyond the hovels and the live-oaks will bring one to something so un-Southern that the whole Southern coast at this moment trembles at the suggestion of such a thing, the camp of a regiment of freed slaves. . . .

The first few days on duty with a new regiment must be devoted almost wholly to tightening reins; in this process one deals chiefly with the officers, and I have as yet had but little personal intercourse with the men. They concern me chiefly in bulk, as so many consumers of rations, wearers of uniforms, bearers of muskets. But as the machine comes into shape, I am beginning to decipher the individual parts. At first, of course, they all looked just alike; the variety comes afterwards, and they are just as distinguishable, the officers say, as so many whites. Most of them are wholly raw, but there are many who have already been for months in camp in the abortive "Hunter Regiment," yet in that loose kind of way which, like average militia training, is a doubtful advantage. I notice that some companies, too, look darker than others, though all are purer African than I expected. This is said to be partly a geographical difference between the South Carolina and Florida men. When the Rebels evacuated this region they probably took with them the house-servants, including most of the mixed blood, so that the residuum seems very black. But the men brought from Fernandina the other day average lighter in complexion, and look more intelligent, and they certainly take wonderfully to the drill.[11]

Higginson asserts that, having training both white and black recruits, he sees no difference in the groups as to aptitude with

regard to comprehension, courage, knowledge of the gun, or the ability to learn through imitation.

January 7.

... We have now a good regimental hospital, admirably arranged in a deserted gin-house,—a fine well of our own digging, within the camp lines,—a full allowance of tents, all floored,—a wooden cook-house to every company, with sometimes a palmetto mess-house beside,—a substantial wooden guard-house, with a fireplace five feet "in de clar," where the men off duty can dry themselves and sleep comfortably in bunks afterwards. We have also a great circular school-tent, made of condemned canvas, thirty feet in diameter, and looking like some of the Indian lodges I saw in Kansas. We now mediate a regimented bakery. ...

January 19.

... To-day, for the first time, I marched the whole regiment through Beaufort and back,—the first appearance of such a novelty on any stage. They did march splendidly; this all admit. M——'s prediction was fulfilled: "Will not —— be in bliss? A thousand men, every one as black as a coal!" I confess it. To look back on twenty broad double-ranks of men (for they marched by platoons),—every polished musket having a black face beside it, and every face set steadily to the front,—a regiment of freed slaves marching on into the future,—it was something to remember; and when they returned through the same streets, marching by the flank, with guns at a "support," and each man covering his file-leader handsomely, the effect on the eye was almost as fine. The band of the Eighth Maine joined us at the entrance of the town, and escorted us in. Sergeant Rivers said ecstatically afterwards, in describing the affair, "And when dat band wheel in before us, and march on,—my God! I quit dis world altogeder." ...

It is worth mentioning, before I close, that we have just received an article about "Negro Troops," from the London Spectator, which is so admirably true to our experience that it seems as if written by one of us. I am confident that there never has been, in any American newspaper, a treatment of the subject so discriminating and so wise. ...

Up the St. Mary's

... The best peg on which to hang an expedition in the Department of the South, in those days, was the promise of lumber. Dwelling in the very land of Southern pine, the Department authorities had to send North for it, at a vast expense. There was reported to be plenty in the enemy's country, but somehow the colored soldiers were the only ones who had been lucky enough to obtain any, thus far, and the supply brought in by our men, after flooring the tents of the white regiments and our own, was running low. An expedition of white troops, four companies, with two steamers and two schooners, had lately returned empty-handed, after a week's foraging; and now it was our turn. They said the mills were all burned; but should we go up the St. Mary's, Corporal Sutton was prepared to offer more lumber than we had transportation to carry. ... I resolved to avoid all undue publicity for our plans, by not finally deciding on any until we should get outside the bar. This was happily approved by my superior officers, Major-General Hunter and Brigadier-General Saxton; and I was accordingly permitted to take three steamers, with four hundred and sixty-two officers and men, and two or three invited guests, and go down the coast on my own responsibility. ... The whole history of the Department of the South had been defined as "a military picnic," and now we were to take our share of the entertainment.

... After the usual vexations and delays, we found ourselves (January 23, 1863) gliding down the full waters of Beaufort River, the three vessels having sailed at different hours, with orders to rendezvous at St. Simon's Island, on the coast of Georgia. Until then, the flagship, so to speak, was to be the "Ben De Ford," Captain Hallet,—this being by far the largest vessel, and carrying most of the men. Major Strong was in command upon the "John Adams," an army gunboat, carrying a thirty-pound Parrott gun, two ten-pound Parrotts, and an eight-inch howitzer. Captain Trowbridge (since promoted Lieutenant-Colonel of the regiment) had charge of the famous "Planter," brought away from the Rebels by Robert Small; she carried a ten-pound Parrott gun, and two howitzers. The John Adams was our main reliance. She was an old East Boston ferry-boat, a "double-ender," admirable for river-work, but unfit for sea-service. She drew seven feet of water; the Planter drew only four; but the latter was very slow, and being obliged to go to St. Simon's

by an inner passage, would delay us from the beginning. She delayed us so much, before the end, that we virtually parted company, and her career was almost entirely separated from our own. . . .

Captain Hallett proved the most frank and manly of sailors, and did everything for our comfort. He was soon warm in his praises of the demeanor of our men, which was very pleasant to hear, as this was the first time that colored soldiers in any number had been conveyed on board a transport, and I know of no place where a white volunteer appears to so much disadvantage. His mind craves occupation, his body is intensely uncomfortable, the daily emergency is not great enough to call out his heroic qualities, and he is apt to be surly, discontented, and impatient even of sanitary rules. The Southern black soldier, on the other hand, is seldom seasick (at least, such is my experience), and, if properly managed, is equally contented, whether idle or busy; he is, moreover, so docile that all needful rules are executed with cheerful acquiescence, and the quarters can therefore be kept clean and wholesome. Very forlorn faces were soon visible among the officers in the cabin, but I rarely saw such among the men. . . .

. . . I was warned that no resistance would be offered to the ascent, but only to our return; and was further cautioned against the mistake, then common, of underrating the courage of the Rebels. "It proved impossible to dislodge those fellows from the banks," my informant said; "they had dug rifle-pits, and swarmed like hornets, and when fairly silenced in one direction they were sure to open upon us from another."[12]

1863

MEN OF COLOR, TO ARMS!

In 1863, New York City was in a state of political and ideological turmoil sparked by violent draft riots, while general unrest rumbled across the Northern states. White men of varying ages complained that while they were fighting for black people, and dying in large numbers as a result, black men did not have to fight and die. The historian Craig Wilder's vivid account of July 1863 is bone-chilling: "Irish and German workers rioted in Manhattan for days. . . . Black people were cursed, chased, slapped, stabbed, kicked, punched, blinded, bitten, scratched, lynched, mutilated, roasted, clubbed, dismembered, stoned, and gouged. Dozens were killed and hundreds were injured. . . . The Colored Orphan Asylum and other African institutions were torched."[1] The historian William Seraile researched and wrote tirelessly about the history of the orphanage and the plight of the children. I recall listening to him often during his visits after exhaustive research at the Schomburg Center in the 1980s and 1990s. Approximately twelve children entered the orphanage during the Civil War because their fathers had been killed in battle or because their absence had made it difficult for their mothers to care for them. Some prior residents of the asylum went on to fight for the Union. One, James Henry Gooding, was born a slave in 1838 in North Carolina; his freedom was purchased by James Gooding, possibly his father, and he came to New York. He entered the orphanage on September 11, 1846, and remained four years. After several whaling voyages out of New Bedford, Gooding

enlisted in the Fifty-Fourth Massachusetts Volunteer Infantry, Company C, on February 14, 1863. He wrote forty-eight letters that were published in the *New Bedford Mercury* between March 3, 1863, and February 22, 1864.[2]

Black people wanted and needed to fight for their own cause to end slavery. The federal government finally recognized that it had to allow black men to serve. As the war continued, and the resistance from whites grew louder, the Lincoln administration eventually recruited black soldiers.

When that call finally came, black men enlisted with pride and were deeply moved by the grand celebrations their hometowns produced to send them off, such as the one given to the men of New York's Twentieth US Colored Troops (USCT) after they completed basic training and headed off to battle. They had never experienced such an outpouring of support and good wishes, which came from both white and black people in their communities. "By the end of 1863, some 37,000 African-Americans had enlisted in the Union Army, in fifty-eight segregated regiments known as the United States Colored Troops," writes Jeff L. Rosenheim. "Another 3,200 served in the Union navy on fully integrated warships. In three years of combat and supporting duties approximately one of five of the African-Americans who fought lost their lives for the nation."[3]

The Union army captured all of the Atlantic seaports according to the Anaconda plan: General Burnside's attacks on the North Carolina coasts at Albemarle and New Bern had resulted in the capture of thousands of Confederate prisoners along with major forts and freedom for the bonded men, women, and children. The Confederates had won most of the battles in the eastern half of the country during that first year of the war. The casualties for both sides were high, and fewer white men were volunteering to fight as the war went into its second year. Newspaper reports from the battle of Antietam showed fifteen to twenty thousand men killed in one day. The war impeded the exports of cotton, tobacco, rice, sugar cane, whiskey, and indigo from the South. And, as a result, the blockade drove up the prices for these products in the North and in England. The Confederacy suffered severely economically, while pirates, smugglers, and others became wealthy, as the hostile response to the draft from Northern white men raged on.

On January 1, 1863, the Emancipation Proclamation became official, freeing enslaved people in the Confederate states as the number of enlisted white men from the North was increasingly lowering. Dr. Seth Rogers was among the celebrants in Port Royal, South Carolina, on that day. Rogers wrote numerous letters while he was a surgeon with the Thirty-Third US Colored Troops, formerly the First South Carolina Volunteers. Harriet Tubman (1822?–1913) served with them as a cook, nurse, and spy. In Rogers's first letter, he describes meeting Charlotte Forten and Frances Dana Barker Gage. Forten, the Philadelphia-born black teacher whose parents and grandparents were staunch abolitionists, traveled to teach on the Sea Islands after Union forces were established there. Gage was the mother of eight children, four of whom served in the Union army, and an abolition, temperance advocate, and women's rights activist. She served on the US Sanitary Commission and as superintendent of a South Carolina freedmen's school.

[From Seth Rogers]

January 1, 1863

This is the evening of the most eventful day of my life. Our barbeque was a most wonderful success. Two steamboats came loaded with people from Beaufort, St. Helena Island, and Hilton Head. Among the visitors were some of my new acquaintances, [including] my friend, Mr. Hall of voyage Delaware. But the dearest friend I found among them was Miss [Charlotte] Forten, whom you remember. She is a teacher of the freed children on St. Helena Island. Gen. Saxton and his father and others came from Beaufort, and several cavalry officers hovered around the outskirts of our multitude of black soldiers and civilians, and in the centre of all was the speakers' stand where the General and our Colonel and some others, with the band, performed the ceremonies of the day. Several good speeches were made, but the most impressive scene was that which occurred at the presentation of the Dr. Cheever flag to our regiment. After the presentation speech had been made, and just as Col. Higginson advanced to take the flag and respond, a negro woman standing near began to sing "America," and soon many voices of freedmen and women joined in the beautiful hymn, and sang it so touchingly that every one was thrilled beyond measure. Nothing could have been more unexpected or more inspiring.

The President's proclamation and General Saxton's New Year's greeting had been read, and this spontaneous outburst of love and loyalty to a country that has heretofore so terribly wronged these blacks, was the birth of a new hope in the honesty of her intentions. I most earnestly trust they not hope in vain.

Col. H. was so much inspired by the remarkable thought of the hymn that he made one of his most effective speeches. Then came Gen. Saxton with a most earnest and brotherly speech to the blacks and then Mrs. Frances D. Gage, and finally all joined in the John Brown Hymn, and then to dinner. A hundred things of interest occurred which I have not time to relate. Everybody was happy in the bright sunshine, and in the great hope. The ten oxen were hearty relish and barrels of molasses and water and vinegar and ginger were drunk to wash them down. Mr. Hall, Miss Forten, and some others took dinner with us.[4]

[From Seth Rogers]

January 2, 1863

I did not observe any reporters at our barbeque yesterday, but I presume some of the journals [were there, making it] unnecessary for me to write more than my letter of yesterday. I will, however, reiterate the statement that it was the most eventful day of my life. To know what I mean, you must stand in the midst of the disenthralled and feel the inspiration of their birth into freedom. For once I heartily cheered for [the] stars and stripes. There is nothing in history more touching and beautiful than the spontaneous outburst of these freed men and women just at the moment when our gallant colonel was receiving the flag of the regiment. None of us had ever heard them sing America, and the most infinite depth and tenderness of "My country 'tis of thee Sweet land of Liberty" was inspiring to the last degree. I doubt if our Col. ever spoke so well and he justly attributed inspiration to the unexpected singing of the hymn.

[From Seth Rogers]

Evening January 3, 1863

We are having summer days and October nights, with the white frost covering the sand of our camp-ground in the morning.

I wish I could send you a photograph of my orderly. I had my choice of a boy from the regiment and selected Wiley Rohan, a

shining black boy of fifteen, with handsome eyes, and teeth so perfect and beautiful that I always like to see his smiling face. He is very bright and tractable, with great fund of active willingness. I questioned him relative to the difference between an orderly and a servant, and found him entirely posted, but when I asked if he preferred I should get another boy, who had not enlisted, for my servant, to having extra compensation himself for doing the little things needful for me, he at once decided to fill the two positions. I doubt not we shall get greatly attached to each other. He knows all about managing a boat, has taken care of a horse and has also been taught to cook.

From what I have heretofore written I hope you have not inferred that our regiment is made up of saints. Now and then a soldier among us is not much superior in morals to members of a white regiment. The principle [*sic*] crime here is that of desertion. Today we have had a melancholy result of which will be likely to exert a salutary influence upon the regiment.

Serg't [Prince] Rivers, our Provost Sergeant, is as black as the ace of spades and a man of remarkable executive ability. He is the one from whom some Philadelphia soldiers attempted to strip the sergeant's strip[e]s and found wiser and safer to leave him alone. It is his duty here to keep the prisoners at work, and yesterday afternoon he left them cutting wood outside the camp while he was at dress parade. Three escaped in spite of the two soldiers who were guarding them. It was already sunset when he started with an armed posse to search for them and as the Col. and I walked out a mile from the camp, it seemed to us impossible that search could avail anything in a country so level and so filled with woodland jungle. But about noon today the party returned with one prisoner in a cart, fatally wounded by a gunshot in the abdomen. The poor fellow would not halt at command and in consequence must linger out a few hours of mortal suffering. This sad contingency of military discipline seems to me just, but falling as it does upon a member of that race so long denied common justice by my own, I cannot help feeling a peculiar sadness about it. Serg't Rivers is off again with twenty eight men, in search of the others. I most earnestly hope that if found they will surrender. The feeling through the regiment in regard to the fatal result is that the deserter received his just punishment.

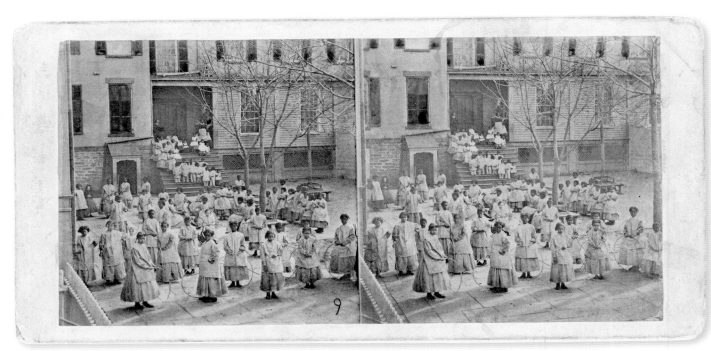

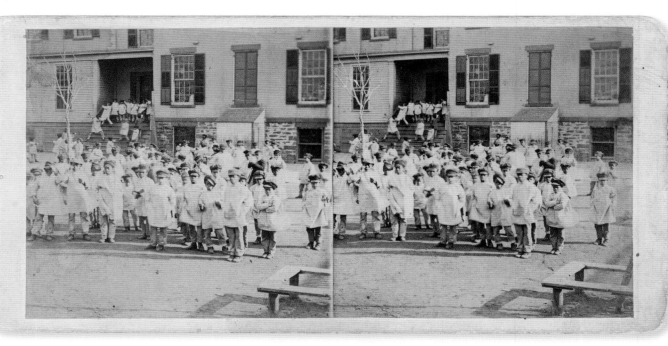

Two stereographs of the Colored Orphan Asylum, New York, 1861. (Courtesy of Greg French and Collection of Greg French)

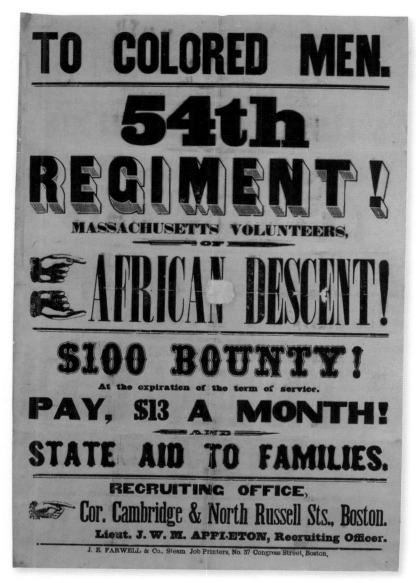

"To Colored Men, 54th Regiment" broadside. (Charles L. Blockson Collection, Temple University Libraries)

[From Seth Rogers]

January 13, 1863

. . . When I sit down at evening it always seems as if there could be but one subject to write upon, the music of these religious soldiers, who sing and pray steadily from supper time till "taps" at 8:30, interrupted only by roll call at eight. The chaplain's pagoda-like school house is the scene of earnest prayers and hymns at evening. I am sure the president is remembered more faithfully and gratefully in prayer by these Christian soldiers than by any other regiment in the army. It is one thing for a chaplain to pray for him, but quite another for the soldiers to kneel and implore blessings on his head and divine guidance for the officers placed over them, such prayers ought to make us true to them.

This afternoon, for the first time, our men are getting some money—not direct from the Government, but through that constant friend to them, Gen. Saxton, who waits for the Government to refund it to him. The real drawback to enlistments is that the poor fellows who were in the Hunter regiment have never been paid a cent by the Government. Without reflection, one would suppose the offer of freedom quite sufficient for them to join us. But you must remember that not the least curse of slavery is ignorance and that the intellectual enjoyment of freedom cannot, by present generation, be so fully appreciated as its material gifts and benefits. Just think how few there are, even in New England, who could bravely die for an Idea, you will see that the infinite love of freedom which inspires these people is not the same that fills the heart of a more favored race.

Many letters show the breadth and depth of experiences of black soldiers. As black men began to fill army regiments and undergo the training to become combat soldiers, news outlets led a debate on whether they would or could actually fight. The early battle reports from the First South Carolina Volunteers in 1862 showed that black men did not flinch under enemy fire when they were led by men like Colonel Higginson who provided the initial training and demonstrated the confidence in their abilities to perform as well as the white soldiers. Higginson saw some of the first combat duty along with the men of the First South Carolina

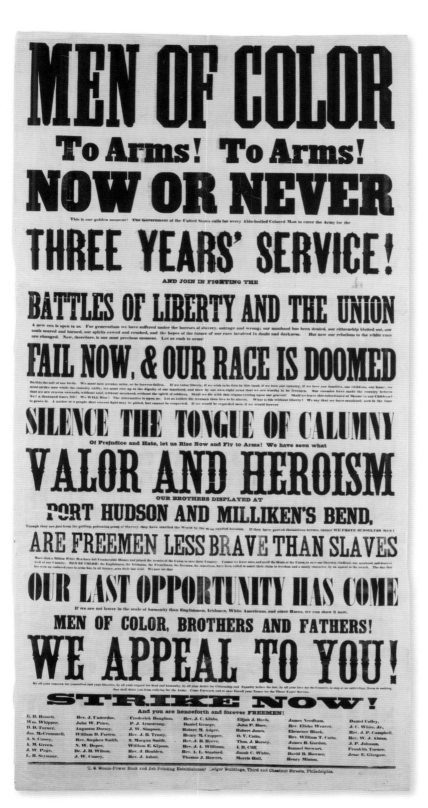

Broadside for "Men of Color," Philadelphia, 1863; recruitment written by Frederick Douglass. (Collection of the Smithsonian National Museum of African American History and Culture, object number: 2012.133)

Volunteers in Port Royal and the rivers of South Carolina, Georgia, and Florida.

Photographs and letters also documented the desire of black doctors and nurses to participate in the war as medical professionals and soldiers. Alexander Thomas Augusta (1825-90) became the first black surgeon to join the Union army's volunteer medical staff. He was born free in Norfolk, Virginia, and studied at Trinity Medical College in Toronto after he received several rejections from medical schools in the United States. Augusta was commissioned as a regimental surgeon of the Seventh US Colored Troops on October 2, 1863.

[From] Toronto, Canada West Jan 7th [18]63
To His Excellency Abraham Lincoln
President of the US

Sir,

Having see[n] that it is intended to garrison the US forts &c with coloured troops, I beg leave to apply to you for an appointment as surgeon to some of the coloured regiments, or as physician to some of the depots of "freedmen." I was compelled to leave my native country, and come to this on account of prejudice against colour, for the purpose of obtaining a knowledge of my profession; and having accomplished that object, at one of the principle [*sic*] educational institutions, of this Province, I am now prepared to practice it and would like to be in a position where I can be of use to my race.

If you will take the matter into favorable consideration, I can give satisfactory reference as to my character and qualification from some of the most distinguished members of the profession in this city where I have been in practice for about six years.

I Remain Sir

Yours Very Respectfully

A. T. Augusta

Bachelor of Medicine Trinity Color Toronto

Freedm[e]n's Hospital, Washington, DC[5]

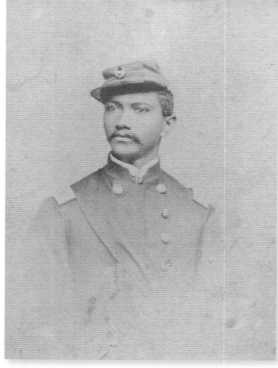

Portrait of Alexander T. Augusta.
(Oblate Sisters of Providence
Archives, Baltimore)

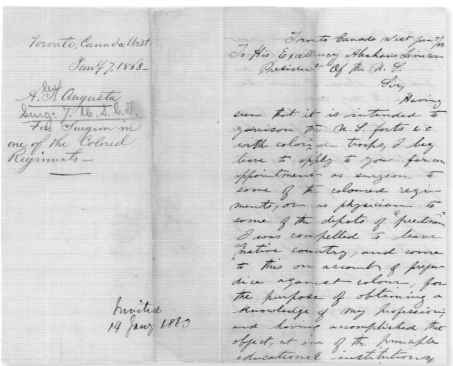

Letter from Alexander Augusta to President Lincoln, 1863. ("Letter from Augusta to
President Lincoln," *Binding Wounds, Pushing Boundaries: African Americans in Civil
War Medicine*, exhibition, National Institutes of Health, US Department of Health and
Human Services, last updated July 15, 2013, www.nlm.nih.gov/exhibition/
bindingwounds/pdfs/LetterFromAugustaToPresidentLincoln1863.pdf)

The letter was referred to the surgeon general and then forwarded to Meredith Clymer, president of the Army Medical Board. According to Edward Bradley, an editor for the quarterly newsletter *Lincoln Editor*, when Augusta appeared in front of the board, "Clymer was shocked to learn that 'he appears to be a person of African descent.' Clymer asked Surgeon General William A. Hammond for instructions. Hammond wished the invitation, but Secretary of War Edwin M. Stanton directed that the examination would proceed. Augusta passed the examination on April 1, was commissioned as a major, and began his service as an Army surgeon to a contraband camp near Alexandria, Virginia. He was the Army's first black physician and its highest-ranking black officer at the time."[6]

In May 1863, Massachusetts became the first Northern state to recruit black soldiers when it formed the Fifty-Fourth and Fifty-Fifth Regiments. The Fifty-Fourth Regiment from Massachusetts became one of the most chronicled and most high-profile of the newly formed regiments after emancipation. Led by the young Colonel Robert Shaw, it was among the first regiments of free black men who had been recruited after emancipation. These men were sent to South Carolina shortly after they completed their training, and the entire country watched to see how they would perform.

Eager to join the fighting, black men all over the North traveled to Massachusetts to enlist in the Fifty-Fourth and Fifty-Fifth. Soon Ohio and other states in the Union followed Massachusetts's lead and authorized their own regiments of black soldiers. For example, Ohio's Governor David Tod authorized black recruitment in his state in the summer of 1863. By November, the 127th Ohio Volunteer Infantry—later renamed the Fifth Regiment, US Colored Troops—had been organized in Delaware, Ohio, as a black regiment with white officers.[7]

As the war progressed, images and letters to and from black soldiers, white officers, sailors, and family members began to form a rich history of the Civil War, also revealing the important role photography and letter writing played in that history. With great pride and hope, soldiers wrote letters home and received letters from their relatives, who were still struggling to find a way to advance. The freedom that was once hoped for was now imagined through a photographer's lens and the pen of soldiers.

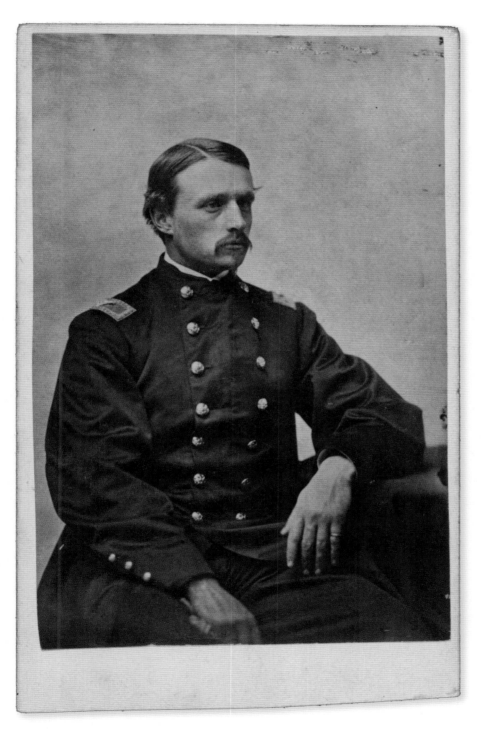

Colonel Robert Shaw (*sitting, facing right*), Boston, ca. 1863. (Photographer unknown; photographic print on carte de visite mount; Library of Congress, Prints and Photographs Division, LC-DIG-ppmsca-10886, call number: LOT 14022, no. 14 [P&P])

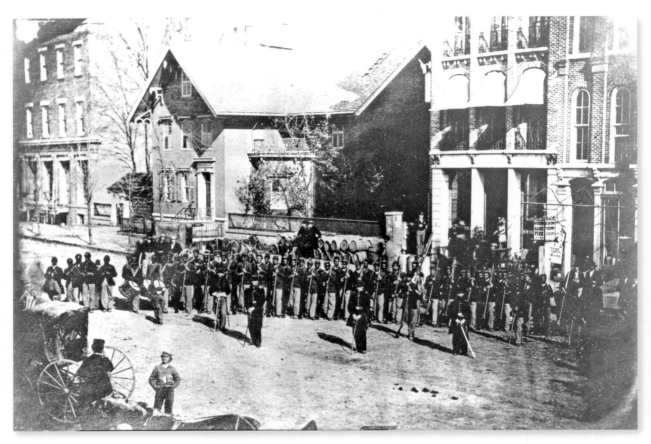

Photograph showing a portion of the 127th Regiment, Ohio Volunteer Infantry (OVI), later designated the Fifth US Colored Troop Regiment Ohio Infantry. The photograph was taken in Delaware, Ohio, on Sandusky Street immediately south of the the Ft. Delaware Hotel, probably in 1863. The 127th Regiment OVI was the first complete African American regiment recruited in Ohio. (127th Regiment, 1861–65, Small Picture Collection OHS OM1277-781147_123, Ohio Historical Society)

Col. Robert G. Shaw

Colonel Robert G. Shaw. (Photographer: John Ritchie; carte de visite album of the Fifty-Fourth Massachusetts Infantry Regiment; Collection of the Smithsonian National Museum of African American History and Culture, Gift of the Garrison Family in memory of George Thompson Garrison, 2014_115_8_002)

Sergt. Major John H. Wilson

Sgt. Major John H. Wilson. (Photographer: John Ritchie; carte de visite album of the Fifty-Fourth Massachusetts Infantry Regiment, Collection of the Smithsonian National Museum of African American History and Culture, Gift of the Garrison Family in memory of George Thompson Garrison, 2014_115_8_043)

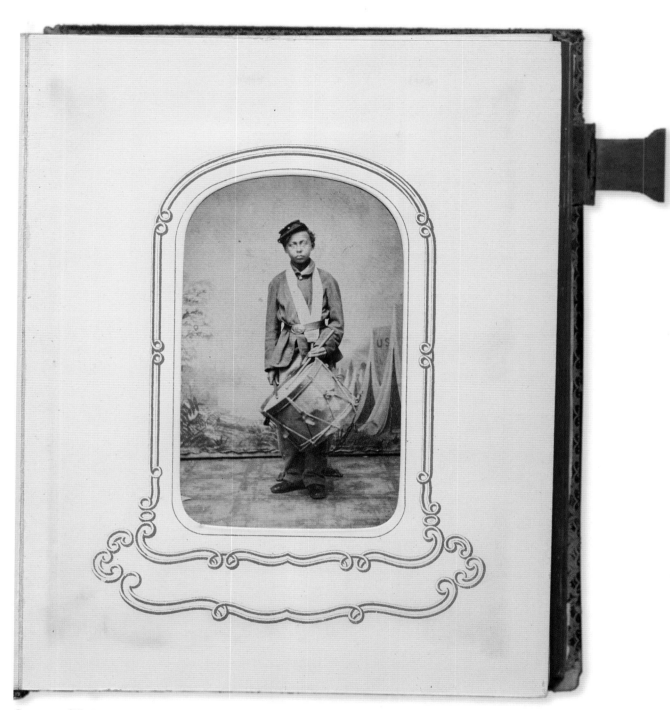

Drummer. (Photographer: John Ritchie; carte de visite album of the Fifty-Fourth
Massachusetts Infantry Regiment, Collection of the Smithsonian National Museum of
African American History and Culture, Gift of the Garrison Family in memory of George
Thompson Garrison, 2014_115_8_028)

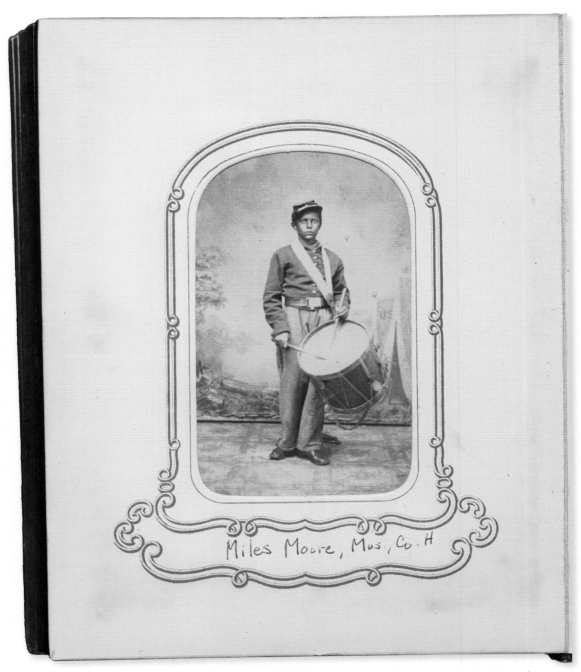

Miles Moore, Mass. Co. H. (Photographer: John Ritchie; carte de visite album of
the Fifty-Fourth Massachusetts Infantry Regiment, Collection of the Smithsonian
National Museum of African American History and Culture, Gift of the Garrison Family
in memory of George Thompson Garrison, 2014_115_8_027)

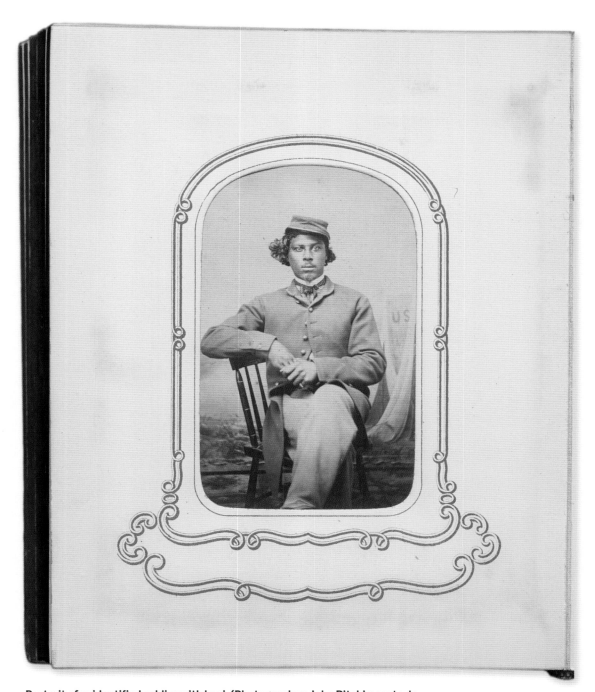

Portrait of unidentified soldier with kepi. (Photographer: John Ritchie; carte de
visite album of the Fifty-Fourth Massachusetts Infantry Regiment. Collection of the
Smithsonian National Museum of African American History and Culture, Gift of the
Garrison Family in memory of George Thompson Garrison, 2014_115_8_025)

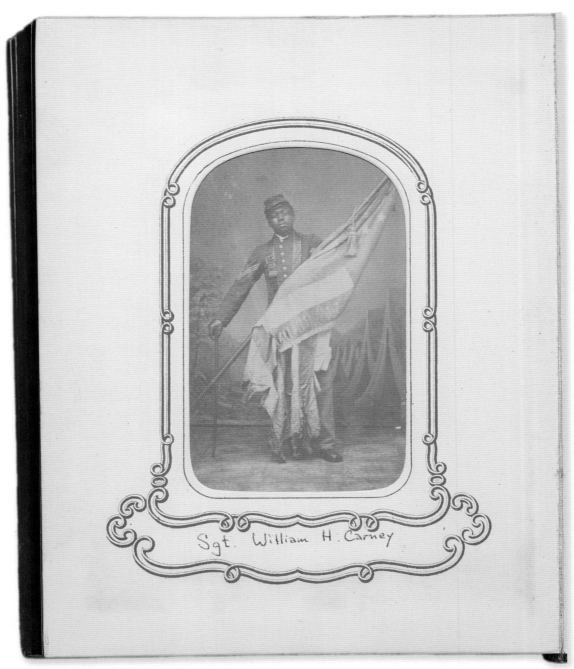

Sgt. William H. Carney with flag. (Photographer: John Ritchie; carte de visite album of the Fifty-Fourth Massachusetts Infantry Regiment, Collection of the Smithsonian National Museum of African American History and Culture, Gift of the Garrison Family in memory of George Thompson Garrison, 2014_115_8_023)

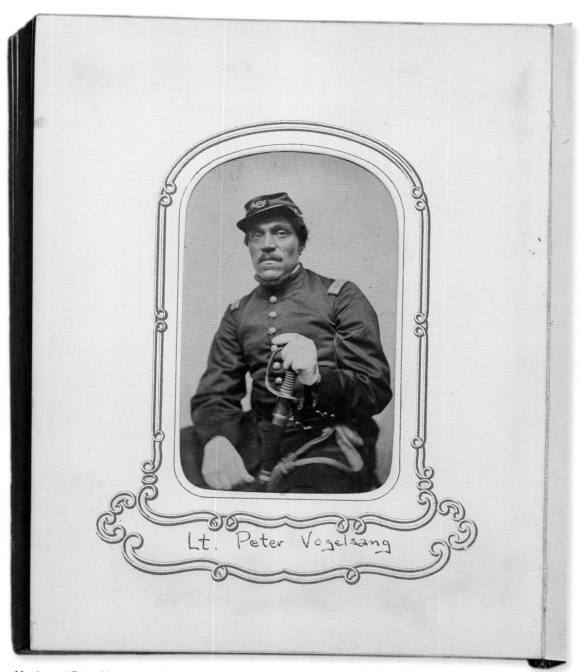

Lt. Peter Vogelsang

Lieutenant Peter Vogelsang. (Photographer: John Ritchie, carte de visite album of the Fifty-Fourth Massachusetts Infantry Regiment, Collection of the Smithsonian National Museum of African American History and Culture, Gift of the Garrison Family in memory of George Thompson Garrison, 2014_115_8_021)

Carte de visite album of the Fifty-Fourth Massachusetts Infantry Regiment. (Collection of the Smithsonian National Museum of African American History and Culture, Gift of the Garrison Family in memory of George Thompson Garrison, 2014_115_8_001)

As mentioned earlier, in words and images, black soldiers and white officers recorded a vivid history of the Civil War and at the same time revealed the critical role played by photography and literacy during that period.

[From] Colonel Robert Gould Shaw, USA
Massachusetts Volunteer Infantry
54th Regiment
Steamer De Molay, June 1, 1863,
Off Cape Hatteras

Dearest Annie,

We have got thus far on our voyage without accident, excepting the loss of Major Hallowell's mare, which died this morning, and was consigned to the sea. We left the wharf at 4pm, having been detained nearly two hours in the packing the arms. That night, and the next day, the sea was very smooth, but Friday evening the wind rose, and before long we had a very sea-sick cargo. Since then, we have been rolling and pitching very steadily. I myself have not been ill at all, so I have done nothing but think over the events of the las three months; which has given me so much occupation, that I have hardly read anything. It is only three months and a half since I got to New York, and Nellie called to you to come down and see me. I hope I shall never forget the happy day we have passed together since then, and that I shall always look back on them with the same pleasure as now. It may be a long time before we find ourselves driving about Berkshire together again; but I do hope that some day we can live over those days at Lenox once more; or even Mrs. Crehore's with a regiment close by to worry us, would not be very bad. . . . The more I think of the passage of the Fifty-fourth through Boston, the more wonderful it seems to me. Just remember our own doubts and fears, and other people's sneering and pitying remarks, when we began last winter, and then look at the perfect triumph of last Thursday. We have gone quietly along forming the regiment, and at last left Boston amidst a greater enthusiasm than has been seen since the first three-months troops left for the war. Everyone I saw, from the governor's staff down, had nothing but words of praise for us. Truly I ought to be thankful; and if the raising of colored troops prove such a benefit to the country, and to the blacks, as many

people think it will, I shall thank God a thousand times that I was led to take my share in it.

This steamer is a very slow one, but fortunately perfectly clean, and well-ventilated. She is entirely free from all disagreeable odours; and the cabin is as comfortable as possible. The weather to-day is perfectly clear, and the sun is getting hot. We have a fine large awning over the quarter-deck, so that we can sit there very pleasantly. You would hardly believe that we have very little trouble in keeping the men's quarters clean, and that the air these is perfectly good. The men behave well; in fact, they have so much animal spirits, that nothing can depress them for any length of time. I heard one man saying *"I felt sick, but I jes' kept' a rambling; sound, and now I'm right well."* My three horses are perfectly well, though thin.

I wonder where you are now; whether on the way to Lenox, or already there. Remember that the vessel is rolling and pitching in the most persevering manner, and don't criticize my calligraphy too severely. . . . Did anyone tell you that, after bidding you and Mother and the girls good bye so stoically, Harry and I had to retire into the back parlour, and have a regular girl's cry? It was putting the last feather on the camel's back; I had so much as I could carry before. It was a great relief, though. . . . How nice and cool and pleasant it must be at Lenox now. The air is pretty hot here, even at sea, but it is not close or oppressive. Remember me to "Mammy Did." I thought yesterday at dinner that I should like some of her soup. Some day we will make that journey we used to talk of, from Lenox through Springfield and Northampton.

I will add a P.S. to this after we get safely established on dry land. Until then, good-bye, darling Annie. I hope you have recovered your spirits, got over your cold, and are feeling happy. Remember all your promises to me; go to bed early, and take as much exercise as you can, without getting fatigued.

Your ever loving Husband

[From] Colonel Robert Gould Shaw, USA
Massachusetts Volunteer Infantry
54th Regiment
St. Helena's Island, South Carolina

July 3, 1863

Dearest Mother,

You will have been some time without letters from me, when you receive this, as the Arago was not allowed to take a mail last week, I understand, because of the late movement on Charleston. Last evening I went over to tea at a plantation four or five miles from here, where some of the teachers, four ladies, and the same number of gentlemen, live.

After tea, we went to what the negroes call a "praise-meeting," which was very interesting. The praying was done by an old blind fellow, who made believe all the time that he was reading out of a book. He was also the leader in the singing, and seemed to throw his whole soul into it. After the meeting, there was a "shout," which is a most extraordinary performance. They all walk and shuffle round in a ring, singing and chanting, while three or four stand in a corner and clap their hands to mark the time. At certain parts of the chorus, they all give a duck, the effect of which is very peculiar. This shuffling is what they call "shouting." They sometimes keep it up all night, and only church-members are allowed to join in it. Their singing, when there are a great many voices, is fine, but otherwise I don't like it at all. The women's voices are so shrill, that I can't listen to them with comfort.

July 4th—Today there has been a great meeting for the colored people, at the Baptist church, six or seven miles from camp. I rode down there, and heard a speech from a colored preacher, from Baltimore, named Lynch. He was very eloquent.

Can you imagine anything more wonderful than a colored abolitionist-meeting on a South Carolina plantation? Here were collected all the freed slaves on this island, listening to the most ultra abolition speeches that could be made, while two years ago their masters were still here, the lords of the soil and of them.

Now, they all own something themselves, go to school and to church, and work for wages! It is the most extraordinary change. Such things oblige a man to believe that God is not very far off.

A little black boy read the Declaration of Independence, and then they all sang some of their hymns. The effect was grand. I would have given anything to have had you there; I thought of you all the time.

The day was beautiful, and the crowd was collected in the church-yard, under some magnificent old oaks, covered with the long, hanging gray moss which grows on the trees here. The gay dresses and turbans of the women made the sight very brilliant. Miss Forten promised to write me out the words of some of the hymns they sang, which I will send to you.

July 6th—Yesterday I went to church at the same place, where the meeting was held on the 4th. The preaching was very bad, being full of "hell and damnation," but administered in such a dull way, that sleep soon overcame most of the congregation, and we counted fifty darkies fast in the "arms of Murphy."

After the sermon, the preacher said, "Those who wish to be married can come forward." Someone then punched a stout young fellow in white gloves, near me; and soon as he could be roused and made to understand that the hour was come, he walked up to the altar. A young woman, still stouter and broader-shouldered than the bridegroom, advanced from the women's side of the church, accompanied by a friend, and they both stood by his side, so that it looked as if he were being married to both of them. However, they got through it all right, as he evidently knew which was which, and they both said "Yes, sir," to all the preacher asked them; they were both coal-black. I couldn't find out if the bride had been sleeping during the sermon, as well as the groom. At the church they sang our hymns, and made a sad mess of them, but they do justice to their own at their "praise-meetings."

9 p.m.—We have just had Miss Forten and two other ladies to tea, and entertained them afterwards with some singing from the men. It made us all think of those last evenings at Readville, which were so pleasant.

If there were any certainty of our being permanently here, you and Annie could come down and spend a month without the least difficulty. You would enjoy it immensely; there is enough here to interest you for months. As you may suppose, I was

bitterly disappointed at being left behind; but nothing has been done at Charleston yet, and we may have a chance. Today I went on board the monitor Montauk and the rebel ram Fingal. The latter is very strong and very powerfully armed; but the work is rough, and looks as if they wanted money and workmen to finish it properly.

We don't know with any certainty what is going on in the North, but can't believe Lee will get far into Pennsylvania. No matter if the rebels get to New York I shall never lose my faith in our ultimate success. We are not yet ready for peace, and want a good deal of purging still.

I wrote to General Strong this afternoon, and expressed my wish to be in his brigade. Though I like Montgomery, I want to get my men alongside of white troops, and into a good fight, if there is to be one. The General sent me word, before he went away, that he was very much disappointed at being ordered to leave us; so I thought it well to put it into his head to try to get us back.

Working independently, the colored troops come only under the eyes of their own officers; and to have their worth properly acknowledged, they should be with other troops in action. It is an incentive to them, too, to do their best. There is some rumor tonight of our being ordered to James Island, and put under General Terry's command. I should be satisfied with that.

I shall write to Effie & Susie tomorrow if nothing happens to prevent it. Please tell them so, if you don't hear from me, for we may have to leave this at any moment. Indeed I have been expecting it, every day. Goodnight darling Mother. Give my love to Father & the girls. I hope you are all well. I had a note from Cousin John today enclosing an ivy leaf from the wall at Hugomount, Waterloo.

If the Rebels get near New York, do go to Massachusetts. I shall be so anxious, if you don't. Lenox would be a safe place.

> *Your every loving son*
> *Will you send this to Annie.*[8]

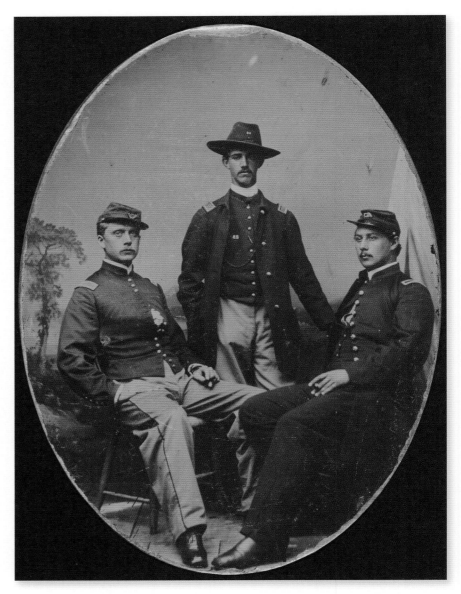

Group portrait, officers of the Fifty-Fourth Massachusetts, 1863. The sitters have been identified as Second Lieutenant Ezekiel G. Tomlinson, Captain Luis F. Emilio (*center*), and Second Lieutenant Daniel G. Spear. (Library of Congress Prints and Photographs Division, LC-DIG-ppmsca-11526)

Among the first people whom Shaw met when he arrived in South Carolina was Charlotte Forten. Forten's diary pages reveal a broad spectrum of her experiences—as a teacher, a black woman, and a memoirist. Her descriptive assessments of her encounters remain engaging today.

From Charlotte Forten's Diary, July 1863

Thursday, July 2. Co. [Robert] Shaw and Major H.[allowell] came to take tea with us, and afterwards stayed to the shout. Lieut. W[alton] was ill, and c'ld not come. I am perfectly charmed with Col. S[haw]. He seems to me in every way one of the most delightful persons I have ever met. There is something girlish about him, and yet I never saw anyone more manly. To me he seems a thoroughly lovable person. And there is something so exquisite about him. The perfect breeding, how evident it is Surely he must be a worthy son of such noble parents. I have seen him but once, yet I cannot help feeling a really affectionate admiration for him. We

Pages from Charlotte Forten's journal: her observations of the wounded, July 23, 1863. (Transcript of pages from Charlotte Forten's journal, pages 80 and 81, July 23-24, 1863; Courtesy Moorland Spingarn Research Center, Howard University)

had a very pleasant talk on the moonlit piazza, and then went to the Praise House to see the shout. I was delighted to find that it was one of the very best and most spirited that he had had. The Col. [Robert Shaw] looked and listened with the deepest interest. And after it was over expressed himself much gratified. He said, he w'ld like to have some of the hymns to send home. I shall be only too glad to copy them for him. Old Maurice surpassed himself to-night in singing "The Talles' Tree in Paradise." He got much excited and his gestures were really tragic. I c'ld see with what astonishment and interest our guests watched the old blind man.

Charlotte Forten, Beaufort, S.C.

Monday, July 20. For nearly two weeks we have waited, oh how anxiously for news of our regiment which went, we know to Morris Island to take part in the attack on Charleston. Tonight comes news, oh, so sad, so heart sickening. It is too terrible, too terrible to write. We can only hope it may not all be true. That our noble, beautiful young Colonel is killed, and the regiment cut to pieces! I cannot, cannot believe it. And yet I know it may be so. But oh, I am stunned, sick at heart. I can scarcely write. There was an attack on Fort Wagner. The 54th put in advance; fought bravely, desperately, but was finally overpowered and driven back after getting into the Fort. Thank Heaven! they fought bravely! And oh, I still must hope that our colonel, ours especially he seems to me, is not killed. But I can write no more to-night.

Friday, July 24. To-day the news of Col. Shaw's death is confirmed. There can no longer be any doubt. It makes me sad, sad at heart. They say he sprang upon the parapet of the fort and cried "Onward, my brave boys, onward"; then fell, pierced with wounds. I know it was a glorious death. But oh, it is hard, very hard for the young wife, so late a bride, for the invalid mother, whose only and most dearly loved son he was,—that heroic mother who rejoiced in the position which he occupied as colonel of a colored regiment. My heart bleeds for her. His death is a very sad loss to us. I recall him as a much loved friend. Yet I saw him but a few times. Oh what must it be to the wife and the mother. Oh it is terrible. It seems very, very hard that the best and the noblest must be the earliest called away. Especially has it been so throughout this dreadful

war. [Mr. Pierce] who has been unremitting in his attention to the wounded—called at our building to-day, and took me to the Officers Hospital, which is but a very short distance from here. It is in one of the finest residences in Beaufort, and is surrounded by beautiful grounds. Saw Major Hallowell, who, though badly wounded—in three places—is hoped to be slowly improving. A little more than a week ago I parted with him, after an exciting horseback ride, how strong, how well, how vigorous he was then! And now how thoroughly prostrated! But he with all the other officers of the 54th, like the privates, are brave, patient cheerful. With deep sadness he spoke of Col. Shaw and then told me something that greatly surprised me; that the Col. before that fatal attack had told him that in case he fell he wished me to have one of his horses—He had three very fine spirited ones that he had brought from the North. How very, very kind it was! And to me, almost a perfect stranger. I shall treasure this gift most sacredly, all my life long.[9]

In the following letter, former officers in a black regiment from Louisiana offer their services to the commander of the Department of the Gulf to continue to fight for the Union.

[From] New Orleans, April 7th 1863
Sir, we the undersigned, in part [are] resigned officers of the Third (3rd) reg[imen]t L[ouisian]a vol[unteers] native guards and others desiring to assist in putting down this wicked rebellion. And in restoring peace to our once peaceful country. And wishing to share with you the dangers of the battle field and serve our country under you as our forefathers did under [Andrew] Jackson in eighteen hundred and fourteen and fifteen.

On part of the ex officers we hereby volunteer our services to recruit a regiment of infantry for the United States army. The commanding Gen[era]l may think that we will have the same difficulties to surmount that we had before resigning. But sir, give us a commander who will appreciate us as men and soldiers, And we will be willing to surmount all outer difficulties. We hope also if we are permitted to go into the service again we will be allowed to share the dangers of the battle field and not be kept for men who will not fight. If the world doubts our fighting give us a chance and we will show then what we can do.

We transmit this for your perusal and await your just conclusion. And hope that you will grant our request. We remain respectfuly your obedient servants

Adolph. J. Gla *James. E. Moore*
Samuel Laurence *William. Hardin*
Joseph G. Parker *William. Moore*
Joseph. W. Howard *Charles. A. Allen*
Charles. W. Gibbons *Dan[ie]l W. Smith Jr.*[10]

The following is a letter from a white officer in a black regiment from Louisiana to the commander of a black brigade from the same state verifying the bravery of the black troops in order to suppress counterperceptions.

Baton Rouge May 29th [18]63.

General. feeling deeply interested in the cause which you have espoused, I take the liberty to transmit the following, concerning the colored Troops engaged in the recent battles at Port Hudson.

I arrived here the evening of the 26th inst., was mustered and reported to Maj. Tucker for duty—

During the night I heard heavy connonadeing [cannonading] at Port Hudson. Early next morning I obtained permission and went to the front. But was so much detained, I did not reach our lines until the fighting for the day had nearly ceased—There being no renewal of the engagement the following day—I engaged in removing and administering to the wounded, gathering meantime as much information as possible concerning the battle and the conduct of our Troops. My anxiety was to learn all I could concerning the Bravery of the Colored Reg. engaged, for their good conduct and bravery would add to your undertakings and make more popular the movement. Not that I am afraid to meet unpopular doctrins, for I am not. But that we may show our full strength. the cause should be one of general sanction.

I have ever believed, from my idea of those traits of character which I deemed necessary to make a good soldier, together with their history, that in them we should find those characteristics necessary, for an effictive army. And I rejoice to learn, in the late engagements the fact is established beyond a doubt.

The following is (in substance) a statement personally made to me, by 1st Lt. Co. F. 1st R[egiment] L[ouisian]a. Native Guard who was wounded during the engagement.

"We went into action about 6. A.M. and was under fire most of the time until sunset.

The very first thing after forming line of battle we were ordered to charge—My Co. was apparently brave. Yet they are mostly contrabands, and I must say I entertained some fears as to their pluck. But I have now none—The moment the order was given, they entered upon its execution. Valiantly did the heroic descendants of Africa move forward cool as if Marshaled for dress parade, under a most murderous fire from the enemies guns, until we reached the main ditch which surrounds the Fort. finding it impassible we retreated under orders to the woods and deployed as skirmishers—In the charge we lost our Capt. and Colored sergeant, the latter fell wrapped in the flag he had so gallantly borne—Alone we held our position until 12 o'clock when we were relieved—

At two o'clock P.M. we were again ordered to the front where we made two separate charges each in the face of a heavy fire from the enemies Battery of seven guns—whose destructive fire would have confuse and almost disorganized the bravest troops. But these men did not swerve, or show cowardice. I have been in several engagements, and I never before beheld such coolness and daring—"

Their gallantry entitles them to a special praise. And I already observe, the sneers of others are being tempered into eulogy—

It is pleasant to learn these things, and it must be indeed gratifying to the General to know that his army will be composed of men of almost unequaled coolness & bravery—

The men of our Reg. are very ready in learning the drills, and the officers have every confidence in their becoming excellent soldiers.

Assuring you that I will always, both as an officer of the US Army and as a man, endeavor to faithfully & fully discharge the duties of my office, I am happy to Subscribe Myself, Very Respectfully, Your Most Obt. Servt,

Elias D. Strunke[11]

Strunke was an officer in the Fifth Regiment US Volunteers (later Eighty-Second US Colored Infantry), one of three black regiments under General Daniel Ullmann's command. Years later, Ullmann shared the same sentiments about the regiments as Strunke: "They were on our extreme right where the ground was very broken and . . . made six or seven charges over this ground against the enemy's works. They were exposed to a terrible fire and were dreadfully slaughtered." He added that "the conduct of these Regiments on this occasion wrought a marvellous change in the opinion of many former sneerers."[12]

"Whatever doubt may have existed heretofore as to the efficiency of organizations of this character," reported General Nathanial P. Banks, who commanded the Union troops at Port Hudson, "the history of this day proves conclusively . . . that the Government will find in this class of troops, effective supporters and defenders."[13]

It is important to contextualize not only the experiences of the soldiers but also the family members who witnessed their departure to war. Mothers wrote and sent impassioned letters expressing their concerns about their sons' welfare. One mother wrote to Abraham Lincoln, asking him to ensure that black soldiers were treated fairly.

[From Hannah Johnson]
Buffalo [New York]

July 31 1863

Excellent Sir

My good friend says I must write to you and she will send it. My son went in the 54th regiment. I am a colored woman and my son was strong and able as any to fight for his country and the colored people have as much to fight for as any. My father was a Slave and escaped from Louisiana before I was born morn forty years agone. I have but poor edication but I never went to schol, but I know just as well as any what is right between man and man. Now I know it is right that a colored man should go and fight for his country, and so ought to a white man. I know that a colored man ought to run no greater risques than a white, his pay is no greater, his obligation to fight is the same. So why should not our enemies be compelled to treat him the same, Made to do it.

Photograph of Charles Douglass (Frederick Douglass's son).
(Carte de visite; courtesy of Greg French and Collection of
Greg French)

My son fought at Fort Wagoner but thank God he was not taken
prisoner, as many were. I thought of this thing before I let my boy
go but then they said Mr Lincoln will never let them sell our col-
ored soldiers for slaves, if they do he will get them back quick, he
will rettallyate and stop it. Now Mr Lincoln dont you think you
ought to stop this thing and make them do the same by the col-
ored men. They have lived in idleness all their lives on stolen labor
and made savages of the colored people, but they now are so furi-
ous because they are proving themselves to be men, such as have
come away and got some edication. It must not be so. You must
put the rebels to work in State prisons to making shoes and things,
if they sell our colored soldiers, till they let them all go. And give

their wounded the same treatment. It would seem cruel, but their [is] no other way, and a just man must do hard things sometimes, that shew him to be a great man. They tell me, some do, you will take back the Proclamation, don't do it. When you are dead and in Heaven, in a thousand years, that action of yours will make the Angels sing your praises, I know it. Ought one man to own another, law for or not. Who made the law, surely the poor slave did not. So it is wicked, and a horrible Outrage, there is no sense in it, because a man has lived by robbing all his life and his father before him, should he complain because the stolen things found on him are taken. Robbing the colored people of their labor is but a small part of the robbery, their souls are almost taken, they are made bruits of often. You know all about this.

Will you see that the colored men fighting now are fairly treated. You ought to do this, and do it at once, Not let the thing run along, meet it quickly and manfully, and stop this mean, cowardly cruelty. We poor oppressed ones appeal to you, and ask fair play.
Yours for Christs sake
 Hannah Johnson.[14]

When connected to photographs, the letters not only tell us what people in the nineteenth century thought about the war but help us imagine the period, by illustrating the personal triumphs and defeats that occur during historical events.

A letter from Frederick Douglass's oldest son, Lewis, to his fiancée, Helen "Amelia" Loguen, is particularly striking. He describes the injuries of soldiers from her hometown as he reassures her about his own status. Amelia was the daughter of the Reverend Jermain Loguen, a Syracuse-based conductor on the Underground Railroad.[15] Lewis Henry Douglass was a soldier in the Civil War with the Fifty-Fourth Massachusetts Volunteer Infantry—a sergeant major, the highest rank an African American could hold. He and Helen exchanged photographs of each other and letters about the war and specifically Morris Island.

My Dear Amelia
I have been in two fights, and am unhurt. I am about to go in another I believe to-night. Our men fought well on both occasions. The last was desperate, we charged that terrible battery on

Sergeant Major Lewis Douglass, Fifty-Fourth Massachusetts Infantry, 1863.
(Photographer: Case & Getchell, Boston; carte de visite; Moorland-Spingarn
Research Center, Howard University)

Portrait of Helen Amelia Loguen, ca. 1863. (Courtesy of the Onondaga Historical Association)

Morris Island known as Fort Wagoner, and were repulsed with a loss of 3 killed and wounded. I escaped unhurt from amidst that perfect hail of shot and shell. It was terrible. I need not particularize, the papers will give a better account than I have time to give. My thoughts are with you often, you are as dear as ever, be good enough to remember it, as I [have] no doubt you will. As I said before, we are on the eve of another fight, and I am very busy and have just snatched a moment to write you. I must necessarily be brief. Should I fall in the next fight, killed or wounded, I hope to fall with my face to the foe.

If I survive I shall write you a long letter. DeForrest of your city is wounded, George Washington is missing, Jacob Carter is missing, Chas Reason wounded, Chas Whiting, Chas Creamer all wounded. The above are in hospital.

This regiment has established its reputation as a fighting regiment, not a man flinched, though it was a trying time. Men fell all around me. A shell would explode and clear a space of twenty feet, our men would close up again, but it was no use—we had to retreat, which was a very hazardous undertaking. How I got out of that fight alive I cannot tell, but I am here. My Dear girl I hope again to see you. I must bid you farewell should I be killed. Remember if I die I die in a good cause. I wish we had a hundred thousand colored troops, we would put an end to this war.
Good Bye to all. Write soon,
Your own loving Lewis[16]

Lewis survived that battle but was diagnosed with typhoid and discharged from the army in 1864. He and Amelia married in 1869 in Syracuse, New York. Their photographs and letters present a vibrant history of love and commitment during the war, emphasizing the importance of postemancipation life. We imagine the alliances that black soldiers coveted; the letters also reveal the soldiers' level of education and their commitment to the war.

The Civil War marked the first time that large numbers of reporters, artists, and photographers followed troops into battle.[17] One of the reporters documenting the war was a black journalist named Thomas Morris Chester. Born free in Harrisburg, Pennsylvania, Chester was the son of an oysterman and a self-emancipated woman from Baltimore. After his journalism career came to an end,

he would work as an attorney, a diplomat stationed in Liberia, and an educator. But in 1864, he was thirty-five years old and reporting for the *Philadelphia Press*—possibly the only black American to cover the war for a major daily His dispatches were

> the only sustained eyewitness account of the activities of black soldiers around Richmond and Petersburg. Chester had a keen eye for detail. His reports, written under the nom de plume Rollin, frequently went beyond mere reporting of battles to include descriptions of how soldiers survived the ordeals of the war. He was particularly empathetic to the suffering soldier. . . . His coverage of the treatment of injured and captured white officers and their black troops aimed to do more than praise their bravery, however; it showed the depth to which man could sink in his pursuit of morally indefensible causes.[18]

In 1865, Chester was in Richmond with the predominantly black Twenty-Fifth Army Corps when Union troops seized the Confederate capital. He reported that the sight of the enslaved population greeting Union soldiers was "not only grand, but sublime."[19] He also recruited black men from Pennsylvania for the Fifty-Fourth and Fifty-Fifth Massachusetts Regiments.

Corporal James Henry Gooding of Company C of the Fifty-Fourth was a correspondent with the *New Bedford (MA) Mercury* and published numerous letters chronicling his experiences, including the following one on March 7, 1863.

> Camp Meigs, Readville, March 6
>
> Messrs. Editors:—Immediately upon our arrival here on Wednesday afternoon, We marched to the barracks, where we found a nice warm fire and a good supper in readiness for us. During the evening the men were all supplied with uniforms, and now they are looking quite like soldiers. They all seem contented, and appear in the best of spirits. We have drill morning and afternoon, and the men are taking hold with a great degree of earnestness.
>
> Col. Shaw is on the ground, doing all he can for the comfort of those now in camp. Lieut. Dexter has been appointed to the New Bedford company but has not yet made his appearance.

Thomas Morris Chester, the first African American war correspondent for a major daily newspaper, the *Philadelphia Press*, ca. 1870. (Photographer: D. C. Burnite; Cartes de Visite Collection, Schomburg Center for Research in Black Culture, Photographs and Prints Division, New York Public Library, Digital ID: 08sccdv Record ID: 745793)

> The men from New Bedford are the largest in camp and it is
> desired to fill Up the company from our city, which can and ought
> to be done. Lieut. Grace will be in the city tomorrow and he wants
> to bring a squad back with him.[20]

A year later and after forty-eight letters to the *New Bedford Mercury*, Gooding was injured, was imprisoned by the Confederates, and died five months later.

Photographs captured the experience of war—on the battle-field, at campsites, and in temporary studios, where soldiers struck poses before the camera, eager to preserve their memories of the war. Thanks to photography and the photographic album, the Civil War became America's first "parlor-room war." Millions of photographs and engravings permeated all aspects of American life in the North.[21] People bought portraits, large-format images, cased photographs, and tintypes of black soldiers standing in front of flags and holding their weapons. Such images projected heroism, which can be seen in a hand-colored ambrotype of Sergeant Henry F. Steward, a twenty-three-year-old farmer from Adrian, Michigan. Steward enlisted on April 4, 1863, and was mustered in (formerly inducted) on April 23. Like all black officers, he was a noncommissioned officer, and he actively recruited soldiers for his regiment. When he died of disease at the regimental hospital on Morris Island, South Carolina, on September 27, 1863, his estate was paid a $50 state bounty.

These letters provide evidence of the the daily lives and yearnings of the soldiers and officers as assembled in the archive of the memory of laborers during the war years. Work assignments for black men in the military ranged from work hand to soldier to cook to surgeon. Letters from the few black surgeons who served reveal their love of the profession and quest to support the war. According to the curator Jill Newmark, "More than 180,000 African Americans—some free born, some escaped slaves—served in the Union Army during the Civil War, but only 13 of them tended to the wounded as surgeons. Few personal accounts by these surgeons exist, and much of their story has remained hidden, but many clues exist in the thousands of documents and records in the National Archives. By piecing together these clues—from existing medical personnel files, contract surgeon records, pension files and other

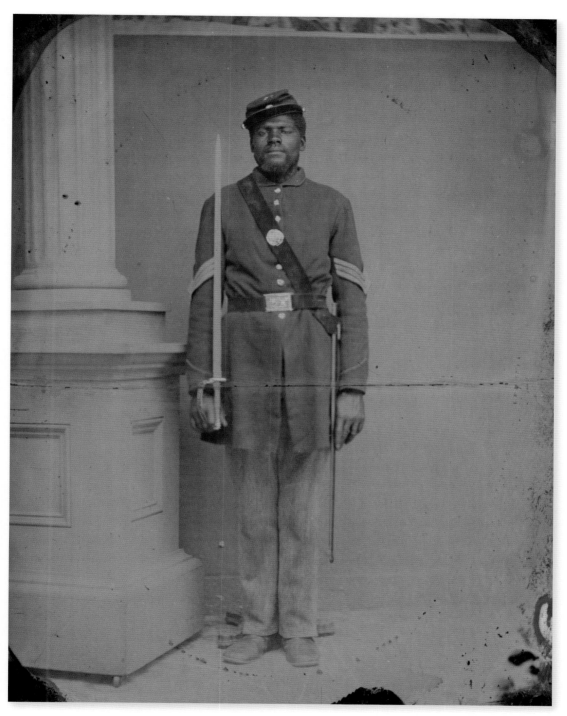

Sergeant Henry F. Steward, 1863. (Hand-colored ambrotype; from the 54th
Massachusetts Volunteer Infantry Regiment photographs, Massachusetts
Historical Society, photo 2.162)

records in the Archives—their stories emerge and their voices can be heard."[22] In 2010, Newmark curated a groundbreaking exhibition, *Binding Wounds, Pushing Boundaries: African Americans in Civil War Medicine*, at the US National Library of Medicine, which introduced rediscovered photographs, letters, and records of black surgeons to a new generation of scholars interested in Civil War history and medicine.

In the book *Practicing Medicine in a Black Regiment: The Civil War Diary of Burt G. Wilder, 55th Massachusetts*,[23] the historian Richard Reid points to the lack of good doctors working during the early war years: "[Burt G.] Wilder's account as a young surgeon is useful both for what it reveals about life and service in an important Northern black regiment and for its insights into the formative years in his becoming an influential scientist, education, and social activist. . . . The 55th Massachusetts was a regiment with an unusually competent and complete medical staff while it served in the South," including three white team doctors, medical officer Wilder, surgeon Dr. William S. Brown, and second assistant surgeon, Dr. Warren M. Babbitt. Reid adds that "the greatest demand on all Civil War surgeons was in combating diseases, not repairing injuries."[24]

The hot, humid weather, a poor water supply, new pathogens, and the severe physical demands took their toll on all the regiments.[25] Wilder's diary is remarkable and engrossing. His observations range from heartwarming stories about his attachment to his horse to finding time to read medical journals and write his thesis. Wilder shared numerous stories about his patients and colleagues.

The following passage from Wilder's diary describes his encounters while traveling through the Charleston, South Carolina, area with his regiment in 1863. The crossed-out and inserted words (rendered in italics here) are Wilder's own.

Goose Creek
Wednesday, [April] 12th, 4:30 p.m. Porcher Mansion. More than a thousand colored people of both sexes and of all ages have followed us. Capt. Soule and I with two companies are left to guard them. Some rebel cavalry are on the other side of the river, and have take some stragglers. We are quartered in and about the house of Mr. Porcher, on a beautiful place, about one-fourth of a mile from the bridge . . .

Thursday, 13th, 3:00 p.m. An officer came up last night with the glorious news of the capture of Richmond and Petersburg with 2500 prisoners and 500 guns. We hardly knew whether to laugh or cry. The joyful news was communicated with the soldiers and through them to the colored refugees; for an hour there was great rejoicing. At noon today a man with his family from Columbia was passed into our lines by the rebel lieutenant on the other side of the creek; he said the rebels had known that had happened five days ago, and we were impressed by their dogged determination to hold out to the last. Gen. Hatch sent an order to send out as many mounted men as could be spared the way we came to convey an order to Col. Chipman who, with his regiment, the 102nd USCT, started out after us two days ago but by following our rear met us not. By the utmost only 16 horses and mules can be found for the duty, and they are tired and ill fed; the officers, however, had not power to revoke the order, so this morning Lt. B. Roberts started with his little force. In an hour he returned reporting that after driving back the half dozen pickets at the other end of the bridge and emptying two saddles he came upon at least 30 more at a turn in the road and was forced to fall back; the number seems probable, for the man who came thu [*sic*] yesterday said that at least 25 were together at what seemed to be their headquarters. It was not thought prudent to make a second attempt and a report was sent to Gen. Hatch. This forenoon I made the rounds of the whole camp; among the colored people there were naturally some women and children ill, which embarrassed me somewhat; I was careful not to hurt any of them with too much medicine. There are two cases of measles, and probably will be more. Our ~~expedition~~ *force* numbered more than 1000 men, abut 700 being from our regiment and the rest from the 54th N.Y., with ~~a section~~ *two pieces* of artillery. The furthest point reached was Eutaw Springs, and during the last two days we held the rear; the ~~rebels~~ *enemy* followed close behind, shot one ~~colored man~~ *negro (not a solder)* as he was climbing a fence and might have made trouble for us; ~~but the colonel ordered the artillery to send~~ a couple of shells ~~after~~ *were fired at* them and they ~~we saw~~ *could see* them riding thru the woods on a parallel track. ~~A few miles from Goose Creek we left the state road and took the road to the right leading to Monks Corners, near Biggins Creek; here we turned again to the left~~ We

stopped at Pineville, a small town in the woods. Here, a few days before, the negroes made a stand against the rebel scouts, and after killing some of ~~them~~ *the latter,* they were defeated and sixteen of them killed. In the town we found some outspoken rebels and some pretended unionists. That night we ~~pushed on to the~~ *reached the plantation of Marzzck* [?] Porcher, whose house was burned next morning by our rear guard; he was sent a prisoner to Charleston and his overseer, a very respectable old man, was left ~~to live on the place and have~~ *in* charge of such negroes as ~~might~~ *choose to* remain ~~with him.~~ At noon next day we reached Eutaw Springs, the scene of a battle in the revolution. Here *was seen* the first rock since leaving the coast. The water bubbled in a very interesting way at the bottom of a depression. Here we stopped for 24 hours, sending small parties in different directions for forage and to look for Gen. Potter's command on the other side of the Santee. Just before reaching here Gen. Hartwell and two of his staff rode alone to a house at some distance from the road when they were fired upon by half a dozen rebels, but escaped unhurt to our forces. Capt. Torrey then rode out with a flag of truce and while talking with the lieutenant in command, a party from the 54th N.Y. came up and unceremoniously captured him and three of his party and carried them to the general; on the way here they were most improperly robbed of their horses, guns and even blankets; the lieutenant said that he had lain in the bushes that day and had seen our whole force pass; they were naturally enraged at the violation of the flag of truce and still more so when, on being released, their equipment could not be found. The same lieutenant is now in command of ~~those~~ *the force* on the other side of the creek for we have today seen a pass in his writing admitting a man to our lines. We marched about 20 miles a day, starting at 6 or 7, halting at noon for dinner, and keeping on till dark and once till near midnight. From Eutaw Springs we crossed to the state road which we reached at noon of day before yesterday, David rode my other horse, but as they had been pretty hard worked during the previous week we often got of and walked. Both that horse and the big saddle-bags which he carried were very useful; no other officer has one or the other.

[13th, cont.] 6 p.m. A recent order forbids the detail of soldiers as officers servants, and David has been really acting as Headquarters orderly and had time to do what I needed; but the arrangement

was irregular and undesirable. Among the refugees is a man name Edward Gailliard, a light mulatto, the son of his master, and unusually well appearing; he has a wife and two children; David has been showing him how to care for Billy. . . .

Camp at Rickersville
Friday, [April] 14th, 9:00 p.m. There has been a great celebration over the glorious news from the north; surely the war must be over soon. Among the children is another little fellow named Robert whom I may try to get.

Sunday, 16th, 4:15 p.m. Soon after dinner yesterday Col. Hartwell rode out and said that Hon. Henry Wilson and others of a visiting party would leave Charleston at 2:30 to look at us and the refugees, and he wished all to be present. We waited in vain till 5, and then I went to Charleston on business, meeting the distinguished visitors on the way. This morning vaccinated all of the recruits. I have secured the little boy, Robert; he is too good to be lost; he can help Edward in various ways; if I am promoted he will serve as my second servant; if not there are many who will be glad of him. Gen. Hartwell rode out with Rev. Henry Ward Beecher and others and ladies; he and others spoke in Charleston this afternoon but I had some business letters to write and let David and Edward go to hear them.[26]

On December 15, 1863, Wilder rode to Morris Island, South Carolina, with a lieutenant in the Fifty-Fourth Massachusetts, John Whittier Messer Appleton, and recorded the moment in his diary. "We had a fine ride up the beach and over the scene of the famous attack, Appleton showed us the place in Wagner where Shaw was killed and he was wounded."[27]

Letters reveal dreams deferred, disappointments, and grievances about the war. For example, one of Gooding's letters was a protest to President Lincoln on September 28, 1863, about black soldiers' unequal compensation.

Your Excellency, Abraham Lincoln:
Your Excellency will pardon the presumption of an humble individual like myself, in addressing you, but the earnest solicitation of my comrades in arms besides the genuine interest felt by myself

in the matter is my excuse, for placing before the Executive head of the Nation our Common Grievance.

On the 6th of the last Month, the Paymaster of the Department informed us, that if we would decide to receive the sum of $10 (ten dollars) per month, he would come and pay us that sum, but that, on the sitting of Congress, the Reg[imen]t. would, in his opinion, be allowed the other 3 (three). He did not give us any guarantee that this would be, as he hoped; certainly he had no authority for making any such guarantee, and we cannot suppose him acting in any way interested.

Now the main question is, are we Soldiers, or are we Laborers? We are fully armed, and equipped, have done all the various duties pertaining to a Soldier's life, have conducted ourselves to the complete satisfaction of General Officers, who were, if anything, prejudiced against us, but who now accord us all the encouragement and honors due us; have shared the perils and labor of reducing the first stronghold that flaunted a Traitor Flag; and more, Mr. President, today the Anglo Saxon Mother, Wife, or Sister are not alone in tears for departed Sons, Husbands, and Brothers. The patient, trusting descendant of Africa's Clime have dyed the ground with blood, in defence of the Union, and Democracy. Men, too, your Excellency, who know in a measure the cruelties of the iron heel of oppression, which in years gone by, the very power their blood is now being spilled to maintain, ever ground them in the dust.

But when the war trumpet sounded o'er the land, when men knew not the Friend from the Traitor, the black man laid his life at the altar of the Nation—and he was refused. When the arms of the Union were beaten, in the first year of the war, and the Executive called for more food for its ravenous maw, again the black man begged the privilege of aiding his country in her need, to be again refused.

And now he is in the War, and how has he conducted himself? Let their dusky forms rise up, out of the mires of James Island, and give the answer. Let the rich mound around Wagner's parapet be upturned, and there will be found an eloquent answer. Obedient and patient and solid as a wall are they. All we lack is a paler hue and a better acquaintance with the alphabet.

Now your Excellency, we have done a Soldier's duty. Why can't we have a Soldier's pay? You caution the Rebel chieftain, that the United States knows no distinction in her soldiers. She insists on

having all her soldiers of whatever creed or color, to be treated according to the usages of War. Now if the United States exacts uniformity of treatment of her soldiers from the insurgents, would it not be well and consistent to set the example herself by paying all her soldiers alike?

We of this Reg[imen]t. were not enlisted under any "contraband" act. But we do not wish to be understood as rating our service of more value to the Government than the service of the ex-slave. Their service is undoubtedly worth much to the Nation, but Congress made express provision touching their case, as slaves freed by military necessity, and assuming the Government to be their temporary Guardian. Not so with us. Freemen by birth and consequently having the advantage of thinking and acting for ourselves so far as the Laws would allow us, we do not consider ourselves fit subjects for the Contraband act.

We appeal to you, Sir, as the Executive of the Nation, to have us justly dealt with. The Reg[imen]t. do pray that they be assured their service will be fairly appreciated by paying them as American Soldiers, not as menial hirelings. Black men, you may well know, are poor; three dollars per month, for a year, will supply their needy wives and little ones with fuel. If you, as Chief Magistrate of the Nation, will assure us of our whole pay, we are content. Our Patriotism, our enthusiasm will have a new impetus, to exert our energy more and more to aid our Country. Not that our hearts ever flagged in devotion, spite the evident apathy displayed in our behalf, but we feel as though our country spurned us, now we are sworn to serve her. Please give this a moment's attention.

James Henry Gooding[28]

Financial support was also the topic of this letter from an enslaved wife in Missouri to her soldier husband.

Mexico, Mo. Dec 30th 1863

My Dear Husband, I have received your last kind letter a few days ago and was much pleased to hear from you once more. It seems like a long time since you left me. I have had nothing but trouble since you left. You recollect what I told you how they would do after you was gone. They abuse me because you went & say they

will not take care of our children & do nothing but quarrel with me all the time and beat me scandalously the day before yesterday—Oh I never thought you would give me so much trouble as I have got to bear now. You ought not to left me in the fix I am in & all these little helpless children to take care of. I was invited to a party to night but I could not go I am in too much trouble to want to go to parties. the children talk about you all the time. I wish you could get a furlough & come to see us once more. We want to see you worse than we ever did before. Remember all I told you about how they would do me after you left—for they do worse than they ever did & I do not know what will become of me & my poor little children. Oh I wish you had staid with me & not gone till I could go with you for I do nothing but grieve all the time about you. Write & tell me when you are coming.

Tell Isaac that his mother come & got his clothes, she was so sorry he went. You need not tell me to beg any more married men to go. I see too much trouble to try to get any more into trouble too—Write to me & do not forget me & my children—Farewell my dear husband from your wife.

Martha[29]

1864

BLACK MEN IN BATTLE

Black men from every state in the Union and Canada joined the war effort. Some came from slaveholding states such as Virginia and South Carolina when they heard that the US government had authorized black enlistment. Joining them were free men who were dedicated to ending slavery.

When federal troops of the Army of the James, commanded by General Benjamin F. Butler, attacked Petersburg, Virginia, on June 15, 1864, black soldiers played a prominent role. In the following letter, Charles Beman of New Haven, Connecticut, describes the action to his father.

> [From] Charles Torrey Beman, Private
> 5th Mas[sachusetts] Co[mpany] C
> 5th Massachusetts Cavalry
> Point-of-Rocks, Virginia

June 20, 1864

. . . Since I last wrote, almost half of the 5th Massachusetts Cavalry have been in several engagements, and about thirty have ben killed and wounded. The first notice I had of going into the engagement was about 1 o'clock, a.m., Wednesday, the 15th. We heard the bugle, and sprang to our arms, and, with two days rations, we started towards Petersburg, and when about four miles on our way toward that city, at a place called Beatty's house, we came in front of the rebels' works. Here we formed a line of

battle, and started for the rebs' works. I was with some thirty of my Company. We had to pass through the woods; but we kept on, while the shell, grape and canister came around us cruelly. Our Major and Col. [Henry F.] Russell were wounded, and several men fell—to advance seemed almost impossible; but we rallied, and after a terrible charge, amidst pieces of barbarous iron, solid shot and shell, we drove the desperate greybacks from their fortifications, and gave three cheers for our victory. But few white troops were with us. Parts of the 1st, 4th, 6th, and 22nd [US Colored Infantry] were engaged.

The colored troops here have received a great deal of praise. The sensations I had in the battle were, coolness and interest in the boys' fighting. They shouted, "Fort Pillow," and the rebs were shown no mercy.[1]

Men, free and bonded, left their wives and families to fight. To mark the occasion, they walked into photo studios carrying and wearing the items they were issued. Letters, diary entries, and contemporary accounts add meaning to the photographs by revealing how black men and women experienced the war.

The soldier Rufus Wright wrote the following two letters to his wife describing his concerns for his fellow soldiers, while reassuring her of his safety and requesting that she send well wishes to his loved ones and neighbors.

> Camp 1st, USCT
> Near Hampton [Virginia]

apl the 2[2] 1864

My Dear wife I thake this opportunity to inform you that I am well and Hoping when thoes few Lines Reaches you thay my find you Enjoying Good Health as it now fines me at Prisent. Give my Love to all my friend. I Recived you Last letter and was verry Glad to Hear fome you. you must Excuse you fore not Riting Before this times. the times I Recive you Letter I was order on a march and I had not times to Rite to you. I met witch a Bad mich-fochens. I Ben [S]ad of I Lost my money. I think I will com Down to See you this weeck. I thought you Hear that I was hear and you wood com to see me. Git a Pass and com to see me and if you cant git

Pass Let me know it. Give my Love to mother and Molley. Give my Love to all inquaring fried.

No more to Say, Still Remain you Husband untall Death

Rufus Wright

Derect you Letter to foresess Monre VA

wilson Creek Va May 25th 1864

dear wife I take the pleasant opportunity of writeing to you a fiew lines to inform you of the Late Battle we have had. we was a fight on Tuesday five hours. we whipp the rebls out. we Killed 200 & captured many Prisener, out of our Regiment we lost 13 Thirteen. Sergent Stephensen killed & priate out of Company H & about 8 or 10 wounded. we was in line Wednesday for a battele. But the rebels did not Appear. we expect an Attack every hour. give my love to all & to my sisters. give my love to Miss Emerline. tell John Skinner is well & sends much love to her. Joseph H Grinnel is well & he is as brave a lion. all the Boys sends there love them. give my love to Miss Missenger. You must excuse my short Letter. we are most getting ready to go on Picket. No more from your Husband,

Ruphus Wright[2]

Ann Valentine, an enslaved woman in Missouri, had to wait to find a scribe to write a letter to her husband, Andrew, an enlisted soldier, at his barracks in St. Louis, Missouri, requesting that he send money to support their child to buy clothes while cautioning him how to send it safely so that it was not stolen by the receiver. The charming postscript conveys that his wife yearned for a gift to share with their child.

January 19, 1864

My Dear Husband,

I r'ecd your letter dated Jan. 9th, also one dated Jan'y 1st but have got no one till now to write for me. You do not know how bad I am treated. They are treating me worse and worse every day. Our child cries for you. Send me some money as soon as you can for me and my child are almost naked. My cloth is yet in the loom and there is no telling when it will be out. Do not send any of your letters to Hogsett especially those having money in them as Hogsett

will keep the money. George Combs went to Hannibal soon after you did so I did not get that money from him. Do the best you can and do not fret too much for me for it wont be long before I will be free and then all we make will be ours.

Your affectionate wife,

Ann

P.S. Please send our little girl a string of beads in your next letter to remember you by. Ann[3]

Letters from soldiers also reflected on their parental responsibilities and concerns for their families. They were often heartbreaking, thoughtful, and angry; for example, the following letters from Spottswood Rice were unusual in expressing not only their love and concern for family members but also the anger expressed toward the addressee. Rice, a tobacco roller and a former slave, had enlisted in early February 1864 in Glasgow, Missouri. Hospitalized with chronic rheumatism a few months later, he wrote to his daughters, expressing his discontent for the slaveholder, Kitty Diggs, who was keeping them in slavery after emancipation.

[Benton Barracks Hospital,

St. Louis, Missouri, September 3, 1864]

My Children I take my pen in hand to write you a few line to let you know that I have not forgot you and that I want to see you as bad as ever now my Dear Children I want you to be contented with whatever may be your lots be assured that I will have you if it cost me my life on the 28th of the mounth. 8 hundred White and 8 hundred blacke solders expects to start up the rivore to Glasgow and above there that's to be jeneraled by a jeneral that will give me both of you when they Come I expect to be with, them and expect to get both you in return Don't be uneasy my children I expect to have you. If Diggs don't give you up this Government will and I feel confident that I will get you our Miss Kaitty said that I tried to steal you But I'll let her know that god never intended for man to steal his own flesh and blood. If I had no confidence in God I could have confidence in her But as it is If I ever had any confidence in her I have none now and never expect to have And I want her to remember if she meets me with ten thousand soldiers she [will?] meet her enemy I once [thought] that I had some respect for them but now my

respects is worn out and have no sympathy for Slaveholders. And as for her cristiantty I expect the Devil has Such in hell You tell her from me that She is frist Christian that I ever hard say that a man could Steal his own child especially out of human bondage

You can tell her that She can hold to you as long as she can I never would expect to ask her again to let you come to me because I know that the devil has got her hot set againsts that that is write now my Dear children I am going to close my letter to you Give my love to all enquiring friends tell them all that we are well and want to see them very much and Corra and Mary receive the greater part of it you sefves and don't think hard of us not sending you anything I you father have a plenty for you when I see you Spott & Noah sends their love to both of you Oh? My Dear children how I want to see you[4]

Then Rice wrote a fiery letter to his former owner, asking her to free his daughters Corra and Mary, but he only mentions the name of one in this letter.

> At Glasgow, Missouri
> I received a letter from Cariline telling me that you say I tried to steal to plunder my child away from you now I want you to understand that mary is my Child and she is a God given rite of my own and you may hold on to hear as long as you can but I want you to remember this one thing that the longer you keep my Child from me the longor you will have to burn in hell and the qwicer youll get their for we are now making up a bout one thoughsand blacke troops to Come up tharough and wont to come through Glasgow and when we come wo be to Copperhood rabbels and the Slaveholding rebels for we don't expect to leave them there root neor branch but we thinke how ever that we that have Children in the hands of you devels we will trie your [vertues?] the day that we enter Glasgow I want you to understand kittey digs that where ever you and I meets we are enmays to each orthere I offered once to pay you forty dollars for my own Child but I am glad now that you did not accept it. Just hold on now as long as you can and the worse it will be for you you never in you life befor I came down hear did you give Children any thing not eny thing whatever not even dollars worth of expencs now you call my children

your pro[per]ty not so with me my Children is my own and I ex-
pect to get them and when I get ready to come afer mary I will hae
bout a powrer and authority to bring hear away and to execute
vengences on them that holds my Child and you will then know
how to talke to me I will assure that and you will know how to
talk rite too. I want you now to just hold on to hear if you want to
iff your conchosence tells that's the road go that road and what it
will brig you to kittey digs I have no fears about getting mary out
of your hands this whole Government gives chear to me and you
cannot help your self.

Spottswood Rice[5]

Christian A. Fleetwood enlisted in Company G of the Fourth
Regiment, US Colored Infantry, Union army, in August 1863. Born
free in Baltimore in 1840, Fleetwood learned to read and write at
an early age. He was mentored by a wealthy family who encouraged
him to study business, and he visited Liberia and Sierra Leone as
a young man. Later he studied at the Ashmus Institute in Oxford,
Pennsylvania, where he studied the classics and business. He
founded a newspaper about the same time in 1863 that the Union
army began recruiting for black troops. He was appointed to the
rank of sergeant-major days after he arrived, as a result of his edu-
cational background and professional interests. Eventually, his regi-
ment was assigned to the Third Division and saw service with the
Tenth, Eighteenth, and Twenty-Fifth Army Corps in campaigns in
North Carolina and Virginia.

At Camp Belger in Carroll County, Maryland, Fleetwood was is-
sued a "forage cap, or kepi, bearing a brass bugle and, above it, the
numeral 4; one uniform coat of dark blue wool; one overcoat; one
pair of light blue woolen trousers; one pair of bootees, or brogans;
two pairs of drawers; two pairs of stockings; two shirts; one knap-
sack; one canteen; one haversack, a case for carrying rations; one
cartridge box; one cap pouch; and two blankets, one of wool, the
other rubber."[6] He later earned the Medal of Honor for his brave re-
sponse at the Battle of Chaffin's Farm, Virginia, where he held onto
the colors when other bearers were shot, and he became one of the
most decorated soldiers in the Civil War.

Fleetwood's diary includes the following entry about the Union
attack on Petersburg.

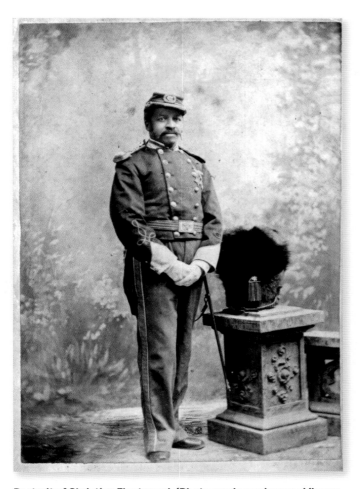

Portrait of Christian Fleetwood. (Photographer unknown; Library of Congress, Prints and Photographs Division, LC-USZ62-48685)

Wednesday, June 15, 1864

Up at break of dawn and under way our Division and White Troops of Gen Smith Went into action early charged Out of woods. Cut up badly Regt. broke and retreated Regt: Regiment Fired into by 5th Mass. Last Regt Charged with 22nd Took the Battery. Advanced. Upon works new & Lay under their fire all balance of thursday 16 the day advancing by degrees in line. About 7 P.M. Final charge made Seven guns taken by our Regt. Our loss pretty heavy. Slept Moved outside and slept till Morning. Moved to the rear and rested. Chaplain about. Brigade moved out in evening and lay in line an hour or so. Returned and turned in. Weather fine and warm[7]

Fleetwood's diary entry, June 15–22, 1864. (Christian A. Fleetwood Papers, Manuscript Division, Library of Congress, 147.00.00)

The Ohio census of 1860 noted that the state was home to seventy-one hundred black males between the ages of fifteen and forty. Yet federal enlistment records indicate that more than fifty-nine hundred men from Ohio joined the Union army. While some probably traveled to Ohio from Kentucky or Indiana, these numbers show how deeply African Americans wanted to contribute to the war as soldiers and how many made the ultimate sacrifice. During the war years, "on the Union side, 604,000 combatants were wounded, of whom 360,000 died; of the Confederacy, 480,000 soldiers were wounded and 244,00 died. For every combat casualty, two soldiers suffered from disease. Medical illness, especially infectious disease, resulted in more deaths during the war than combat."[8] Approximately thirty thousand black soldiers would die of various diseases, from smallpox to dysentery.

The unfortunate death of James Henry Gooding, who reported on the war, occurred in 1864 at Olustee, and the following letter was sent to the *Mercury* by Gooding's captain.

To [*Mercury*, published March 9, 1864]

Jacksonville, Fla., Feb. 25, 1864

Messrs. Editors:—I am pained to inform you that Corporal James H. Gooding was Killed in battle on the 20th inst. at Olustee Station. He was one of the Color Corporals and was with the colors at the time. So great was the rout of our troops That we left nearly all our dead and wounded on the field. The fight lasted four hours. We were badly beaten that night, and the next day we kept falling back, until we reached Jacksonville. The fifty-fourth did honor to themselves and our city. All concede that no regiment fought like it.

James H. Buchanan, of New Bedford, was killed; and Sergeant Wharton A. William, also of our city was wounded in the hand. Many other of Co. C were Wounded; but none of them from our city.

The regiment is pleased to learn that the bill to pay them $13 per month passed.

The total loss of the regiment, I am unable to give you at this time. All we want now is more troops; with them we would go forward again and drive the rebels from the State.

Your friend

James W. Grace
Captain Fifty-Fourth Regiment[9]

Soldiers' remarkable reports from the battlefield often stand in sharp contrast to newspaper accounts from the period. For example, the press blamed black soldiers for the Union defeat at the Battle of the Crater near Petersburg, Virginia, on July 30, 1864. In a letter published by the *Christian Recorder* on August 20, Garland H. White, a self-emancipated man who became a Methodist minister and chaplain of his Indiana regiment, angrily criticizes the newspaper reports, writing that the real problem was the generals. He describes the tragic battle as it was witnessed by the men themselves.

[From] Garland H. White—Chaplain
28th USCI
Near Petersburg, Virginia

August 8, 1864

I should remain perfectly silent, so far as the action of the 30th ult. is concerned, but for one reason, which, when presented, I hope the public will accept as being philosophic as well as patriotic.

It is said by a large number of cowards at home that the colored troops under General [Ambrose] Burnside who participated in the recent attack on Petersburg acted cowardly. This slanderous language I first saw in the *New York Herald* . . . a paper familiar with political corruption. It did not astonish me to find such calumny heaped upon an innocent and brave people, laboring under disadvantages unparalleled in the history of civilized warfare. These colored troops, who were from New York, Ohio, Indiana, Illinois, and several of the slave States, were led by as brave white men as the country affords. Our friends at home need not think that the failure to accomplish the design of that memorable event or day grew out of any neglect or incompetency upon the part of our regimental or company commanders, nor even the men themselves; for, as an eye-witness to the whole affair, I am compelled, from every consideration of justice to my profession, my God, my country, and my regiment to make some statement respecting the true nature of the case.

At a given hour all the officers of the colored troops were notified to have their men in readiness and at a certain place. This order was carried out to the crossing of a T. Afterward a charge was made, every officer heading his men, and the troops seemed as though they were going to a camp meeting or to a 1st of August dinner.[10] I was with the boys and intended to follow them to the last. Just at this juncture the earth began to shake, as though the hand of God intended a reversal of the laws of nature. This grand convulsion sent both soil and souls to inhabit the air for a while, and then return to be commingled forever with each other, as the word of God commands, "From dust thou art, and unto dust thou shalt return." By this time the colored troops had seen sufficient to convince them of the mighty struggle which would soon follow, and many began to make preparation accordingly, some by saying to me. "I want you, brother White, to write to my father and

mother," in New York, Philadelphia, Chicago, Boston, Cincinnati, Cleveland, and other places, "that George (Thomas, John, or Peter, as we call each other out here) died like a man; and when pay-day comes, if it ever does come, send what money is due to my wife, and tell her to raise Sally and Mary in the fear of the Lord."

The Colonel gave the order: "Fix bayonets; charge bayonets!" The last words to me were, "Brother White, good-bye. Take care of yourself for today someone must die, and, if it be me, I hope our people will get the benefit of it."

I must be plain in my remarks, though should offend somebody. The First Division of Colored Troops, who led the charge, were those who were principally raised in the Slave States. They did not stand up to the work like those from the Free States; for when the Second Division of Colored Troops went into the action, they charged over the first and carried two line of rifle pits. They made no stop there; for our gallant Colonel (Charles S. Russell, of Indiana) who led the gallant Twenty-Eighth, told the boys that he intended leading them to Petersburg that day. Colonel [John A.] Bross, who led the Twenty-Ninth, or the Illinois Colored Regiment, told his boys the same thing.

Now, I would have the people at home, both white and colored, to understand that the victory of that day was as certainly ours as anything could be. I call upon all candid hearted men, who stood and saw the affair from beginning to end, to corroborate what I say in making this statement. When I saw our colors waving over the enemy's works, I, with a number of others, said: "Boys, the day is ours, and Petersburg is sure."

For several rods the dead lay thick, both white and colored, Union and rebel. It was a sad sight. Recollect, the colored troops went as far as they were ordered to go, and did just what they were told to do, both in going in and remaining there; and in coming out, the brave officers who led them in, when they saw that bad management had taken place somewhere, and thinking that remaining longer would endanger that portion of the army, through wisdom and good policy, ordered the retreat.

This statement is the truth, to which I am willing to take my solemn oath. Leave no ground for a set of cowards at home like Bennett[11] and other foul-hearted buzzards, to attribute the loss that day to the arms of the colored troops. None of the troops, white or colored, are responsible for the actions of the Generals.

Let every man answer before the tribunals of his country for himself—Generals as well as privates—for he has grown too . . . to be responsible for his conduct in common with all men.

I hold that there can be no higher sin in all the world than to blame innocent people for consequences for which they are not responsible. I care not who it is, whether king or subject, General or private, it makes no difference with me in a point of exposition of truth.[12]

Another religious leader, the Reverend James H. Payne, left his home in Kentucky to join an Ohio regiment that was headed for Petersburg. In his letter to the *Christian Recorder*, which—like White's—was published on August 20, he provides graphic details of the disastrous Battle of the Crater.

[From] James H. Payne
Quartermaster Sergeant
27th USCI
Near Petersburg, Virginia

August 12, 1864
. . . I will now give you a brief and concise account of the battle of the 30th of July, in which I called the members of our regiment together, and delivered an exhortation and held a prayer meeting. Indeed, it was a solemn and interesting time among us. Many professors [of religion] appeared to be greatly stirred up, while sinners seemed to be deeply touched and aroused to a sense of their danger and duty. Our prayer meeting was short but not without good and lasting impressions being made upon the hearts and minds of many. About 12 o'clock that same night, orders came to march. Our brave boys, as on all such occasions, were soon ready to move off. The direction soon proved to them that they were going to contest the strength of the enemy; it was the first time too. Did they flinch or hang back? No; they went forward with undaunted bravery! About 4 o'clock, on Saturday morning, the 30th, one of the enemy's forts in which the garrison were reposing in pleasant slumber, dreaming of no danger, nor apprehending any, was blown up destroying nearly all who were in it at the same time. At this moment, the Union line for a mile opened upon the enemy with their batteries, and the most terrific cannonading continued until 10 o'clock A.M. But about 9 o'clock our brave boys, the colored troops belonging

to the Fourth Division, Ninth Army Corps, made one of the most daring charges ever made since the commencement of the rebellion. The First Brigade, consisting of four regiments, namely, the Forty-third [US Colored Infantry] Pennsylvania, Twenty-seventh [US Colored Infantry] Ohio, and the Thirtieth and Thirty-ninth [US Colored Infantry] Maryland, led in the charge. The first two named regiments drove the enemy from their breastworks, and took possession of the blown up fort; but while they did, all the white soldiers lay in their pits and did nothing to support our men in the struggle; they lay as if there was nothing for them to do for one hour after the explosion took place. The rebels deserted all their forts fearing that some more of their works were about to be blown up.

How easily Petersburg could have been taken on the 30th of July, had the white soldiers and their commanders done their duty! But prejudice against colored troops prevented them. Instead of a general effort being made, as was contemplated, only a few men were taken in to be slaughtered and taken prisoner, which is the equivalent to death, for no mercy is shown to them when captured, although some still please that the rebels are treating the colored prisoners very well; but before I can be convinced that this is so, I wish to hear one of the prisoners tell the story.

After our men had driven the enemy and taken possession of a portion of their works, I cannot conceive of a plausible reason why it was that reinforcements were not sent to them. This neglect was the cause of their being repulsed with such heav[y] loss. I can only conclude that our men fell unnecessarily in the battle of the 30th. In their retreat, they received the cross-fire of the enemy, and no small number were killed by our own artillery.

Such was the terrible fate of the day. Time will tell who was in the fault, and who made the great blunder in the battle of the 30th of July.

Among the captured was my brother-in-law, William Johnson of Upper Sandusky, Ohio, where my family now reside; but I can only give him up into the hand of God, who knows just how to deal with his case. If he is murdered by the rebels all is right, his blood will speak for the cause in which he fell.[13]

The wartime photographic experience—making portraits of soldiers in uniform in front of backdrops that illustrated

battlegrounds—was designed to engage people in ideas about citizenship and self-representation. To the soldiers, the very act of sitting for portraits represented freedom. The photographers' understanding of battle is revealed by their use of painted studio backdrops: idealized battlefields that created a specific narrative of bravery. Both the soldiers and the photographers were invested in how their images were made, used, displayed, and distributed. Some photographers saw black people's interest as their own, and this was reflected in their images and image making. They were aided by the transformations that had taken place during the first twenty-five years of photography, including ongoing changes to the medium—from cased images to paper prints to photographic albums to mass distribution.

Through word and image, the experience of war was reimagined, as were their aspirations. Some of the soldiers were medical men, and their correspondence and photographs show how they viewed themselves and their profession, as well as showing their determined will and strength of character. Others were nurses such as Ann Bradford Stokes, who was listed as a contraband on the USS *Red Rover*, the first Union naval hospital ship in 1863, and who was the first black woman to work as a nurse on a US vessel, working with the Sisters of the Holy Cross.[14]

John H. Rapier Jr. was born free in Alabama in 1835, studied in Ohio and Michigan, and received his medical education at Keokuk Medical College (later Iowa State University), where he received his MD in June 1864. He signed up to assist the US government during the Civil War. He had a wide range of interests, at one point writing articles about cotton planting in Jamaica and the study of tooth manipulation in Canada. He was stationed at Freedmen's Hospital, Washington, DC, as acting assistant surgeon with the rank of first lieutenant.[15]

[From John H. Rapier Jr.]
James P. Thomas, Esq.
St. Louis, Missouri

August 19, 1864
Dear Uncle,
Your letter of the 13th is before me. I had come to conclusion to "damn" you if I might use the expression.

I am always glad to hear from you and our St. Louis friends, but I am a little afraid I will be considered as a very poor correspondent

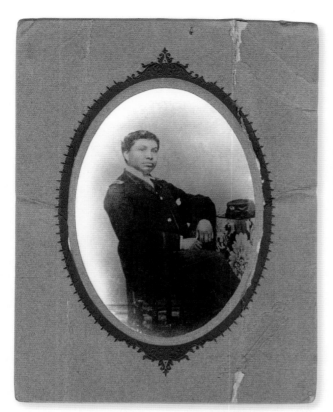

William P. Powell Jr. was one of the first African American physicians to receive a contract as a surgeon with the Union army. (Records of the Department of Veterans Affairs, RG 15, National Archives)

CHARLES BURLEIGH PURVIS.

Portrait of Charles Burleigh Purvis, MD, ca. 1900. (Courtesy National Library of Medicine)

Portrait of John H. Rapier Jr., MD, ca. 1864. (Courtesy Anne Straith Jamieson Fonds, Western University Archives and Special Collections)

Freedman's Capital. Washington D.C. Aug't 19" 64

James P. Thomas Esq'}
St Louis Missouri }

Dear Uncle

Your letter of the 13th
is before me. I had come to conclusion to "damn" you
if I might use the expression —

I am always glad to hear
from you and our St Louis friends, but I am a little
afraid I will be considered as a very poor corres-
-pondent after awhile, on account of the few letters
I write — Indeed. Uncle James I never worked
so hard, and had so little rest, and felt so tired
at night as I do now —

Of my success and failures, for I have
both, it does not become me to speak, for
your satisfaction and of those others who kindly
feel an interest in me, and my welfare, I may
venture to say that my mortality list so far
stands approved by the Med — Director of the
Department to whom I make daily, weekly monthly
and quarterly Reports —

There are many ladies here from
the East, blessed Old Massachusetts always in the lead
in good works engaged in teaching and general
supervision of the interest of the freedmen in this City

First page of a letter from Dr. John H. Rapier Jr. to his uncle James P. Thomas, Esq.,
St. Louis, Missouri, from Freedmen's Hospital, Washington, DC, August 19, 1864.
(Courtesy Moorland-Spingarn Research Center, Howard University)

after awhile, on account of the few letters I write. Indeed Uncle James I never worked so hard, and had so little rest, and felt so tired at night as I do now.

Of my success and failures, for I have both, it does not become me to speak, for your satisfaction and of those others who kindly feel an interest in me and my welfare I may venture to say that my mentality . . . so far stands approved by the Med. Director of the Department to whom I make daily, weekly, month and quarterly reports.

There are many ladies here from the East, blessed old Massachusetts always in the lead of good works engaged in teaching and general supervision of the interest of the Freemen in this City.

They are a class the most indefatigable and earnest laborers I have eve[r] seen engaged in any cause—wind, rain and storm never stop them—night and day these Angels of Mercy may be found engaged in the miserable filthy hovels of these poor people doing the most servile and menial duties.

Foremost and bravest of these is a Miss Harritte Carter of Mass. Do not imagine Miss Carter to be an old and homely "one" who has [signed?] for some one to love many years in vain, and has when up this occupation, perhaps as a penance for youthful in-discretion is saying "no" when somebody thought she ou[gh]t to have said "yes." By no means—Miss Carter is 24 with rose cheeks, pretty eyes and a . . . of the sof[t]est brown hair you ever felt, and as full of learning as an Episcopal Minister or a Catholic Priest and would make even Henry Green laugh at her humor and wit.

She is never seen with a sober face. And in making my daily rounds, I always encounter her, and have a half [hour?] Pleasant chat before I assume the duties of the day. I have but little time to visit and therefore have but few acquaintances, and these poorly cultivated. I am socially speaking a "stick" and have but little plea-sure as you know in making new friends. I much rather presume upon those I know.

In our Hospital some changes have taken place. Surg. Horner (white) supercedes [sic] Surg. Powell (colo). The change was for the good of the services and I believe complexion had nothing to do with it. Surg. Horner is a skillful and well educated Surg, and polite agreeable gentlemen. Dr. Powell is retained as Asst.

They are as a class the most indefatigable and earnest labourers I have ever seen engaged in any cause — Wind, Rain and Storm never stop them. Night and day these Angels of Mercy may be found engaged in the miserable filthy hovels of these poor people doing the most servile and menial duties.

Foremost and bravest of these is a Miss Harriette Carter of Mass — Do not imagine Miss Carter to be an old Maid and homely "one" who has sighed for some one to love for many years in vain, and has taken up this occupation, perhaps as a penance for youthful indiscretion in saying "No" when somebody thought She ought to have said "Yes" — By no means — Miss Carter is 24 with a rosy cheeks, pretty eyes and and wilderness of the softest brown hair you ever felt, and as full of learning as an Episcopal Minister or a Catholic Priest and would make even Henry Green laugh at her humour and wit.

She is never seen with a sober face — And in making my daily rounds I always encounter her, and have a half hour's pleasant Chat before I resume the duties of the day.

I have but little time to visit and therefore have but few acquaintance, and these poorly cultivated — I am socially speaking a "stick" and take but little pleasure as You know in making new friends, I much rather presume upon those I know —

In our Hospital some changes have taken

Second page of a letter from Dr. John H. Rapier Jr. to his uncle James P. Thomas, Esq., St. Louis, Missouri, from Freedmen's Hospital, Washington, DC, August 19, 1864. (Courtesy Moorland-Spingarn Research Center, Howard University)

I have thought of resigning in Oct. for the purpose of attending lectures in the University of Harvard in Boston and trying for a Surgeon's Post in the spring.

Perhaps I may, perhaps I may not give up this idea—I am undecided.

On the 14th the most eventful event of my life occurred—I drew $100, less war tax $2.50, for Medical Services rendered [to] the US Government. My draft was in favour of "Acting Asst. Surgeon Rank 1st Lieut. USA." I read the address several times—I liked it tho' I confess it read strange to me.

In the spring I want my drafts payable to Maj. John H. Rapier Surg. USA.

I do not like the US Service. However half loaf is better than no loaf. It is better to have a blue coat than no military coat. I would rather have the Mexican Green or English Purple.

But I must tell you coloured men in the US Uniform are much respected here, and in visiting the various Departments if the dress is that of an Officer, you receive the military salute from the ground as promptly as if your blood was a Howard or Plantagenet instead of a Pompey or Cuffee's.

I had decided not to wear the uniform but I altered my mind—and I shall appear hereafter in the full dress gold lace, pointed hat, straps and all. Mr. Fred Douglass spoke here last night to an immense audience and today the President sent for him to visit him in the Capitol. Did you ever hear such nonsense. The President of the US sending for a "nigger" to confer with him on the State of the country.

I have been invited to take supper with Mr. Douglass to night. I am proud of it. He visited the Hospital to day. He is a fine looking gentleman. He made a fine impression on the public.

I exceedingly regret to hear of Miss Virginia's ill health and hope she may be well soon. I shall write to Miss Pauline in a few days to whom make my apologies for not writing earlier. I have an opening here for Lady Teacher. It may be $50 or $30 per month. If I had the money I would send for Sarah—I believe she could get $50.

If you go to New York come by Washington if you can. I am sorry I have not money in my pocket to offer you a big time. But wait until September 30th and I will be on the "clean thing" by you.

place — Surg Horner (white) supercedes Surg Powell (Cold)

The change was for the good of the Service and I believe complexion had nothing to do with it — Surg. Horner is a skillfull and well educated Surg, and polite agreeable gentleman —

Dr Powell is retained as Asst.

I have thought of resigning in Oct for the purpose of attending Lectures in the University of Harvard in Boston and trying for a Surgeon's Post in the spring —

Perhaps I may, perhaps I may not give up this idea — I am undecided —

On the 14th the most eventful event of my life occurred — I drew $100 less war tax $2.50 — for Medical Services rendered the U.S. Government. My draft was in favour of "Acting Asst Surgeon Rank 1st Lieut U.S.A." I read the address several times — I liked it — Tho' I confess it read strange to me —

In the spring I want my drafts payable to Maj John H. Rapier Surg U.S.a.

I do not like the U.S. service — However half loaf is better than no loaf — It is better to have a blue coat, than no military coat — I would rather have the Mexican Green or English Purple —

But I must tell you Coloured men in the U.S. Uniform are much respected here, and in visiting the various Departments if the dress is that of an Officer, you receive the Military Salute from the guard as promptly as if your blood was a Howard or Plantagenet instead of Pompey or Cuffee's

Third page of a letter from Dr. John H. Rapier Jr. to his uncle James P. Thomas, Esq., St. Louis, Missouri, from Freedmen's Hospital, Washington, DC, August 19, 1864. (Courtesy Moorland-Spingarn Research Center, Howard University)

I had decided not to wear the uniform
but I have altered my mind — And I shall
appear hereafter in full dress gold lace, pointed
hat Straps and all — Mr Fred Douglass spoke
here last night to an immense audience — and to
day the Presd. sent for him to visit him in the
Capitol — Did you ever hear such nonsense. The
President of the U.S. sending for a "Nigger" to confer
with him on the state of Country —
I have been invited to take supper with Mr
Douglass to night — I am proud of it — He visited
the Hospital to day — He is a fine looking gentle
-man. He made a fine impression on the public
I exceedingly regret to hear of Miss Virginia's ill health
and hope she may be well soon — I shall write to Miss Pauline
in a few days to whom make my apologies for not writing
sooner — I have an opening here for Lady Teacher —
Pay depends on her qualifications. It may be $50 or
$30 per Month — If I had the money I would send for
Sarah — I believe she could get $50 —
If you go to New York come by washington If you
can — I am sorry I have not money in my pocket
to offer you a big time — But wait until September
30th And I will do the 'clean thing' by you —
In all washington there is not an a Number
one place for a Cold Gentleman to stop —
But I will 'fix' you up — if you give 'due and
timely' notice — Write to me — Direct my letters
John H Rapier M.D. Actg Asst Surg. U.S.A.
Tell Mrs Baily I have written to her —
Remember me to Mr Clamorgan and the Johnsons
Mrs Pritchard & Mr Pritchard write soon
I am as usual Yours John Jr

Fourth page of a letter from Dr. John H. Rapier Jr. to his uncle James P. Thomas, Esq.,
St. Louis, Missouri, from Freedmen's Hospital, Washington, DC, August 19, 1864.
(Courtesy Moorland-Spingarn Research Center, Howard University)

In all Washington there is not a number one place for a Col. Gentlemen to stop. But I will "fix" you up—if you give me "due and timely" notice. Write to me. Direct my letters John H. Rapier, M.D., Actg. Asst. Surg. USA. Tell Mrs. Bailey I have written to her. Remember me to Mr. Clamorgan and the Johnsons, Mrs. Pritchard and Mr. Pritchard. Write soon.

I am as usual yours.

 John Jr.[16]

Anderson Ruffin Abbott was a Canadian and had worked with Dr. Alexander Augusta in Canada. He was appointed an acting assistant surgeon in 1863, prior to obtaining his degree, and worked at the Contraband Hospital in Washington, DC, during the war. He returned to Ontario, Canada, where, to supplement his medical license, he received a medical degree from the Toronto College of Medicine in 1867. Abbott practiced in Ontario until his death in 1913.

John Van Surly DeGrasse was an 1849 graduate of Maine Medical College, affiliated with Bowdoin College. He served as an assistant surgeon (lieutenant) in the Thirty-Fifth US Colored Infantry, returning to Massachusetts to practice after the war. He was the only black physician to serve in the field with his regiment. He died in Massachusetts in 1868 at the age of forty-two or forty-three.

A black soldier named G. H. Freeman, originally from Maryland, wrote to a grieving mother to explain the impact her son's death had on the rest of his regiment.

Portrait of Anderson R. Abbott, MD. (Courtesy Oblate Sisters of Providence Archives)

> [From G. H. Freeman]
> Near Petersburg [Virginia]

August 19th 1864

Dear Madam I receave A letter from You A few day Ago inquir in regard to the Fait of Your Son I am sarry to have to inform You that thear is no dobt of his Death he Died A Brave Death in Trying to Save the Colors of Rige[ment] in that Dreadful Battil Billys Death was unevesally [mourned] by all but by non greatter then by my self ever sins we have bin in the Army we have bin amoung the moust intimoat Friend wen every our Rige[ment] wen into Camp he sertan to be at my Tent and meney happy moment we seen to gether Talking about Home and the Probability of our Living to get Home to See each other Family and Friend But

Providence has will other wise and You must Bow to His will You and His Wife Sister and all Have my deepust Simppathy and trust will be well all in this Trying moment

You Inquired about Mr Young He wen to the Hospetol and I can not give You eney other information in regard to Him

Billys thing that You requested to inquired about I can git no informa of as in the bustil [bustle] of the Battil every thing was Lost

Give my Respects to Samual Jackson and Family not forgeting Your self and Family I remain Your Friend

G. H. Freeman[17]

Frequently, the letters came from mothers seeking information about their sons. Jane Welcome, the mother of a black soldier from Pennsylvania, wrote to President Lincoln, pleading for him to release her son from military service. The letter is in the collection of the National Archives, accompanied by the reply from C. W. Foster of the Bureau of Colored Troops: "the interests of the service will not permit that your request be granted."

Carlisles [Pennsylvania]

Nov 21 1864

Mr abarham lincon I wont to knw sir if you please wether I can have my son relest from the arme he is all the subport I have now his father is Dead and his brother that wase all the help that I had he has bean wonded twise he has not had nothing to send me yet now I am old and my head is blossaming for the grave and if you dou I hope the lord will bless you and me if you please answer as soon as you can if you please tha say that you will simpethise withe the poor thear wase awhite jentel man told me to write to you Mrs jane Welcom if you please answer it to he be long to the eight rigmat co a u st colard troops mart welcom is his name he is a sarjent

[Jane Welcome][18]

Black and white women did more than wait at home for their loved ones (hopefully) to return; they played a crucial role in the war. Mothers, wives, girlfriends, and sisters nursed, mended clothing, cooked, fought, and taught literacy classes to soldiers and children. In addition, historians and enthusiasts continue to uncover evidence that black women served in the Union army as nurses and

soldiers. Take, for example, the rarely discussed story of Cathay Williams, a cook and washerwoman who dressed as a man and used the name William Cathay.[19] She is the only black woman identified as serving as a soldier in the Union army, joining the Eighth Indiana Volunteer Infantry Regiment as early as 1861 at age seventeen. In a January 2, 1876, interview for the *St. Louis Daily Times*, she recalled,

My Father was a freeman, but my mother a slave, belonging to William Johnson, a wealthy farmer who lived at the time I was born near Independence, Jackson county, Missouri. While I was a small girl my master and family moved to Jefferson City. My master died there and when the war broke out and the United States soldiers came to Jefferson City they took me and other colored folks with them to Little Rock. Col. Benton of the 13th army corps was the officer that carried us off. I did not want to go. He wanted me to cook for the officers, but I had always been a house girl and did not know how to cook. I learned to cook after going to Little Rock and was with the army at The Battle of Pea Ridge. Afterwards the command moved over various portions of Arkansas and Louisiana. I saw the soldiers burn lots of cotton and was at Shreveport when the rebel gunboats were captured and burned on Red River. We afterwards went to New Orleans, then by way of the Gulf to Savannah Georgia, then to Macon and other places in the South. Finally I was sent to Washington City and at the time Gen. Sheridan made his raids in the Shenandoah valley I was cook and washwoman for his staff I was sent from Virginia to some place in Iowa and afterwards to Jefferson Barracks, where I remained some time. You will see by this paper that on the 15th day of November 1866 I enlisted in the United States army at St. Louis, in the Thirty-eighth United States Infantry Company A, Capt. Charles E. Clarke commanding. . . .

The regiment I joined wore the Zouave[20] uniform and only two persons, a cousin and a particular friend, members of the regiment, knew that I was a woman. They never "blowed" on me. They were partly the cause of my joining the army. Another reason was I wanted to make my own living and not be dependent on relations or friends. Soon after I joined the army, I was taken with the smallpox and was sick at a hospital across the river from St. Louis, but as soon as I got well I joined my company in New Mexico. . . . The

men all wanted to get rid o f me after they found out I was a woman. Some of them acted real bad to me.[21]

As mentioned earlier, free blacks, contraband, and other civilians often accompanied army regiments as servants, wagon drivers, sutlers,[22] or cooks in both white and black regiments. In an earlier letter to the *Christian Recorder*, Sergeant James H. Payne of Lima, Ohio, had described the Battle of the Crater. In the following letter, published in the *Christian Recorder* on January 7, 1865, Payne describes Sister Penny, a nurse who traveled with the Fifth US Colored Infantry.

> [From] James H. Payne,
> Quartermaster Sergeant
> 27th USCI
> Near Richmond, Virginia

December 21, 1864

Permit me the privilege, through your worthy columns, to give your readers a brief historical introduction to our very worthy and eminent sister and mother in the army, Sister Lydia Penny.

Sister Penny was born a slave in Blount County, East Tennessee, in the year of our Lord 1814. At the time of the Indian War, when General [Winfield] Scott and General Wood [John E. Wool?] drove the Indians from their habitations in Tennessee,[23] Sister Penny served two years as a cook. She was, at the time, only a girl; but she informed me that she subsequently became the mother of a family of children whose companionship she had long been deprived of through slavery, and that she was left a widow to suffer torments of cruel oppression.

She was finally sold to a Dutch butcher in Memphis, Tennessee. By this time she had learned to trust in God, who had promised to deliver the oppressed and open the prison doors to them that are bound. She said that she had a falling-out with her Dutch mistress about something, and that she gave her master and mistress both to understand distinctly that she intended to run away from them, which threat she carried into effect about one week after it was made, by which time they thought that she had become contented to remain with them.

Sister Penny says that she kept herself concealed among her friends in Memphis until the Union army had extended its lines near the city, when she made her way within its lines, and again, engaged herself as cook. Here, she said, being a lonely widow, and having no one in particular to befriend or protect her, prudence dictated the propriety of making selection of a companion, which she did, as soon as she found one who she thought would treat her as a wife and act the part of a faithful husband by her.

While in the army she formed the acquaintance with Mr. Penny, a native of Pennsylvania, who had enlisted as a servant in the three months' service. They finally came to the city of Cincinnati, Ohio, where Thomas Penny, her husband, re-enlisted in the service, and joined the Fifth United States Colored Troops, at Camp Delaware, Ohio. Sister Penny said that she felt it to be her duty to go along with her husband, not merely on account of the love she had for him, but also for the love which she had for her country—that the cause which nerved the soldiers to pour out their life-blood was her cause, and that of her race, and that she felt it to be her Christian duty to do all she could for the liberty of her afflicted and down-trodden race.

This good woman is called by those who are acquainted with her, "the mother of the army." She well deserves the name, for she has been in the service ever since this rebellion broke out, or very nearly as long.

Sister Penny says that she is not tired of the service, nor does she think of leaving the field until the last gun is fired and peace is declared, and every slave is freed from captivity. Many of our officers and men who were wounded at the battle of Deep Bottom [July 27, 1864] will never forget the kind deeds of Sister Lydia Penny, who went among them and administered to their wants as they lay weltering in their blood on the banks of the James, near Jones' Landing. There she could be seen, the only woman present, like an angel from above, giving words of cheer, and doing all in her power to relieve the suffering of the wounded and dying.

Yes, while others stood aloof, thinking themselves too good even to go near enough to give them a drink of water to quench their burning thirst, Sister Penny was seen, like a ministering

angel, or one of those holy women who in primitive days administered to Christ and His apostles. She gave them water to drink and bread to eat, and assisted the surgeons in dressing their wounds.

When the wounded were placed on the boats to be taken to hospitals at Fortress Monroe, she left her tent and all behind and went on board the boats to minister to their comfort. When they were delivered in to the hands of careful nurses, Sister Penny returned to her tent, where she ever waits to administer to the wants of the afflicted soldier.

Her husband seems to be much of a gentleman. I hope that all Christians who shall be permitted to read this short statement of Sister Penny's life and character will pray for her; and I can assure them; they will pray for a worthy woman.[24]

In diaries, journals, and letters, soldiers lamented about the harsh work and the unequal pay. According to Richard Reid, "a letter to the *Christian Recorder* written in April 1864 by an enlisted man in the Fifty-fifth Massachusetts captured the sentiment of most. Why would Congress not pay black soldiers equal wages? The writer explained: 'I rather think that it is the color and quality and citizenship of the United States that is the reason they want us to take ten dollars per month, and three deducted for clothing. No, never will I take it. You may sever my head from my body first.'"[25]

Many black soldiers served the Union army as servants and laborers, while others fought on battlefields; their commitment and courage can be seen in the visual record. While a few soldiers were displeased with their menial roles, most black men were portrayed as hypermasculine in the photographs. For example, Milton M. Holland, who fought with the Fifth US Colored Infantry, was characterized as "brave, aggressive, fearless, uncompromising" when he fought at Petersburg and Richmond.[26] The evidence that black soldiers were committed to receiving full citizenship can be found in their own words. Holland was a free man when he enlisted on April 19, 1861, at the start of the Civil War, and he recruited a company of men to join him. Three years later, he wrote a letter to the *Messenger*, a newspaper in Athens, Ohio; the paper had been taken over by Colonel Nelson H. Van Voorhees, Holland's commanding officer in the Third Ohio Volunteer Infantry Regiment.

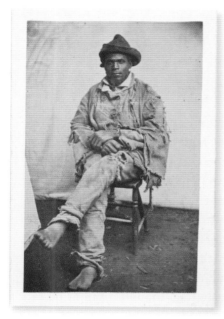

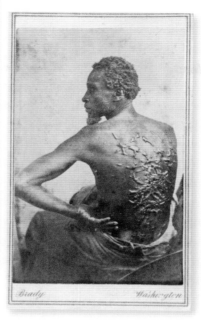

Private Gordon, also known as "Whipped Peter," showing his scarred back, Baton Rouge, Louisiana. ("The Scourged Back"; photograph by Mathew Brady, after William D. McPherson and Mr. Oliver, 1863; Charles L. Blockson Afro-American Collection, Temple University)

Portrait of Gordon as he entered camp. (Courtesy of John Stauffer)

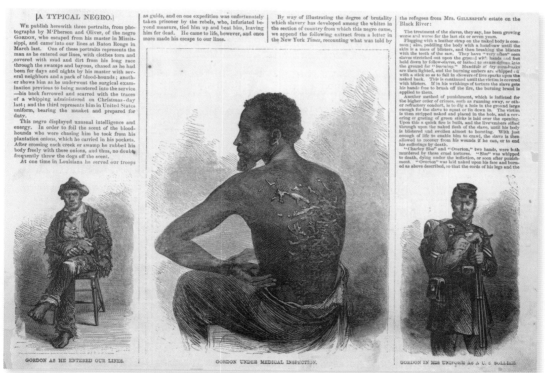

Gordon as he entered Union lines, under medical inspection, and in his uniform as a US soldier; photograph and illustration in *Harper's Weekly*, July 4, 1863. (Retrieved from the Library of Congress, LC-USZ62-98515)

[From Milton M. Holland]
Norfolk, Va.

Jan. 19, 1864

Dear Messenger:

You will be reminded of the company of colored soldiers raised by myself in the county of Athens, and taken to Camp Delaware, 25 miles north of Columbus, on the Olentangy. It has since been mustered into the service in the 5th Regt. US Colored Troops. The regiment is organized, and has been in active service for three months. Our company is C—the color company—in which you may remember of the flag presentation, made by the kind citizens of Athens, through Mr. Moore, at which Mr. [John Mercer] Langston was present and received it, pledging in behalf of the company, that they would ever be true to the flag, though it might be tattered or torn by hard service, it should never be disgraced. I am happy to say that those colors have been used as the regimental colors for several months, and we had the honor of forming the first line of battle under their floating stars. We now have new regimental colors, and the old ones are laid away in my cabin, and I am sitting now beneath them writing.

The regiment, though young, has been in one engagement. The men stood nobly and faced the cowardly foe when they were hid in the swamp firing upon them. They stood like men, and when ordered to charge, went in with a yell, and came out victorious, losing four killed and several wounded. The rebel loss is large, as compared with ours. As for company C she played her part admirably in the charge. Our 4th sergeant, Charles G. Stark, is said to have killed the picket guard while in the act of running away.

I must say of the 5th, that after twenty days of hard scouting, without overcoats or blankets, they returned home to camp, which the soldiers term their home, making twenty-five and thirty miles per day. Several of the white cavalry told me that no soldiers have ever done as hard marching through swamps and marshes as cheerfully as we did, and that if they had to follow us for any length of time it would kill their horses. During that raid, thousands of slaves belonging to rebel masters were liberated. You are aware that the colored man makes no distinction in regard to persons, so I may say all belonging to slaveholders were liberated. We hung one guerilla dead, by the neck, by order of Brig. Gen. E[dward] A. Wild,

a noble and brave man, commanding colored troops—the right man in the right place. He has but one arm, having lost his left one at the battle of Antietam, but with his revolver in hand, he was at the head of our regiment cheering us on to victory.

One of the boys belong[ing] to Co[mpany] D was captured and hung. He was found by our cavalry pickets yesterday and is to be buried today. We hold one of their "fair daughters," as they term them, for the good behavior of her husband, who is a guerilla officer, toward our beloved soldiers. The soldier was found with a note pinned to his flesh. Before this war ends we will pin their sentences to them with Uncle Sam's leaden pills.

The boys are generally well, and satisfied that though they are deprived of all the comforts of home, and laboring under great disadvantages as regards pay and having families to support upon less wages than white soldiers, still trust that when they do return they will be crowned with honors, and a happier home prepared for them, when they will be free from the abuses of northern and southern fire-eaters. Though we should fall struggling in our blood for right and justice, for the freedom of our brothers in bondage, or fall in defense of our national color, the Stars and Stripes, our home and fireside will ever be protected by our old friend Gov. [David] Tod, by the loyalty of Abraham Lincoln, our Moses, and the all-wise God that created us. Friends at home be cheerful, cast aside all mercenary compensation. Spring forth to the call and show to the world that you are men. You have thus far shown, and still continue to show yourselves worthy of freedom, and you will win the respect of the whole nation. There is a brighter day coming for the colored man, and he must sacrifice home comforts if necessary to speed the coming of that glorious day. I will close my letter in the language of the immortal [Patrick] Henry—"Give me liberty, or give me death!"
Yours truly,

Milton M. Holland
O[rderly] S[ergeant], Co[mpany] C, 5th USCT.[27]

The Union army's attack on Petersburg made heroes of the black soldiers. In the following letter, Sergeant Holland (who later received a Congressional Medal of Honor) recalls his experiences during the charge and criticizes the US generals for their timid leadership.

[From Milton M. Holland]
Co[mpany] C, 5th USCI
Near Petersburg, Virginia

July 24, 1864

. . . We have been successful in achieving the object we aimed at. We have also undergone severe marches to Bottom Bridge, within twelve miles of the Confederate Capitol. On some of those marches it rained incessantly, making it very fatiguing. I have also seen men sleep while marching. If I should say that I have been guilty of the same art myself it would not be less than the truth. It seemed like imposing on green troops, but the boys bore it admirably with great patience and endurance. Near the latter part of April, we were ordered to Fort Monroe to organize into the 3rd division of the 18th Army Corps, commanded by Brigadier Gen. [Edward Ward] Hinks. While at Fort Monroe [the men in the regiment] were reviewed by Maj. Gen. [Benjamin F.] Butler, and was classed among the best grade of white troops. All passed off very nicely until about the 4th day of May, when an order came to break camp, and be ready at moments' warning [to be moved] by transports, which we quietly did in good order, as all good soldiers do. We were then awaiting the orders of the Adjutant to fall in. The Adjutant with a loud voice sang out, "Fall in Fifth"; the companies were formed and moved out on the parade ground and were formed in line of battle under supervision of the Adjutant. We moved off by the right flank to the transports and embarked, shoved in the bay a short distance from the fort, and cast anchor for the night to wait for the fleet to gather. About daybreak on the following morning all was ready, and we set sail for the James River, the fleet of gunboats taking the advance. Immediately in rear were the boats of General Butler and Hinks followed by the Fifth USCT. Many things attracted our attention along the banks of the James, too numerous to mention. One I might mention particularly was the ruins of Jamestown, the spot where the curse of slavery was first introduced into the United States. A serpent that has inserted its poisonous fangs into the body of this government, causing it to wither in its bloom. Slowly we worked our way up the winding James, until within sight of the City Point celebrated for being the Department where the exchange of Prisoners was made. As we neared the shore at that point, Co[mpany] C was ordered to

take the advance as soon as we landed. Up the hill we marched to where the rebel flag was stationed. Down with it cried the boys, and in a moment more the flag of the glorious free could be seen floating in the breeze. The company banner was the first company flag that waved over the rebel city. Forty prisoners were captured at this place by the provost guard of the division. One platoon of our company was deployed as skirmishers and followed a sort distance the retreating foe that escaped.

On the following day we began throwing up fortifications around the city. In less than sixteen days we had completed the works and was ready for some new adventure. The regiment then moved to Point of Rocks, and on the 9th of June a detachment of the 1st, 5th, 6th [US Colored Troops] under Gen. [Quincy A.] Gilmore made a demonstration against Petersburg, Va., where we were brought into line of battle, under a most galling fire of the enemies' guns. The 1st USCT took the right, the 6th [took] the left, and our detachment supported the artillery. In this order we advanced while Gen [August V.] Kautz with a superior force of cavalry made a flank movement and broke the enemies' left, reaching the town. Had he been supported by General Gilmore the town would have been ours on that day, with slight loss of life. But did he do it? No. He withdrew without a fight, putting the enemy on his guard and consequently allowing him to prepare for an emergency. Suffice it to say that we withdrew and fell back to Point of Rocks. All passed off very quietly until the 14th, when we were summoned to make a second demonstration against the rebel city under the command of Gen. [William F.] Smith. In a few moments we were out and on the road. We crossed the Appomattox shortly after nightfall, and lay down to rest our weary limbs. On the following morning about daybreak, we dispatched a hardy breakfast of hardtack and coffee. Orders were given then to fall in; of course, we made no delay, knowing duty to be before everything else, a moment before and the column was off. About sunrise our advance came in contact with the rebel pickets who, discharging the contents of their pieces into our ranks, fled back to their main force. Skirmishers were then thrown out in front of the different regiments. Companies C and B were deployed in front of the 5th, other skirmishers in front of their respective regiments, forming a skirmish line in front of the line of battle. We moved forward slowly, making our way clear and open,

we advanced about a mile in this manner till in sight of the first line of earthworks. We were then in the open field, halted, where we kept up a brisk fire on the skirmish line until the regiments could get through the swamps and form in order again. All this while the enemy poured a galling fire of musketry, grape and canister into the ranks, slaying many. The order was given to forward the skirmish line one hundred paces. This being done we halted, keeping up our fire along the line. One thing that I must mention which attracted the attention of the whole division. It was that brave and daring but strange personage that rides the white charger. We could see him plainly riding up and down the rebel lines, could hear him shouting from the top of his voice to stand, that they had only niggers to contend with. This peculiar personage seems possessed with supernatural talent. He could sometimes ride his horse at lighting speed, up and down his lines amid the most terrific fire of shot and shell. But when the command was given to us, "Charge bayonets! Forward double quick!" the black column rushed forward raising the battle yell, and in a few moments more we mounted the rebel parapets. And to our great surprise, we found that the boasted Southern chivalry had fled. They could not see the nigger part as the man on the white horse presented it. We captured here one gun and caisson. [Our] column moved out to the left in front of the second line of fortifications while the white groups took the right. We moved off in a line of battle, took positions right in range of the enemies' guns, in which position we remained six hours, exposed to an enfilading fire of shot and shell. Just at nightfall after the placing of our guns had been affected, we were ordered to charge a second fort, which we did with as much success as the first. It is useless for me to attempt a description of that evening their cannonading. I have never heard anything to equal it before or since; for a while whole batteries discharged into the rebel ranks at once. The result was a complete success.[28]

Sergeant William McCoslin of Bloomington, Illinois, traveled by rail with his regiment to Washington, DC; then by ship to White House Landing, Virginia; and finally on foot to trenches near Petersburg. He was tired of digging trenches and eager for combat by the time he wrote the following letter, which was published in the *Christian Recorder* on August 27, 1864.

[From] William McCoslin
1st Sergeant
Co[mpany] A, 29th USCI
Near Petersburg, Virginia

July 26, 1864

As I have little leisure time, I thought I would give you a short history of our campaign in Virginia. As you are aware, we left Illinois, our glorious state, under the command of Lieutenant Colonel John A. Bross, formerly of Chicago, but lately of the 88th Ill[inois] Regiment, for the Army of the Potomac, with orders to report to Major General [Ambrose] Burnside. We had a pleasant journey of it, but very tiresome, on account of having to stay on board the cars all the time, until we arrived in the city of Chicago, when we were marched to the Soldier's Rest, where a fine breakfast was in waiting for us. We charged on it immediately, and captured it without any loss whatever. We rested here all day and then started for the cars on route for Pittsburgh, where we arrived after a fatiguing ride of thirty hours, but all in good spirits. On our arrival in the Iron City, we were marched to the Soldiers' Rest, where we were served up with a splendid supper; every kindness was shown us that could be shown on so short a notice. At 11 o'clock, p.m., we started en route for the East, tolerably well rested, and in good spirits, feeling proud of the treatment we have received, being the same if not better than some of he white soldiers received. Our trip over the mountains was a new thing to some of our Western boys, who have never been away from home. It seemed to interest them very much; crossing the mountains was quite an undertaking, especially when we went through the tunnels. Not[h]ing of any great importance transpired until we arrived in Baltimore, when we marched up the identical street where the citizens mobbed the first white regiment. There was talk of mobbing the colored regiments. We did not have any arms then; but success ever favors the brave, and so it was with us. We were treated with some respect by all the citizens. We had to remain here over one day. During the time we went abut the city, and were not molested by any one. So when transportation was furnished to us, we started for Washington City, which place we reached on the evening of April 30th, 1864. After disembarking from the cars, we marched to the Soldiers' Rest, where we stopped

till the evening of the 1st of May. Our regiment marched over to Alexandria, a distance of five miles, and stopped for one day; then we were ordered back to Camp Casey, near Washington, where we went into camp for instruction. Here we received our arms and equipment for the field. Nothing of note transpired until the 19th of May, when I was taken sick with symptoms of small-pox; then I was sent to the Rest Hospital at Alexandria. Here I was treated kindly, getting the same treatment as white officers and soldiers, and everything was kept in the neatest possible manner.

On the 30th of May our regiment was ordered to take transportation from Alexandria for White House Landing, Va., where, on the application of my Captain, I was allowed to rejoin my regiment. The Surgeon in charge of the hospital gave me a new suit of clothing before I started. I then rejoined my regiment, and accompanied it into the field, landing at White House Landing. After disembarking from the boat, we went into camp. For several days during our stay there, our men were engaged in throwing up redoubts and rifle pits. Then about the 6[th or] 7th of [June], we were ordered to escort a large train of supplies to the front. This was our first march, and a sorry one it was. It was a forced march, and many of the men had to throw away nearly all of their baggage, so as to keep up. We expected to get a rest here for a day or two, but were disappointed. We had to start almost immediately en route for Petersburg. Here, at Old Church Tavern, we joined our corps, and were assigned to the 4th Division, 2nd Brigade, 9th Army Corps. Our brigade being the rear guard of the corps, we had a great deal of hard marching, and being in a very important position, we all felt the responsibility that was resting on us as rear guards. We proceeded along finely till we arrived at Dawson Bridge, near the Chickahominy [River], where we rested one day, and a Godsend it was to us. So, the next evening we started, but went only a short distance, and stopped till morning, crossing the Chickahominy. We expected to be attacked. The crossing was accomplished without any difficulty—our regiment being the last to cross the river. We learned since that a brigade of rebels were watching us at the time we crossed, but they did not molest us. We continued on our march until we came to Charles City Point, on the James River, which being a fortified place, we stopped over night; but

next day, learning that a large force of rebels intended to attack us, we crossed the river on a pontoon bridge.

No sooner had the crossing been accomplished than the rebels came in sight and began shelling us; but luckily for us, a gunboat was lying in the river protecting the bridge, and soon drove them away. After crossing, we rested one day, when our brigade was ordered to the front immediately, so as to assist in storming the rebel works that night. So on we went, expecting to have battle very soon.

Although the men were very tired, they were anxious to give fight to their enemies; but on arriving at the front, the programme being changed, we were ordered to rest until further orders, which was a godsend to us. We had two days' rest, and then were ordered to the front, to take a position in the rifle pits, which we consider healthier than going into the fight; but when ordered, we are ready and willing to fight.

Our regiment is not in good fighting trim at present, on account of an insufficiency of officers. In other respects they are all right. We are expecting every day to be sent to the front; but it is ordered otherwise, probably for the best. Our regiment has built two forts and about three miles of breastworks, which shows that we are not idle, and that we are learning to make fortifications, whether we learn to fight or not.

We are now lying in camp, about a mile and a half from the city, resting a day or two. It is quite a treat for the boys to get a rest after working day and night, four hours on and four hours off. We have worked in that way for eight or ten days, without stopping. But my opinion now is, that the laboring work is nearly over, so that we will have nothing to do but watch the rebels.

There is heavy firing of artillery and small arms every night from both sides, which sounds most beautiful to us.[29]

George W. Reed served on a gunboat that had many African American sailors in its mixed-race crew. The boat operated in the Potomac River near Washington, DC, and also in the nearby Chesapeake Bay and the rivers that flowed into it. One of those rivers, the Rappahannock, separated the Union army from the Confederate army near Fredericksburg. On May 4, 1864, Union General Ulysses S. Grant crossed the river and launched his offensive against Confederate General Robert E. Lee. The gunboats

downstream rescued wounded Union troops and escorted rebel prisoners, but—as Reed describes—there were also exciting moments on shore. His letter was published in the *Christian Recorder* on May 21, 1864.

[From] George W. Reed
Drummer
USS *Commodore Reed*
Potomac Flotilla

May 14, 1864

Sir, having been engaged in the naval service nearly six years, I have never before witnessed what I now see on board this ship. Our crew are principally colored; and a braver set of men never trod the deck of an American ship. We have been on several expeditions recently. On the 15th of April our ship and other gunboats proceeded up the Rappahannock River for some distance, and finding no rebel batteries to oppose us, we concluded to land the men from the different boats and make a raid. I was ordered by the Commodore to beat the call for all parties to go on shore. No sooner had I executed the order than every man was at his post, our own color being first to land. At first there was a little prejudice against our colored men going on shore, but it soon died away. We succeeded in capturing 3 fine horses, 6 cows, 5 hogs, 6 sheep, 3 calves, an abundance of chickens, 600 pounds of pork, 300 bushels of corn, and succeeded in liberating from the horrible pit of bondage 10 men, 6 women, and 8 children. The principal part of the men have enlisted on this ship. The next day we started further up the river, when the gunboat in advance struck a torpedo, but did no material damage. We landed our men again, and repulsed a band of rebels handsomely, and captured three prisoners. Going on a little further, we were surprised by 300 rebel cavalry, and repulsed, but retreated in good order, the gunboats covering our retreat. I regret to say that we had the misfortune to lose Samuel Turner (colored) in our retreat. He was instantly killed, and his body remains in the rebel hands. He being the fifer, I miss him very much as a friend and companion, as he was beloved by all on board. We also had four slightly wounded.

On the 28th of April we landed two boats' crew, armed and equipped, on the shore at Mathias Point, a distance of seventy-five

miles from Washington, and captured 400 pounds of salt port, corn, etc., and a rebel captain, who happened to be home on a furlough eating his dinner. He very politely asked to march on board the ship, where we gave him a fine dinner of double irons, and bread and water.

On the 9th of May we landed three boats' crew on shore at night and captured a rebel signal company and two officers, and all their provisions. The *Commodore Reed* is the fighting ship of the Potomac Flotilla, and we are never idle.

On Thursday, the 12 inst., we were notified that wounded soldiers were drifting on rafts in the river near Aquia Creek, having been driven there by guerrillas in their retreat from the front. We have been lying here ever since—when there have been over 20,000 wounded brought here to be transported to Washington. I had the pleasure of conversing with some of the colored soldiers who were wounded in the late battles. I am told by them that their officers could not manage them, they were so eager to fight. Whenever they caught a rebel, they cried out "No quarter! Remember Fort Pillow! No quarter for rebs."[30] They distinguished themselves highly. They are doing as well here as can be expected, and are being properly cared for. They seem principally to belong to Burnside's division, and many who were slightly wounded have gone back to the front. They are all eager to go back to retaliate for the Fort Pillow massacre.

I must close now, as we are ordered to convoy a steamer loaded with rebel prisoners to Washington.[31]

On August 5, 1864, John Lawson, from Pennsylvania, was a sailor on the USS *Hartford* during one of the most unsung naval battles of the Civil War: the attack on Fort Morgan, Mobile Bay, Alabama. Although wounded during battle, Lawson continued to fight; he had been wounded before, when the USS *Cayuga* helped capture New Orleans in 1862.

The sailors on the *Hartford* awoke at two in the morning and prepared to attack Mobile Bay. As Edwin Redkey describes,

At 5:30 a.m., Admiral David Farragut had himself tied to the upper mast of the *Hartford* and ordered the fleet to attack. There were four major obstacles: Fort Morgan, which guarded the entrance to the bay; some Confederate gunboats inside the bay; the monster

ironclad *Tennessee*; and three lines of mines, or as they were called then, "torpedoes." The Confederate ships and forts fired away at Farragut's eighteen-ship fleet. In the smoke and confusion of battle, the ship ahead of him stopped, so the admiral had to send the *Hartford* around it, straight into the minefield. When the crew pointed out that they were heading for the mines, Farragut shouted from his perch high above the deck, "Damn the torpedoes! Full speed ahead!" Only one ship sank owing to the mines, and the rest of the fleet steamed on to fight the rebel gunners.

On the gun deck of the *Hartford*, John Lawson fired away at Fort Morgan, and the guns of the fort fired back. Solid shot and explosive shells from the fort did serious damage; dead bodies were lined up on the far side of the ship, and the wounded were tended by the surgeons below decks. One shell from the shore hit the shell-whip where Lawson and five other men were loading and firing. It exploded, killing or wounding all six men. Lawson was struck in the leg and thrown across the deck against the side of the ship, badly stunned. He was told by his officers to go below to get help from the doctors. But he returned to his post and continued firing away. Other shells tore off men's arms, legs, and heads, but Lawson stayed at his post until the fleet had passed the fort and the minefield, sunk most of the rebel gunboats and captured the iron-clad *Tennessee*. By ten o'clock, the great battle ended, and Lawson could get care for his wounds. The next day, the captain of the *Hartford* commended him for his bravery in action; for his heroism, he received the Congressional Medal of Honor.[32]

Similar accounts of bravery and discontent are affirmed in the letters that close out the year 1864. One letter helps us to imagine life between battles, while another is a severe indictment of the despair that many soldiers experienced in not being able to take care of their families because of unequal pay. The pride of character and commitment to serving the US government are presented in great detail as the writer pleads once again for full pay and expresses his concerns for his fellow soldiers. Isaac Van Loon's letter to the *Anglo-African* newspaper is written as if he were sending to a specific person, as he describes an attack on his unit by a group of starving Confederate soldiers desperately looking for food and shelter.

[From] Isaac Van Loon
Camp Shaw, Plaquemine, La.

August 1864

Dear *Anglo*:

Having a few leisure moments, I thought I could do no better than to devote them to you; for we colored soldiers have not much time, I can assure you, to devote to much else than military duties.

Saturday, the 6th of August, is a day that will long be remembered by the 2d Battalion. We were aroused about 4 o'clock in the morning by the firing of musketry in the village and the old cry of "The Rebs! the Rebs!" Such hurrying to and fro of armed and unarmed soldiers, being awakened as we were from a sound sleep, beggars description. But, nevertheless, we were quickly in line, and we double-quicked to the fort, ready and willing to offer up our lives at the shrine of Liberty; but our fighting qualities were not called into requisition; it proved to be only one of those rebel raids that frequently occur near small towns, where they dash in for provisions. Being driven to the last extremity for the necessities of life, they will often dash into the midst of Union troops, intent only on one object—something to eat; but here they were sadly disappointed. They rushed right into the midst of our Provost Guard, who caused them to beat a hasty retreat, carrying with them three of our advance pickets—Saml. O. Jefferson, of Troy; Saml. Mason and Anthony King, who are, I believe, Western boys, all of Co. I. They were all good soldiers. They were taken by those fiends in human shape a short distance down the road and then inhumanly shot, being first stripped of all clothing, and then brutally murdered and left upon the road. Think of us, ye Northern men!—of the poor soldier who has forsaken home comforts—yes, everything! to aid in this civil sacrifice of life.

But, dear *Anglo*, I will not weary your patience any longer. Nothing pleases the colored soldier better than to receive a copy of your heart-cheering paper. I hear from you often through my father, Dr. William Van Loon, who forwards me your paper, which has to go the grand rounds through our camp before I can get a chance to peruse it thoroughly myself. You will hear from me again.

Isaac Van Loon
Co. C, 8th U.S. (formerly 14th R.I.) H.A.[33]

[From "Bay State"]
Headquarters 55th Reg. Mass. Infantry
Palatka, Fla.

April 10th, 1864

Mr. Editor: This Regiment was mustered into the United States service about the 18th or 20th of June, 1863, consequently we have been ten months working for Uncle Sam, not taking into account the time when some of us were sworn in.

The only thing that engrosses the mind now, is the old and troublesome subject of pay.

We have been promised that we would be paid, and a paymaster came (last November) to pay us. He offered us $7 per month. We enlisted for $13 per month, with the promise (and I wish the public to keep this fact before them, to see how these promises are being fulfilled) that we should be treated in all respects like white soldiers, our bounty, rations, and emoluments being the same. The same inducements were held out to us as to all Massachusetts volunteers.

You, sir, no doubt, have copies of the circulars that were distributed through the country to encourage enlistments. By whose authority this was done I cannot say; but I know that his Excellency, John A. Andrew, Governor of Massachusetts, name was on them.

Mr. Editor, we wish to be plain, and state the exact truth, and this we shall do regardless of whomsoever we may offend.

We do not look upon Massachusetts as being responsible for our sufferings; but upon the government of the United States, and how a government, with such a lofty reputation can so act, is beyond our conception or comprehension. We know, and the world knows that had we been white men the whole land would have been in a blaze of indignation in regard to the great injustice done us.

How the authorities expect our families to live without the means to buy bread, pay house rent, and meet the other incidental expenses of living in these terrible times, we know not; but if it does not exert its well known power it certainly will not be held guiltless in this matter.

Are our parents, wives, children, and sisters to suffer, while we, their natural protectors, are fighting the battles of the nation? We leave the government and Congress to answer.

That they *do* suffer we have abundant evidence.

I have seen a letter from a wife in Illinois to her husband, stating that she had been sick for six months, and begged him to send her the sum of *fifty cents*. Was it any wonder that the tears rolled in floods from that stout-hearted man's eyes.

How can it be expected that men will do their duty consistently with a soldier's training, under such circumstances?

Patience has an end, and with us will soon cease to be a virtue. We would be contented and happy could we but receive our pay.

I have been asked by officers, not connected with our Regiment, why we did not take our pay when we could get it. My answer was: that our pay has never been sent to us. True, money has been sent here, but it was not our pay. When the United States authorities shall send us $13 per month, which is our just due, we will take it, *and not until then, will we take one cent.*

We cannot accept pay from the Old Bay State while we are working for the United States; for we do not want two paymasters. One will answer, provided he be the right one.

We have waited long for our just dues, but many have waited and many will wait in vain.

The battle-field and grief are doing their work, and many a poor fellow will sleep his last sleep ere the adjusting time shall come. We begin to think that that time will never come *as long as we stay in the field.*

There is evidently something wrong about this business. The United States government says nothing about it, and Gov. Andrew never comes to see us! Does it not seem strange? The presence of Gov. Andrew here would inspire us with renewed confidence, and send a thrill of great joy through our victimized regiments.

Money has been sent to us through different channels which we have refused, and which we must continue to refuse. To accept our pay in this way would degrade us, and mark us as inferior soldiers, and would be a complete annihilation of every vestige of our manhood.

The United States knows our value as soldiers too well to suppose that we will sacrifice the position that we have gained by most arduous labor, and we, thoroughly comprehending our relation to the past glorious history of our race, and the verdict that must fall upon us in the future if we falter; will stand up for our rights, come what may.

As regard the question whether we are equal in value as soldiers to white troops, we have only to say that if Port Hudson, Milliken's Bend, Pocotaligo, Fort Wagner, Olustee, and Fort Pillow, do not settle it in our favor, then it is because our enemies will not have it settled in that way.

But it is a matter of indifference to us now how they settle it; we, by God's help, will settle it for ourselves before this war is over, *and settle it right too, or die in the attempt.*

It is glorious to see how our noble fellows stand up under their trials. Pride has kept them where they are to-day, and they certainly deserve to be respected.

But you, sir, was not aware of the fact that we have passed into an Holy (holey) and hungry order—but it is true. The boys pantaloons are at this time flapping about their legs trying to whip them to death; while the "vacuum" within is calling for something to assuage the gnawing. Scarce rations have been our luck since we came to the department.

Our men, as a general thing, are obedient, and the detachment now at Yellow Bluff, Fla., under [Lt.] Col. [Charles B.] Fox, and which has been there since February 28, are the ones to whom I allude as being so ragged. Yet only one of these men has been punished for disobedience.

We have been silent in regard to our wrongs hitherto, but it will not do to be so any longer. Agitation and legislation must do what silence has failed to accomplish.

We have been tried in the fire both of affliction and of the rebels, and nothing remains but pure metal. We took our first lesson at Forts Wagner and Gregg, and our last we are now taking in the field of want, and under the guns of prejudice and hate.

We should like to know whether we belong to Massachusetts or Uncle Sam; for we are tossed about from pillar to post, one saying come here, and another saying go there, and we come and go like dogs, and this has been the case ever since we went to Folly Island.

Promises have no weight with us now, until the past and present is fulfilled—future ones we will not heed.

Three years cannot pass in this way. Some change must come.

The words of cheer that we once received from our mothers, wives and sisters, are becoming fainter and fainter, and their cries of want stronger and stronger with each revolving day. In the

picture of our desolate households, and the gaunt figures of our friends now suffering almost the pangs of starvation, to haunt us by day and night in our camp? Is this dread sight to hang between us and our starry flag upon the battle-field?

Oh God! most bitter is the cup presented to our lips; but that others may live we will drink it even to the dregs.

Our debasement is most compete. No chances for promotion, no money for our families, and we little better than an armed band of laborers with rusty muskets and bright spades, what is our incentive to duty? Yet God had put it into our hearts to believe that

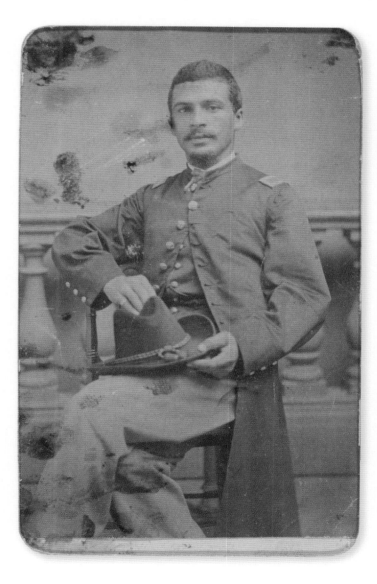

Second Lieutenant James Monroe Trotter, Company G, Fifty-Fifth Massachusetts Infantry, ca. 1865. (Unidentified photographer; carte de visite; Collection of the Gettysburg National Military Park Museum)

we will survive or perish with the liberty of our country. If she lives, we live; if she dies we will sleep with her, even as our brave comrades now sleep with Col. Shaw within the walls of Wagner.

More anon,
Bay State[34]

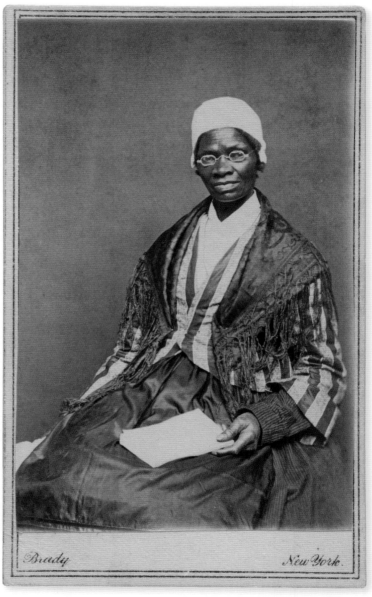

Portrait of Sojourner Truth. (Charles L. Blockson Collection, Temple University Libraries)

1865-66

THE END OF THE WAR

Black men generally were not given command of soldiers. But their command of language, passion for freedom, concern for family, and determination to tell and preserve their stories have shaped this book.

The following letter recounts a risky encounter in Jacksonville and shows the resilience of the troops under fire. A sergeant-major of the Third US Colored Infantry led a group of thirty black soldiers on a raid in the deep swamps of Florida. The letter was sent to the editors of the *Christian Recorder*, probably written by Sergeant Henry S. Herman. The sergeant-major, Henry James, received an official commendation from the commanding general. Herman's letter was published some two weeks later, on April 22, 1865.

[From] Henry S. Herman
Sergeant, Co[mpany] B, 3rd USCI
Jacksonville, Florida

April 3, 1865
. . . I take the liberty of your columns to present for their perusal an account of an expedition which left Jacksonville under the command of Sergeant-Major Henry James, 3rd USCT, on the night of the 7th of March, consisting of sixteen (16) of the 3rd USCT, six men of the 34th USCT, and seven colored citizens, and one (1) of the 107th O[hio] V[olunteer] I[nfantry], thirty (30) men in all. After waiting some time for darkness to throw her pall over the scene, the

Commander gave the order to push off. The party then moved up the St. John's River in pontoon boats to Orange Mills, where he landed with ten men and skirmished the country to a point near Palatka, where the boats met them, and seeing all well, he again skirmished to what is called Horse Shoe Landing, said to be 100 miles from Jacksonville, which brought them well up in the day; having fatigued themselves considerably, they remained in the swamp until the boat came up about nine o'clock in the evening, when he embarked again and came up to what is called Fort Gates. He then ordered the boats pulled close into shore under cover of the dense swamps, and proceeded with the whole force across the country to the Ocklawaha River, to what is known as Marshall's plantation. Here was one of the objects of the expedition reached without serious opposition, and almost in the heart of the enemy's country, and as yet quite unknown to him. Here the expedition captured some 25 horses and mules, burnt a sugar mill with 85 barrels of sugar, about 300 barrels of syrup, a whiskey distillery, with a large amount of whiskey and rice, and started on their return, bringing along 95 colored persons, men, women and children, re-crossed the Ocklawaha River, burning the bridge. Six men then were detached from the command and sent under charge of Sergeant Joel Benn, of Co[mpany] B, 3rd USCT, with Israel Hall, scout of Hawley plantation, where they were attacked by a small body of rebels, and Sergt. Benn was killed, shot through the heart. Henry Brown, scout, wounded, and Israel Hall, chief scout, captured, as was another citizen named Ben Gant, the others being compelled to return to the main body.

Their troubles had now commenced in earnest, this being the second fight of the day, for having to charge the bridge in going to Marshall's, and killing three rebels had only stirred them up, but they pushed on, for much of their success depended on their speed, but when within about twenty miles of the St. John's River, the enemy, numbering about fifty men well mounted, came down on them, calling on them to surrender or suffer themselves to be hanged. But there was another alternative which he, the enemy, did not think of, and which the Sergeant-Major, who by the way is not a surrendering man, resolved to take, which was to fight them a while first. Seeing this, the enemy prepared himself to make it warm for the little band of colored men. Breaking to the right and to the left under cover of a hill, they dismounted and formed their line of attack, and

came over the crest of the hill, in quite an imposing array to find the little band of seventeen men (the balance being left to guard some prisoners and the avenues of retreat) deployed as skirmishers to meet them, covered as much as possible by the trees.

But on they came. And every man selecting his man, when they were near enough for every man to make sure and waste no ammunition, Sergt. James gave the command to commence firing, and for a while nothing was heard but the sharp crack of the soldier's rifle and the louder roar of the citizens fowling piece [shotgun], blended with the yells of their wounded and dying. The firing on the part of our men was good, as was shortly proved, for the enemy suddenly broke for their horses, when our men, leaving their cover, dashed in among them with the bayonet and clubbed guns, scattering them in every direction, leaving some 20 of their men dead and a few wounded. Finding the way clear again, Sergt. James, on the summing up, found the woods had afforded them such good covering that he had only two men wounded, after taking possession of the best of their horses (although the enemy suffered so severely, he showed himself to be no mean marksman, as numerous holes in our men's clothing amply testified, among which, a hole through the commander's cap, caused him to withdraw his head from a dangerous position), he again took up the line of march for the St. John's, having to abandon one wagon on the way, and soon reached the river and commenced crossing it at twelve o'clock on the night of the 10th, and at daylight on the 11th, had all across except 9 horses, when the enemy coming up made it impossible to re-cross, consequently had to leave them. They then destroyed the three boats which they had used, and pushed on towards St. Augustine, and by time they had got one day's start, Dickerson's guerrilla cavalry were in full pursuit, and when within seven miles of St. Augustine, the enemy overtook some of the colored people who were unable to keep up. The remainder of the party reached St. Augustine on the 12th inst. in safety with the wounded, 4 prisoners, 74 liberated slaves, 1 wagon, 6 horses, and 9 mules having traveled over 200 miles of our own country, in five days and nights, reaching Jacksonville, last evening, the 19th inst., with all their booty.

The expedition reflects great credit on Sergt. Major James, for the masterly manner in which it was commanded, and gives further proof that a colored man with proper training can command among his fellows and succeed where others have failed. And a

great deal is due to the men for their good behavior, and steadiness, and obedience, and if it were not for occupying too much of your space, which I fear I have done already I would give their names, but that at some other time.

I am still an ardent lover of my race, and a soldier.[1]

Photographs of the 108th Regiment of the US Colored Troops, produced in 1865 at Rock Island, Illinois, build on this history.[2]

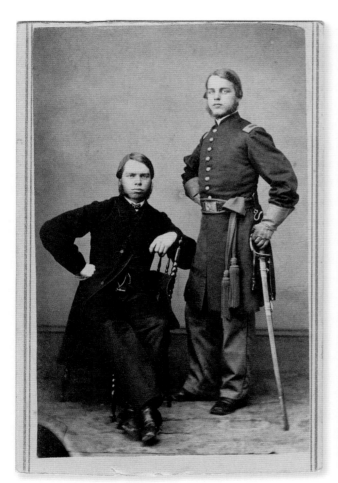

Double portrait of two white officers, one is First Lieutenant T. F. Wright, Company F, who assembled the album. Most of the portraits bear either a two-cent orange or a three-cent green revenue stamp. (Sarah A. Wright's Album, Photographs of Officers and Privates of the 108th Regiment of the U.S.C.T. taken at Rock Island, Ill., in 1865; Photographers: Gayford & Speidel, 1865, cartes de visite; Yale Collection of American Literature, Beinecke Rare Book and Manuscript Library, Randolph Linsly Simpson African-American collection, Box 35, Folder 1082–83)

Cartes-de-visite in an album assembled by Lieutenant T. F. Wright, a white officer, show how black soldiers in the regiment were viewed, assessed, and admired. The photographers, Alfred B. Gayford and Conrad Speidel, operated a studio in Rock Island, Illinois. Unusually, the cartes-de-visite provide more than visual information; the backs of the images in the Wright album contain some astonishing handwritten remarks.

Corporal Rendwick Allen, 108 USCT, now Sergeant and an excellent one, and commands obedience.

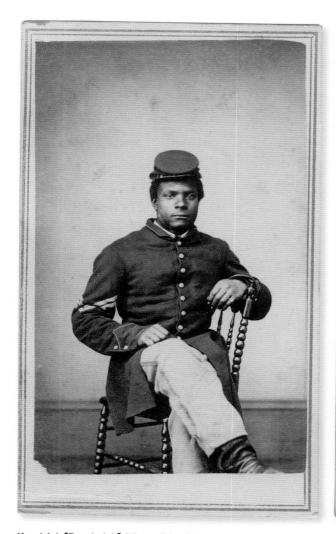

Kendrick [Rendwick] Allen, 1865. (Photographers: Gayford & Speidel; cartes de visite; Yale Collection of American Literature, Beinecke Rare Book and Manuscript Library, Randolph Linsly Simpson African-American collection, Box 35, Folder 1082-83)

John Leech, First-rate soldier, prompt and obedient. His father brought him into me in Louisville.

Henry Lively, corporal. Best man in the company, born enslaved in Louisville, Kentucky, freed in summer of 1864, joined Company F of the 108th, mustered out and died at 38 of malaria six years later when he contracted [it] in in Vicksburg. His wife collected his pension, she was pregnant at the time and had another child with him. And two by her white owner.

Henry Price, Pvt., USCT 108, one of the cooks . . . does his duty faithfully to the satisfaction of the men.

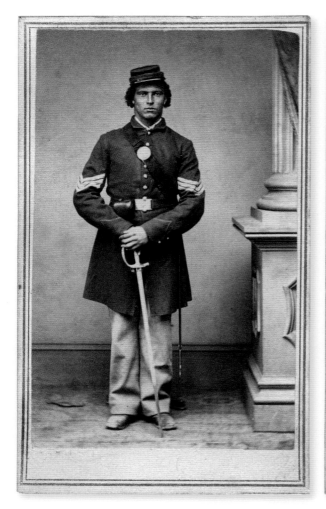

Samuel Martin, Sgt. Com., 108th US Colored Troops. (Yale Collection of American Literature, Beinecke Rare Book and Manuscript Library, Randolph Linsly Simpson African-American collection, Box 35, Folder 1082–83)

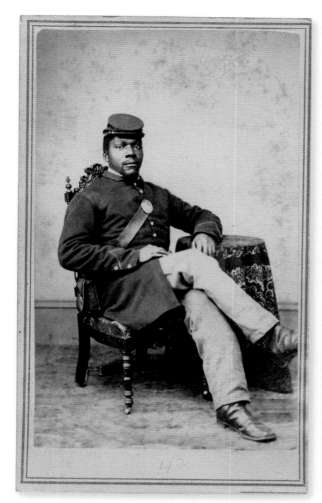

Emmit Adams. (Yale Collection of American Literature, Beinecke Rare Book and Manuscript Library, Randolph Linsly Simpson African-American collection, Box 35, Folder 1082-83)

Sergeant Alfred Jackson, USCT 108—freeman in the army as teamster, is considered one of the best sergeants in the regiment.

Samuel Martin, Sergt. Com. 108 USCT, very light eyes and hair and light complexion . . . uses no tobacco or stimulant and [is] of soldierly bearing, appreciated by his officers.

Daniel Hodgens, corp. USCT, a bartender and house servant, very bright and steady, can read and write.

Emmit Adams, reads well, makes the morning reports of the company and by his diligence and good conduct has won the esteem of his officers. He was a tobacconist.

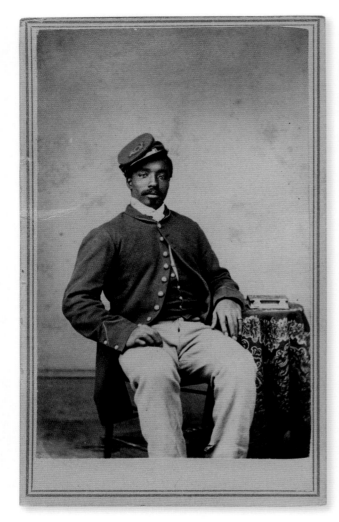

James Roberts, drummer, 108th US Colored Troops. (Yale Collection of American Literature, Beinecke Rare Book and Manuscript Library, Randolph Linsly Simpson African-American collection, Box 35, Folder 1082–83)

The most fascinating and illuminating description is of James Roberts, described as a drummer in the 108th US Colored Troops and also as "a freeman, hard to manage . . . stubborn and reckless." The comment suggests that Roberts's self-image was as a free man, and he was not intimidated or fazed by white control over the black body.

Union soldiers who were taken prisoner by Confederate forces suffered greatly. The worst prison was in Andersonville, Georgia; thousands of Union men, black and white, died from various

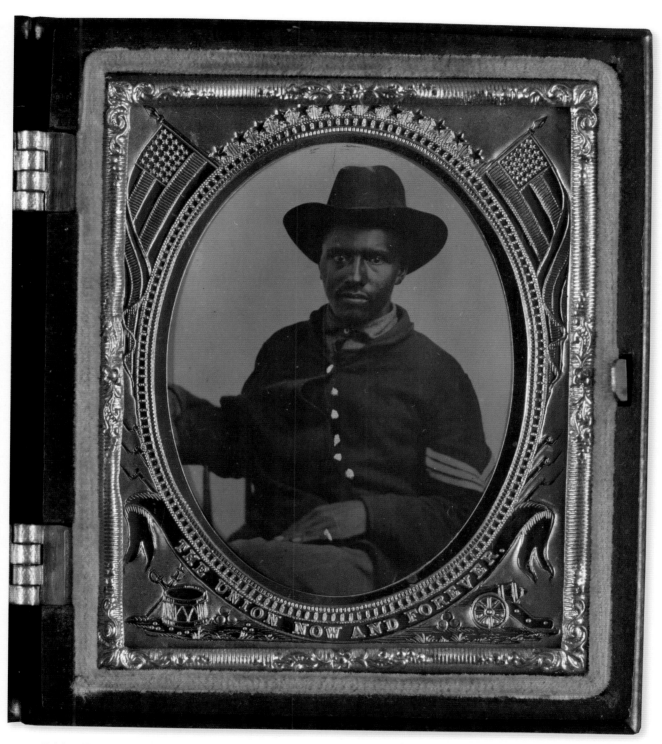

Unidentified African American soldier in Union corporal's uniform. (Library of Congress, Prints and Photographs Division, LC-DIG-ppmsca-34366)

diseases and malnutrition because of contaminated water. After the war, the prisoners were released to federal forces. Some of them first headed south; they went to Jacksonville, Florida, in order to take a boat back to the North. In the emotionally charged letter that follows, William B. Johnson describes how the former prisoners were received by his regiment. His letter was published in the *Christian Recorder* on May 20, 1865.

[From] W. B. Johnson
Private
Co[mpany] A, 3rd USCI
Jacksonville, Florida

[April 1865]
About Half past four o'clock this P.M, I heard cheer after cheer break from the lips of the quiet inhabitants of Jacksonville, and all running towards Battery Myrick, and I there saw over 500 Union prisoners making their way from Rebeldom. It would have done you good to have seen them look at the old flag. Some of them had been prisoners for eighteen months. Fancy you can see 500 men clad in the poorest garment, coming into our lines, crying, "God save the flag."

The 3rd USCT, with the assistance of the 34th, soon had campfires made, and in half an hour many were partaking of US salt beef and hard bread. They continued to come in during the night, and as I now write, they are singing:

"My country, 'tis of thee,
Sweet land of Liberty."

April 20.—This morning as I was going to my boarding house for breakfast, I met a crowd of exchanged prisoners: having a pitcher of sweet milk, they asked me if I could get them some. I told them to follow me, and I assure you I felt proud to see them gather around, and drink to their hearts' content. One told me that there are 250 acres of land, filled with our Union dead, that died completely from starvation. Another said he subsisted on the coarsest of meal, and was glad to grind up the cob from the corn. I call on God to judge such treatment. May God speed on the time when peace shall reign throughout the land.

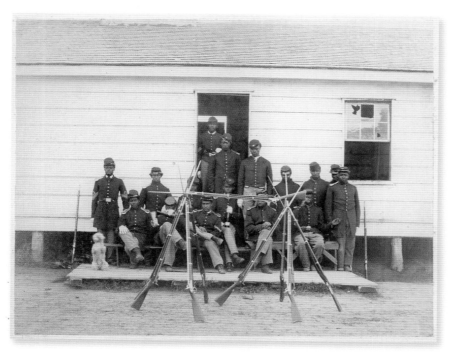

Quarters of US Colored Troops. (Photographer: Alexander Gardner; albumen print; Courtesy of Greg French and Collection of Greg French)

We have received the sad news of the death or our President. The churches are all in mourning. But I shed not a tear for him. He has done the work that was given him, and today sings the song of redeeming love. I shed tears for our country. May we humble ourselves and cry aloud: "God save the State." Yes, Abraham Lincoln has done his work, and

> Sleeps in Jesus, Blessed sleep,
> From which none ever wake to weep:
> A calm and undisturbed repose,
> Unbroken by the last of foes.[3]

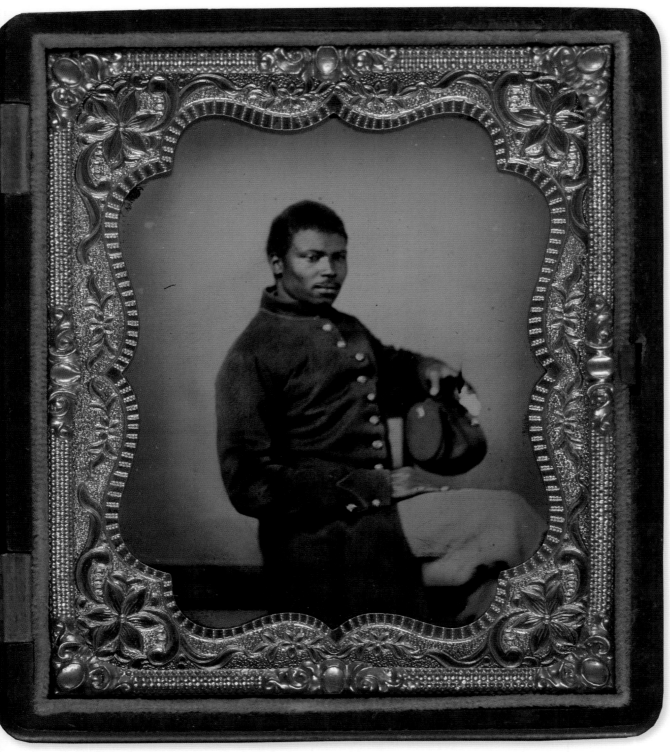

Unidentified African American soldier in Union uniform. (Sixth-plate ambrotype, hand-colored; Library of Congress, Prints and Photographs Division, call number: AMB/TIN no. 2782 [P&P])

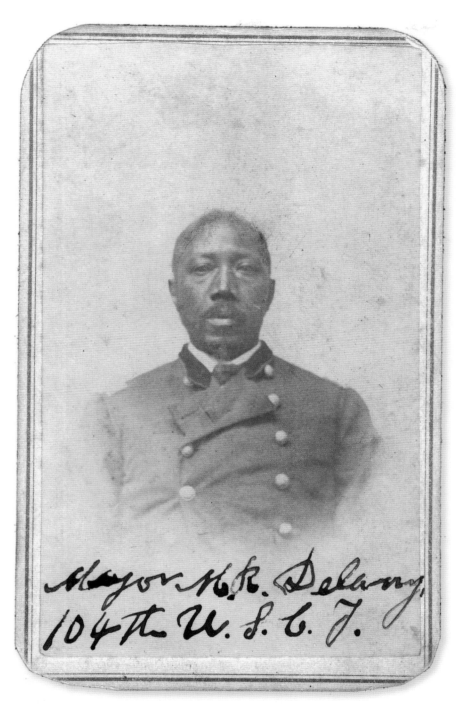

Portrait of Major Martin R. Delany, 104th US Colored Troops (hand-signed).
(Carte de visite; courtesy of Greg French and Collection of Greg French)

Portrait of Rhode Island Soldier. (Carte de visite; courtesy of Greg French and Collection of Greg French)

Quarter-plate tintype of a drummer. (Carte de visite; courtesy of Greg French and Collection of Greg French)

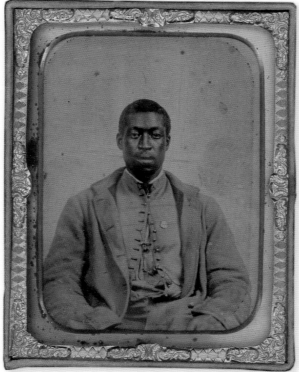

Portrait of soldier wearing Ninth Corps Badge. (Quarter-plate tintype, carte de visite; courtesy of Greg French and Collection of Greg French)

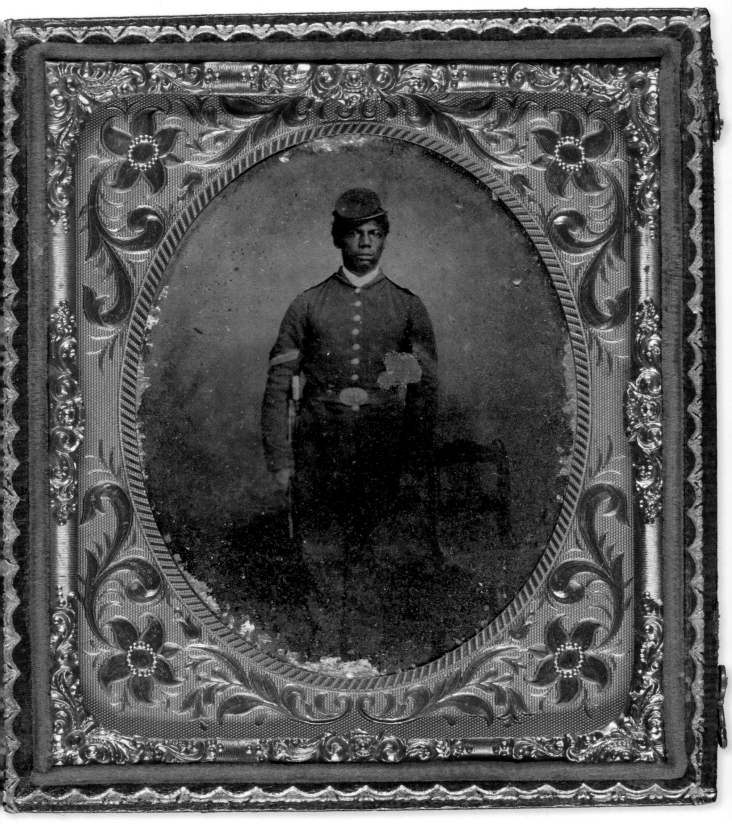

Unidentified African American soldier in uniform standing next to chair with bayonet. (Tintype; AMB/TIN no. 2140 [P&P])

The casualties of war included the women and children left behind. On April 3, 1865, troops in the Union's Twenty-Fifth Corps were among the first to enter Richmond, the Confederate capital. The Twenty-Fifth Corps, which consisted solely of US Colored Troops units, pursued Robert E. Lee's army and participated in the closing battle at Clover Hill, April 9, the day of Lee's surrender. Black troops continued to follow General Lee to Appomattox, where he surrendered.

One of the members of the US Colored Troops was a chaplain named Garland White, of the Twenty-Eighth Infantry. White wrote pieces for the AME Church's *Christian Recorder*. White, described as a "runaway slave" from the Richmond/Petersburg area who escaped his plight by moving to Canada, later moved to Ohio, where he discovered his mother, who had been searching for him for years. This heartwarming letter is a clear example of why this book and the archives of the black families during the war years are so important.

[From Chaplain Garland H. White]
28th USCI, Richmond, Virginia

April 12, 1865

I have just returned from the city of Richmond; my regiment was among the first that entered that city. I marched at the head of the column, and soon I found myself called upon by the officers and men of my regiment to make a speech, with which, of course, I readily complied. A vast multitude assembled on Broad Street, and I was aroused amid the shouts of ten thousand voices, and proclaimed for the first time in that city freedom to all mankind. After which the doors of all the slave pens were thrown open, and thousands came out shouting and praising God, and Father, or Master Abe, as they termed him. In this mighty consternation I became so overcome with tears that I could not stand up under the pressure of such fullness of joy in my own heart. I refired to gain strength, so I lost many important topics worthy of note.

Among the densely crowded concourse there were parents looking for children who had been sold south of this state in tribes, and husbands came for the same purpose; here and there one was

singled out in the ranks, and an effort was made to approach the gallant and marching soldiers, who were too obedient to orders to break ranks.

We continued our march as far as Camp Lee, at the extreme end of Broad Street, running westwards. In camp the multitude followed, and everybody could participate in shaking the friendly but hard hands of the poor slaves. Among the many broken-hearted mothers looking for their children who had been sold to Georgia and elsewhere, was an aged woman, passing through the vast crowd of colored, inquiring for [one] by the name of Garland H. White, who had been sold from her when a small boy, and was bought by a lawyer named Robert Toombs, who lived in Georgia. Since the war has been going on she has seen Mr. Toombs in Richmond with troops from his state, and upon her asking him where his body-servant Garland was, he replied: "He ran off from me at Washington, and went to Canada. I have since learned that he is living somewhere in the State of Ohio." Some of the boys knowing that I lived in Ohio, soon found me and said, "Chaplain, here is a lady that wishes to see you." I quickly turned, following the soldier until coming to a group of colored ladies. I was questioned as follows:

"What is your name, sir?"

"My name is Garland H. White."

"What was your mother's name?"

"Nancy."

"Where was you born?"

"In Hanover County, in this State."

"Where was you sold from?"

"From this city."

"What was the name of the man who bought you?"

"Robert Toombs."

"Where did he live?"

"In the State of Georgia."

"Where did you leave him?"

"At Washington."

"Where did you go then?"

"To Canada."

"Where do you live now?"

"In Ohio."

"This is your mother, Garland, whom you are now talking to, who has spent twenty years of grief about her son."

I cannot express the joy I felt at this happy meeting of my mother and other friends. But suffice it to say that God is on the side of the righteous, and will in due time reward them. I have witnessed several such scenes among the other colored regiments.

Late in the afternoon, we were honored with his Excellency, the President of the United States, Lieutenant-General Grant, and other gentlemen of distinction. We made a grand parade through most of the principal streets of the city, beginning at Jeff Davis's mansion, and it appeared to me that all the colored people in the world had collected in that city for that purpose. I never saw so many colored people in all my life, women and children of all sizes running after Father, or Master Abraham, as they called him. To see the colored people, one would think they had all gone crazy. The excitement at this period was unabated, the tumbling of walls, the bursting of shells, could be heard in all directions, dead bodies being found, rebel prisoners being brought in, starving women and children begging for greenbacks and hard tack, constituted the order of the day. The Fifth [Massachusetts] Cavalry, colored, were still dashing through the streets to protect and preserve the peace, and see that no one suffered violence, they having fought so often over the walls of Richmond, driving the enemy at every point.

Among the first to enter Richmond was the 28th U.S.C.T.—better known as the First Indiana Colored Volunteers. . . .

Some people do not seem to believe that the colored troops were the first that entered Richmond. Why, you need not feel at all timid in giving the truthfulness of my assertion to the four winds of the heavens, and let the angels re-echo it back to the earth, that the *colored soldiers of the Army of the James were the first to enter the city of Richmond.* I was with them, and am still with them, and am willing to stay with them until freedom is proclaimed throughout the world. Yes, we will follow this race of men in search of liberty through the whole Island of Cuba. All the boys are well, and send their love to all the kind ones at home."

Chaplain Garland H. White[4]

In the following document, the widow of a soldier from Kentucky recounts the constant mental and physical abuse she suffered under

her owner when her husband left to join the Union army. Her desperate plea provides insight into the plight of women who were left on plantations when their husbands left to fight for the Union.

Camp Nelson, K[entuck]y

25 March 1865

Personally appeared before me, J M Kelley, Notary Public in and for the County of Jessamine, State of Kentucky, Patsey Leach a woman of color who being duly sworn according to law doth depose and say—

I am a widow and belonged to Warren Wiley of Woodford County Ky. My husband Julius Leach was a member of Co[mpany] D, 5th US C[olored] Cavalry and was killed at the Salt Works, Va., about six months ago. When he enlisted sometime in the fall of 1864, he belonged to Sarah Martin, Scott County Ky. He had only been about a month in the service when he was killed. I was living with aforesaid Wiley when he died. He knew of my husband's enlisting before I did but never said any thing to me about it. From that time he treated me more cruelly than ever, whipping me frequently without any cause and insulting me on every occasion. About three weeks after my husband enlisted, a Company of Colored Soldiers passed our house, and I was there in the garden and looked at them as they passed. My master had been watching me and when the soldiers had gone I went into the kitchen. My master followed me and Knocked me to the floor senseless saying as he did so, "You have been looking at them darned Nigger Soldiers." When I recovered my senses he beat me with a cowhide. When my husband was Killed my master whipped me severely saying my husband had gone into the army to fight against white folks and he, my master, would let me know that I was foolish to let my husband go he would "take it out of my back," he would "Kill me by picemeal" and he hoped "that the last one of the nigger soldiers would be Killed." He whipped me twice after that using similar expressions. The last whipping he gave me he took me into the Kitchen tied my hands tore all my clothes off until I was entirely naked, bent me down, placed my head between his Knees, then whipped me most unmercifully until my back was lacerated all over, the blood oozing out in several places so that I could not wear my underclothes without their becoming saturated with

blood. The marks are still visible on my back. On this and other occasions my master whipped me for no other cause than my husband having enlisted. When he had whipped me he said "never mind God dam you when I am done with you tomorrow you never will live no more." I knew he would carry out his threats so that night about 10 o'clock I took my babe and travelled to Arnolds Depot where I took the Cars to Lexington. I have five children, I left them all with my master except the youngest and I want to get them, but I dare not go near my master knowing he would whip me again. My master is a Rebel Sympathizer and often sends Boxes of Goods to Rebel prisoners.

And further Deponent saith not.

> *[Her mark]*
> *Signed Patsey Leach*[5]

Rufus Wright marriage certificate, December 3, 1863, filed with affidavit of Elisabeth Wright, August 21, 1865, Richmond. The marriage of two former slaves, Private Rufus Wright and Elisabeth Turner, was presided over by a black army chaplain, the Reverend Henry M. Turner. (National Archives)

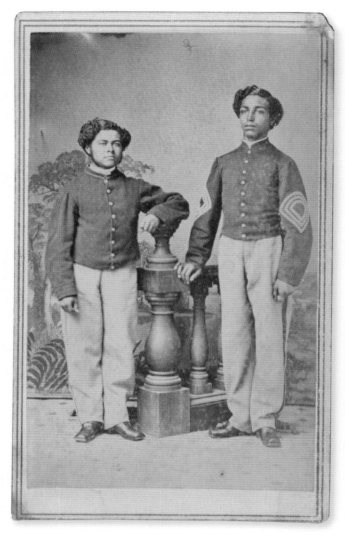

Sergeant Major William L. Henderson and hospital steward Thomas H. S. Pennington of Twentieth US Colored Troops Infantry Regiment in uniform. (Photographer: W. H. Leeson; Library of Congress, Prints and Photographs Division, LC-DIG-ppmsca-40621)

Soldiers also complained about cruel and unfair treatment when they railed against the officers in the regiment who kept them under close surveillance and would not permit black soldiers' wives to visit them, while white soldiers' wives were welcomed. The following letter to the commander of the Military Division of the Tennessee Regiment questions why the wives of black soldiers had

been turned away from the camp, and the response from the regiment's commander casts doubt on the union by marriage of black men and women and suggests that the visits would encourage illicit affairs. The last letter in the section is addressed to the secretary of war from a black New York soldier, who states that the murders of black soldiers by the rebels need to be treated as an act of war and that the secretary should consider retaliatory executions of rebel prisoners—not in a spirit of revenge but to demonstrate to black soldiers that the government stands behind them.

<div style="text-align: right;">Bridgeport Ala[bama]</div>

N[ovember] 19th 1865

Dear Ser We are here at this place under the cormand of Colonel luster genel I rite you thes few lines to let you know the condishon that we are living we are guarded there night and day no even permitted to go to the spring after a drink of water onley by companys wether Corprel Sargent they hav all got in to such a comfuse ment they say they will not stand it any longger I say to you less than ten days there will be over half the men gon from the regment if they is not treatted better they keep they bys hand cuf evver day and night and I cant see what it is for if they do any thing to be hand cuff for we wold not exspec any thing eles mens wifes comes here to see them and he will not alow them to come in to they lines uur the men to go out to see them after the comg over hundred miles but evver offiscer here that has a wife is got her here in camps & one mans wif feel jest as near to him as anurther a colard man think jest as much of his wife as a white man dus of his if he is black they keep us hemd up here in side the guarde line and if our wife comes they hav to stand out side & he in side and talk a cross they lines that is as near as they can come they treat this hold reg ment like it was prisners we volenterd and come in to the servest to portec this govverment and also to be portected our selves at the same time but the way colonel luster is treating us it dont seem like to me that he thinks we are human

I rite these few lines to you to see if we cant get some releaf yours truly a friend

George Buck Hanon

[From Colonel F. W. Lister]
Bridgeport Ala[bama]

Dec[embe]r 14th [18]65

General I have the honor to acknowledge the receipt of a communication addressed to the Major Gen[eral] com[manding], professing to be signed and written by "George Buchhanon 40th USCI."

Altho' no such man can be found in the rolls of the regiment nor any name approximating to it, neither can any man be found to father the document, yet in obedience to the order contained in your endorsement, I subjoin the following statement.

The sum & substance of the complaint set forth against me seems to resolve into this, that I am endeavoring to maintain discipline in a regiment of US troops committed to my care, and that I prevent the camp of the said regiment from becoming a brothel on a gigantic scale. To this I plead guilty.

The marital relationship is but little understood by the colored race, and, if possible still less respected.

I have from time to time caused a careful inquiry to be made by company commander's with the view to ascertain the number of men who are married by any process known to civilization, or even those who by long cohabitation might be looked on as possessing some faint notions of constancy and decency. Even with this lax view not more than one in four who claim to have wives can support that claim.

In fact the larger proportion of the enlisted men change their so called wives as often as the regiment changes stations.

The immorality developed after last pay day required a strong effort to repress it. Large herds of colored prostitutes flocked to Bridgeport from both ends of the line, but the guard regulations not suiting them, the greater proportion soon left for "fresh fields & pastures new."

It is just within the bounds of possibility that some virtuous wives may have been amongst the number so excluded from camp, but I gravely doubt it.

The Rev[erend] John Poucher, Chaplain of my regiment is doing his best to correct the vices so prevalent amongst colored soldiers, but the habits of licentiousness not only permitted but greatly encouraged by the former owners of these men are hard to eradicate.

The charge of guarding parties going for water is partly true. Water has to be brought from a considerable distance, the road to it lies thro' the line of stores erected here for the express purpose of robbing soldiers, the proprietors of which having laid in a stock of whisky in anticipation of pay-day did, both on and on the day after that day, make nearly the entire regiment drunk.

I was compelled to adopt severe measures with store keepers and soldiers, since which there has been no trouble on that subject.

It is also true that I keep some of the men hand-cuffed, and only regret I cannot have some of them shot. Deserters who have twice escaped and who are constantly trying to escape, men who draw their bayonets on officers, and who stab their comrades are I think fit subjects for irons whilst awaiting trial.

On the subject of leave from camp &c I submit the following rules. All men not on duty may leave camp without passes between company drill and dinner roll call or from 10 A.M. to 12. M, and again from 12.30 to 1.30 P.M, making in all three hours daily. I have a vivid recollection of the time when I did not spend that time from my regiment in one year, and think that three hours daily is sufficient for these men of tender and domestic feelings to enjoy in the bosoms of their families.

Prowling over the country between tattoo & reveille is entirely stopped, in fact it never existed, and that is of course the time the badly disposed men want to commit outrages. I have the honor to be, General, Very respectfully, Your obed[ien]t Serv[an]t[6]

[From Theodore Hodgkins]
F. W. Lister
Black New Yorker to the
Secretary of War
New York [NY] April 18th 1864

Sir: Some Sixty or Seventy thousand of my down trodden and despised brethren now wear the uniform of the United States and are bearing the gun and sword in protecting the life of this once great nation with this in view I am emboldened to address a few words to you in their behalf if not in behalf of the government itself. Jeff Davis issued a threat that black men fighting for the U.S. should not be treated as prisoners of war and the President issued a proclamation threatening retaliation. Since

then black soldiers have been murdered again and again yet where is there an instance of retaliation. To be sure there has been a sort of secrecy about many of these slaughters of colored troops that prevented an official declaration to be made but there is now an open and bold murder, an act following the proclaimed threat made in cold blood gives the government an opportunity to show the world whether the rebels or the U.S. have the strongest power. If the murder of the colored troops at Fort Pillow is not followed by prompt action on the part of our government. it may as well disband all its colored troops for no soldiers whom the government will not protect can be depended upon. Now Sir if you will permit a colored man to give not exactly advice to your excellency but the expression of his fellow colored men so as to give them heart and courage to believe in their government you can do so by a prompt retaliation. Let the same no. of rebel soldiers, privates and officers be selected from those now in confinement as prisoners of war captured at the west and let them be surrounded by two or three regiments of colored troops who may be allowed to open fire upon them in squads of 50 or 100, with howitzers loaded with grape. The whole civilized world will approve of this necessary military execution and the rebels will learn that the U.S. Govt. is not to be trifled with and the black men will feel not a spirit of revenge for have they not often taken the rebels prisoners even their old masters without indulging in a fiendish spirit of revenge or exultation. Do this sir promptly and without notice to the rebels at Richmond when the execution has been made then an official declaration or explanation may be made. If the threat is made first or notice given to the rebels they will set apart the same no. for execution. Even that mild copperhead Reverdy Johnston avowed in a speech in the Senate that this govt. could only be satisfied with man for man as an act of retaliation. This request or suggestion is not made in a spirit of vindicativeness but simply in the interest of my poor suffering confiding fellow negros who are even now assembling at Annapolis and other points to reinforce the army of the Union Act first in this matter afterward explain or threaten the act tells the threat or demand is regarded as idle. I am Sir with great respect Your humble Servant.

Theodore Hodgkins[7]

Almost as soon as the fighting ended, soldiers and others who survived the horrid experiences, as well as scholars, educators, photographers, and activists, started to tell the history of the war in exhibitions, books, displays, and news stories. They organized campaigns to build monuments to honor and remember. For example, Daniel A. P. Murray produced a pamphlet that presented a more objective history of the experiences of black soldiers in the Civil War: "The pen of the historian has been used to almost exclude any reference to the service of Negro soldiers in the Union army. It is not known that any black men ever distinguished themselves as soldiers. None of the individual acts of unsurpassed bravery, courage, coolness, dash of the Negro regiments are recorded by those who have furnished us history."[8]

Mass-produced photographs played a major role in visualizing this history, such as stereographs printed and produced under thematic titles such as *Incidents of the War* and *The War for the Union*. "In addition to the public demand for images of battlefields and newsmakers, photographers profited from the immense market for individual portraits of servicemen. . . . This great demand for portraits was a natural consequence of the departure of hundreds of thousands of young men for the uncertainties of war. Soldiers routinely exchanged portraits with their loved ones before they left for war [and] then transmitted later images by mail. With death an unignorable reality, many soldiers sat repeatedly for portraits in order to ensure the longevity of at least their image and memory."[9]

The horrific moments captured in the following affidavit from the wife of a discharged soldier from Georgia probably mirrored the experiences of other women who were raped and tortured because their husbands joined the Union army.

[Griffin, Georgia]

Sept. 25, 1866

Rhoda Ann Childs came into this office and made the following statement:

"Myself and husband were under contract with Mrs. Amelia Childs of Henry County, and worked from Jan. 1, 1866, until the crops were laid by, or in other words until the main work of the year was done, without difficulty. Then (the fashion being prevalent among the planters), we were called upon one night, and

my husband was demanded; I Said he was not there. They then asked where he was. I Said he was gone to the water mellon patch. They then Seized me and took me Some distance from the house, where they 'bucked' me down across a log, Stripped my clothes over my head, one of the men Standing astride my neck, and beat me across my posterior, two men holding my legs. In this manner I was beaten until they were tired. Then they turned me parallel with the log, laying my neck on a limb which projected from the log, and one man placing his foot upon my neck, beat me again on my hip and thigh. Then I was thrown upon the ground on my back, one of the men Stood upon my breast, while two others took hold of my feet and stretched My limbs as far apart as they could, while the man Standing upon my breast applied the Strap to my private parts until fatigued into stopping, and I was more dead than alive. Then a man, Supposed to be an ex-confederate Soldier, as he was on crutches, fell upon me and ravished me. During the whipping one of the men ran his pistol into me, and Said he had a hell of a mind to pull the trigger, and Swore they ought to Shoot me, as my husband had been in the 'God damned Yankee Army,' and Swore they meant to kill every black Son-of-a-bitch they could find that had ever fought against them. They then went back to the house, Seized my two daughters and beat them, demanding their father's pistol, and upon failure to get that, they entered the house and took Such articles of clothing as Suited their fancy, and decamped. There were concerned in this affair eight men, none of which could be recognized for certain."

X [her mark]
Rhoda Ann Childs[10]

Letters also emphasized the need to educate soldiers and prepare them for life after the war. In the following letter, a black sergeant from Kentucky writes to the assistant commissioner at the Tennessee Freedmen's Bureau, Brigadier General Clinton H. Fisk.

Nashville Tenn[essee]

October 8th 1865

Sir I have the honor to call your attention To the neccesity of having a school for The benefit of our regement We have never

Had an institution of that sort and we Stand deeply inneed of in-
struction the majority of us having been slaves We Wish to have
some benefit of education To make of ourselves capable of buis-
ness In the future We have estableshed a literary Association
which flourished previous to our March to Nashville We wish
to become a People capable of self support as we are Capable of
being soldiers my home is in Kentucky Where Prejudice reigns
like the Mountain Oak and I do lack that cultivation of mind that
would have an attendency To cast a cloud over my future life
after have been in the United States service I had a leave of ab-
scence a few weeks a go on A furlough and it made my heart ache
to see my race of people there neglected And ill treated on the
account of the lack of Education being incapable of putting Thier
complaints or applications in writing For the want of Education
totally ignorant Of the Great Good Workings of the Government
in our behalf We as soldiers Have our officers Who are our pro-
tection To teach how us to act and to do But Sir What we want is
a general system of education In our regiment for our moral and
literary elevation these being our motives We have the Honor of
calling your very high Consideration Respectfully Submitted as
Your Most humble serv[an]t.

John Sweeny[11]

This collection of words gathered from letters and diaries can
be seen as an object lesson in reconstructing memory. The let-
ters are distressingly painful to read because of the descriptions
of the exploitation of black men and the molestation of the women
and and daughters; yet some share a hopeful future, as the writers
fight for their collective freedom. In reading the letters and view-
ing these photographs, we become more and more aware of the
long fight for justice that continues today. These observations and
firsthand experiences are extraordinary, as we sit at the elbow of
the scribe, the knee of the narrator, the table of the journalist and
teacher.

In 1900, the bibliophile Murray, the sociologist and educator
W. E. B. Du Bois, the lawyer and educator Thomas J. Calloway,
and Andrew F. Hilyer of the National Negro Business League col-
laborated on an exhibition titled *A Small Nation of People* for the

Exposition des Nègres d'Amerique (Exhibit of American Negroes) at the Universelle de Paris Exposition. One of the points the distinguished exhibition organizers wanted to make was to "show . . . Negroes in America since their emancipation." Reporting on the exhibition, Calloway wrote, "Almost the first object seen in the United States negro exhibit, with figure and arms in the attitude of speaking, was the statuette of the famous negro scholar and orator, Frederick Douglas [*sic*]. . . . In the last case to the right was a miscellaneous collection of photographs, charts, etc., showing medal-of-honor men, factories owned or operated by negroes . . . [and] negro soldiers."[12]

The *Exposition des Nègres d'Amerique* was located in a small corner, and the display included charts, numerous photographs and albums, maps, 270 books, and more than 1,400 pamphlets focusing on African American history. Du Bois described the exhibit as an "honest, straight-forward exhibit of a small nation of people, picturing their life and development without apology or gloss."[13] He included a composite portrait of Medal of Honor recipients along with 363 photographs titled *Types of American Negros, Georgia, USA* and *Negro Life in Georgia, USA*. The exposition judges awarded Du Bois a gold medal for his role in organizing the exhibit.

The photographs of the men, some in uniform, were identified by name.

(Facing page) Portraits of fifteen African American soldiers and sailors who received Medals of Honor for service in the Civil War, American Indian Wars, and Spanish-American War: Sergeant John Denny, Co. B, Ninth US Cavalry Regiment; Private James Gardiner, Co. I, Thirty-Sixth US Colored Troops Infantry Regiment; Sergeant-Major Milton M. Holland, Co. C, Fifth US Colored Troops Infantry Regiment; Private Dennis Bell, Troop H, Tenth US Cavalry Regiment; Sergeant Brent Woods, Co. B, Ninth US Cavalry Regiment; Sergeant Thomas Hawkins, Co. C, Sixth US Colored Troops Infantry Regiment; Corporal Isaiah Mays, Co. B, Twenty-Fourth US Infantry Regiment; Sergeant Robert A. Pinn, Co. I, Fifth US Colored Troops Infantry Regiment; Landsman John Lawson, US Navy; Sergeant William H. Carney, Co. C, Fifty-Fourth Massachusetts Infantry Regiment; Sergeant Powhatan Beaty, Co. G, Fifth US Colored Troops Infantry Regiment; Sergeant James H. Harris, Co. B, Thirty-Eighth US Colored Troops Infantry Regiment; Sergeant Thomas Shaw, Co. K, Ninth US Cavalry Regiment; Sergeant Alexander Kelly, Co. F, Sixth US Colored Troops Infantry Regiment; and Sergeant-Major Christian Fleetwood, Co. G, Fourth US Colored Troops Infantry Regiment. (Library of Congress, Prints and Photographs Division, call number: LOT 11931, no. 69 [P&P])

MEDAL OF HONOR MEN.

ARMY.

NAVY.

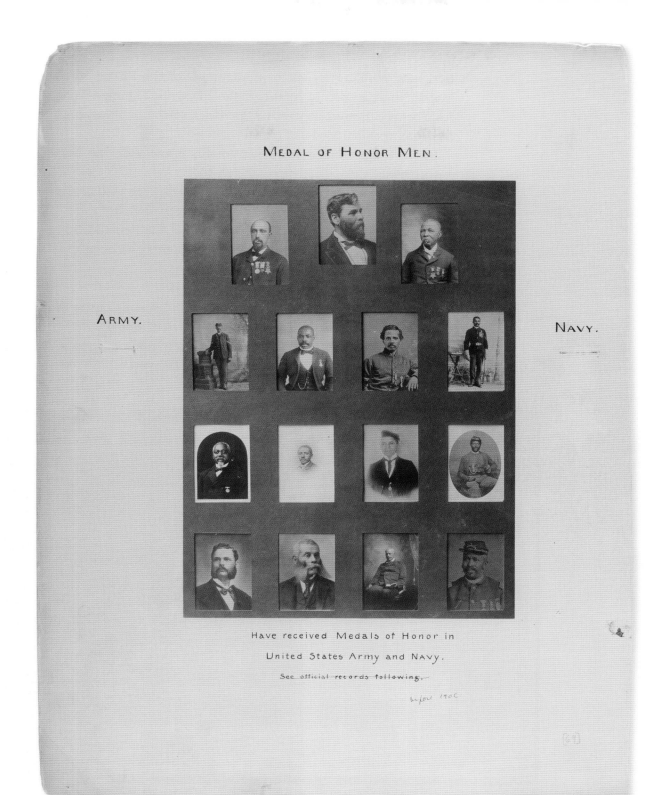

Have received Medals of Honor in
United States Army and Navy.

See official records following.

Sergeant William Carney, of Company C of the Fifty-Fourth Massachusetts Colored Infantry, who saved the regiment's flag from being captured; he was the first black soldier to be awarded the Congressional Medal of Honor

Sailor Robert Blake, rewarded for his bravery on the USS *Marblehead*[14]

First Sergeant Powhatan Beaty, Company G, Fifth USCT, who took charge after all officers had died or were wounded

Sergeant Major Christian A. Fleetwood of the Fourth USCT, who rescued the banner when two colors guards had been shot down.

Several of the portraits of military men and scenes of the Civil War convey the quiet dignity found in the act of wearing the uniform. A similar sense of pleasure can be seen in photographs of parades and community celebrations honoring the veterans. There is

Black family by fireplace, artwork (depicting the battle at Fort Wagner) from the series "Southern Negroes" by Lewis Hine, ca. 1920. (Gelatin silver print; George Eastman House; transfer from Photo League Lewis Hine Memorial Committee; ex-collection of Corydon Hine)

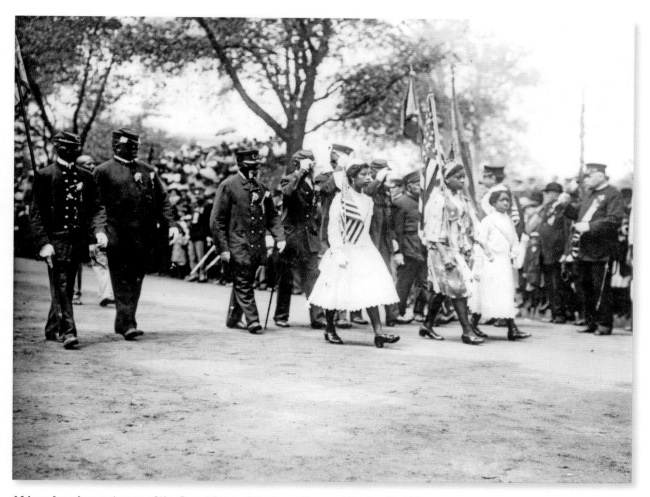

African American veterans of the Grand Army of the Republic marching in a Civil War Veteran's Memorial Day parade, New York City, May 30, 1912. (Charles L. Blockson Afro-American Collection, Temple University)

a powerful connection between the photographs, diary pages, and letters in the *Exposition des Nègres d'Amerique*. Another exhibit at the Paris exposition included the *Shaw Memorial*, the sculptor Augustus Saint-Gaudens's tribute to Robert Gould Shaw and the Fifty-Fourth Massachusetts Regiment. As Lindsay Harris observes, "international audiences [saw] the significance of Saint-Gaudens' monument as a symbol of the New Negro, who had risen from slave to soldier during the Civil War and now faced the challenge of defining himself as an American citizen."[15] The images in the exposition gave voice to the written record of the newly free black class.

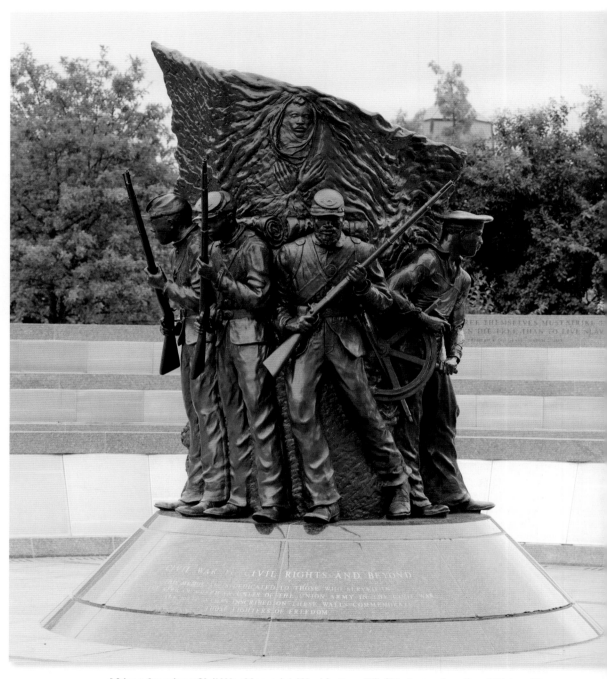

African American Civil War Memorial, Washington, DC. (Photographer: Carol Highsmith; Library of Congress, Prints and Photographs Division, LC-DIG-highsm-04880)

"Come Join Us Brothers." (Photographer: Wendel A. White; from the Manifest Portfolio 2019 postcard from Duke Library; Courtesy of Wendel White)

Restless after the Longest Winter You Marched & Marched, by Carrie Mae Weems. (From the series "Where I Saw What Happened and Cried," 1995-96; chromogenic print with etched text on glass; courtesy of Carrie Mae Weems and Jack Shainman Gallery)

Sergeant Carney Monument, West Point Cemetery, Norfolk, Virginia. (Photographer: William Earle Williams, 2004; courtesy of William Earle Williams)

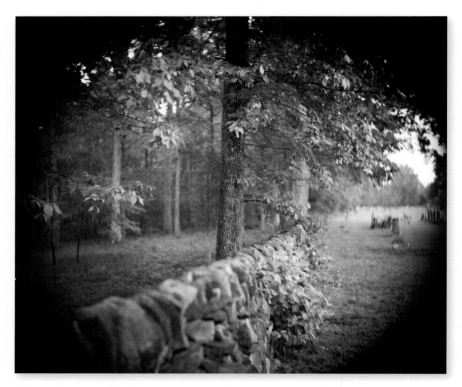

Divided in Death, from "Lament," a song of sorrow for those not heard. (Photographer: Linda Foard Roberts, 2016; toned gelatin silver photograph; courtesy of Linda Foard Roberts)

The role of portraiture has evolved since the nineteenth century; today, contemporary photographers like Carrie Mae Weems, Wendel A. White, Linda Foard Roberts, and William Earle Williams reflect on the individual and community concerns of the Civil War soldier. They have visited and reinterpreted monuments and grave sites—such as the Shaw Memorial and a statue in Norfolk, Virginia, of William Carney (1840–1908), a Civil War veteran and Medal of Honor recipient—that have had an impact on our collective history and memory. White's photographs highlight the memory of the Civil War soldiers, as he uses a soft-focused lens to blur the story that has been hidden for decades in the archive. Weems and Williams create new stories about hope and freedom, the expressive act of self-fashioning and self-emancipation, and the idea of resistance, as represented by the two monuments.

For a number of years, Williams has photographed Civil War battlegrounds in an effort to document and reimagine the experience of

black soldiers, who fought in numerous battles all over the South—at New Market Heights, Chaffin's Farm, Petersburg, and Richmond in Virginia; Milliken's Bend in Louisiana; Fort Wagner, James Island, and Honey Hill in South Carolina; and Olustee in Florida. Williams's photograph titled *Sergeant Carney Monument, West Point Cemetery, Norfolk, Virginia*, taken in 2004, some ninety years after Carney's death in 1908, captures the soldier's heroism and bravery. Positioning the uniformed Sergeant Carney atop a granite column, holding a rifle, the monument was completed in 1920 after twelve years of construction.

The notion of resistance and recovering stories is key to this image. As Alan Trachtenberg observes, "The role of African Americans in the struggle against slavery has been long repressed by guardians of certain 'official' and privileged versions of the American past. Racial prejudice has been the major cause of the expunging and erasure of the role of blacks in determining their own future. It remains in the interests of some groups vested in continuing and preserving racial inequality to portray African Americans as unable to take command of their own lives, as inherently subordinate."[16] Williams recognized this absence in history and had the tenacity to research, document, and fill in the gaps. In doing so, he made remarkable photographs that kept this memory ever-present.

Restless after the Longest Winter You Marched & Marched & Marched, by Carrie Mae Weems—part of her series "From Here I Saw What Happened and I Cried"—makes the individual experience visible through diaristic text etched on glass over a strikingly red-tinted print. Weems uses the printmaker Richard Benson's photograph of Saint-Gaudens's monument to dramatize the long marches and cold wintery nights the soldiers endured in their fight for freedom. In her work, collective memory and the imaginary remind us about the heavy toll of war and the lives lost. The photograph is cropped closely to focus on the sculpture's profiled portraits of the men "of the 54th Regiment marching down Beacon Street on May 28, 1863 as they left Boston to head south." Weems brilliantly focuses on one soldier; sweat appears to drip from his cap, but it is tarnish, a reaction to the elements found in Boston winters. Roberts's "Lament Series" centers on the long story of the Underground Railroad and takes us on a journey of the past and present. Her photographs depict a stone wall, focusing our attention

on a burial ground in North Carolina where the remains of black and white residents are still segregated.

White, Williams, Roberts, and Weems honor the memory of black soldiers, including those of the Fifty-Fourth Massachusetts, which lost seventy-four enlisted men and three officers, including Colonel Shaw, at Fort Wagner in 1863. Sergeant William H. Carney was one of the regiment's many wounded.

The original works presented here represent some of the most compelling writing and visual responses to what was known at the time as the Rebellion. Rediscovered voices and photographs help us grapple with a history that has often excluded stories about the bravery of black soldiers and the uncelebrated work of black women teachers and nurses. As you look at these images, I urge you to recall the words of Lewis Douglass: "The regiment has established its reputation as a fighting regiment. . . . I wish we had a hundred thousand colored troops—we would put an end to this war."[17] We imagine what such words meant to the proud and determined black troops who defended the Union and fought for freedom.

ACKNOWLEDGMENTS

I have a good number of people to thank, and as I think back to the beginning, I would like to acknowledge my work with Claudine K. Brown, Jane Lusaka, Mark Wright, and Deirdre Cross at the Smithsonian's National African American Museum Project. As a curator and the collections coordinator for that project—which eventually became the Smithsonian Institution's National Museum of African American History and Culture—I traveled all over the United States, visiting collectors, families, historical societies, and libraries, reviewing collections for possible inclusion in the museum. During the 1980s and 1990s, I met collectors who had rare photographs of black Civil War soldiers. Many of them wanted to share stories about their findings and their extraordinary collections. Early on I met Charles L. Blockson, Bill Gladstone, and Randolph Linsly Simpson, and today their collections are at Temple University, Library of Congress, Amistad at the Wadsworth, and Yale University. All three had exemplary collections of photographs that changed the national memory about the activities of black people during the Civil War years.

In 2013, Barbara Krauthamer and I published a book titled *Envisioning Emancipation: Black Americans and the End of Slavery*, which opened up a discussion about how to imagine "freedom" through the photograph. I was invited to present a paper on the black Civil War soldier at the National Gallery of Art in 2015 and in 2017 at Canterbury Christchurch University in Belfast at the

British Association for American Studies and the Irish Association for American Studies joint conference, and during my research for the two presentations, I came across images of black men and women standing in front of the camera with powerful poses that shaped the idea for a book of this type.

In *Stranger in the Village*, James Baldwin noted, "People are trapped in history and history is trapped in them." That statement resonated with me as I considered the diverse ways in which to identify themes for this book. How should I tell the stories of the Civil War? Where should I begin? I turned to images from popular culture, movies such as *Gone with the Wind* and *Glory*, and Ken Burns's and Henry Louis Gates's extraordinary documentaries focusing on the Civil War and Reconstruction. I was thrilled to see exhibitions on the Civil War at the Metropolitan Museum of Art, the National Gallery of Art, the Smithsonian American Art Museum, the National Museum of African American History and Culture, and the Schomburg Center, as well as the remarkable online exhibition *Mirror of Race* hosted by Gregory Fried, Suffolk University, and the collection of Greg French, to name a few. Following Baldwin's words, I wanted to unpack the idea of history as being "trapped" and open up the door to photographs that held new and old stories.

I thank Ronald S. Coddington for his books on this topic, as they helped me identify the names of key figures and places. Pamela Newkirk's book on letters written by black Americans helped me complete the counternarrative of the war. I also read Jill Watts's *Hattie McDaniel: Black Ambition, White Hollywood*. Hattie's story warmed my heart in numerous ways. Jill and I had the same mentor, Richard Newman, and as I read her book, I embraced all of the wonderful mentoring Dick shared with us as we explored different stories about black America. Hattie's father, Henry McDaniel, was a Civil War soldier, and in addition to describing his service in Fort Pillow and Nashville, Jill includes a photograph of Henry McDaniel holding a rifle and wearing a soldier's hat. Even though he had a difficult time—he served under a racist commander, earned less pay than white soldiers, and wore a substandard uniform—his photograph encouraged me to look through the pension records for additional stories of wounded soldiers, to find ways to acknowledge the history of the black soldiers who worked, battled, and died during the war. McDaniel was mustered out of the Twelfth US Colored

Infantry on January 16, 1866, with a paycheck of $5.88. Watts's vivid and heart-wrenching account of McDaniel's eighteen-year attempt to obtain his pension was also an inspiration for this book.

Many remarkable people assisted in the research and conversations, including Awam Amkpa, Millington Bergeson-Lockwood, Celeste-Marie Bernier, Isolde Brielmaier, Kalia Brooks Nelson, Rachelle Browne, Lonnie Bunch, A'Lelia Bundles, Mary Schmidt Campbell, Edgar Castillo, Manthia Diawara, David C. Driskell, Sandra Jackson Dumont, Cheryl Finley, Henry Louis Gates Jr., Lonnie Graham, Susan Kae Grant, Allyson Green, Sharon Harley, Sharon Howard, Tera Hunter, Kellie Jones, Niki Kekos, Leslie Willis-Lowry, Patricia McKelvin, Sarah Elizabeth Lewis, Maaza Mengiste, Jennifer Morgan, Mary Natori, Jill Newmark, Clement Price, Guthrie Ramsey, Linda Foard Roberts, Jeff Rosenheim, Kathe Sandler, Gunja SenGupta, John Stauffer, Ellyn Toscano, Zenobia Tucker, Sharon Watson-Mauro, Carrie Mae Weems, Wendel A. White, Carla Williams, William Earle Williams, and Francille Rusan Wilson.

I especially thank staff members in the public and private collections I visited over the years, including the New-York Historical Society; National Archives; 54th Massachusetts Volunteer Infantry Regiment photography collection, Massachusetts Historical Society; Manuscript Division, Prints and Photographs Division, and Liljenquist Family Collection of Civil War Photographs, Library of Congress; Moorland-Spingarn Research Center, Howard University; Onondaga Historical Association; Schomburg Center for Research in Black Culture, Photographs and Prints Division, New York Public Library; Randolph Linsly Simpson African-American Collection, Beinecke Rare Book and Manuscript Library, Yale University; National Gallery of Art; Charina Endowment Fund; Jack Shainman Gallery; Charles L. Blockson Afro-American Collection, Temple University; National Museum of African American History and Culture, National Museum of American History, and National Portrait Gallery, Smithsonian Institution; National Gallery of Art; Jacob Loewenthiel Collection; Greg French Collection; Oblate Sisters of Providence Archives; National Library of Medicine; Stephan Loewentheil History of Photography Collection, Kroch Library, Cornell University; Beaufort County Black Chamber of Commerce; Louisiana Collection, State Library of Louisiana; Archives and Research Collections Centre, Western Libraries, Western University.

In many cases, my captions directly reproduce those supplied by the collections or have been lightly edited.

I owe an enormous debt to the people I have met—from graduate students to friends to professors to enthusiasts. They shared a number of wonderful stories; many I could follow up on, while others I could not, and I thank all who remain supporters of my work.

My heartfelt appreciation goes to my family, Hank Thomas, Hank Willis Thomas, Rujeko Hockley, Zenzele Ruth Hockley Thomas, Melvina Lathan, and my ninety-eight-year-old mom, Ruth Holman Willis, who listened over the years and helped me create the broad stories of the Civil War. I thank Hank's steadfast interest in helping me find new discoveries while looking through historical newspapers, rare books, the History Channel, PBS, and the Smithsonian Channel. Special thanks to my big sis, Yvonne Willis Brooks, who will miss reading this book but read early versions with great enthusiasm. Thanks go to Dean Phillip Brian Harper for introducing this project to New York University Press; to all the NYU Press team, especially Eric C. Zinner and Dolma Ombadykow; to the NYU Center for the Humanities and the Office of the Provost; and, as always, to Faith Childs, my wise guide through the halls of publishing.

NOTES

Preface

1. In particular, I am referring to the work of Stuart Hall, Marianne Hirsch, Richard Powell, Saidiya Hartman, Eric Foner, Maurice Berger, Cheryl Finley, Kellie Jones, Jasmine Nichole Cobb, and Tina Campt.

2. Okwui Enwezor, review of *The Unfinished Conversation*, by John Akomfrah, *Art Forum*, December 2013, www.artforum.com.

3. "So far as learned, claimant's manner of living since she has been in Hudson, N.Y., subsequent to the death of Henry M. Brewster, has been above reproach, and she bears a fairly good reputation. She stated that the picture of Henry M. Brewster loaned for use during this examination is the only picture she has of him, and requested that it be returned to her." Hon. Commissioner of Pensions, August 13, 1909, Department of the Interior, Bureau of Pensions, Washington, DC.

4. Case of Susan Ann Brewster, No. 829330, Bureau of Pensions, August 11, 1909, Hudson County of Columbia, State of New York, National Archives, Washington, DC, www.archives.gov/research/military/civil-war.

5. Hunter, *Bound in Wedlock*, 163.

6. Budge Weidman, "Black Soldiers in the Civil War: Preserving the Legacy of the United States Colored Troops," Educator Resources, National Archives, 1997, accessed March 19, 2019, www.archives.gov/education/lessons/blacks-civil-war/article.html.

Introduction

1. Holland, *Frederick Douglass*, 301; Cecelski, *Fire of Freedom*, 98; "Dr. Alexander T. Augusta: Patriot, Officer, Doctor," in *Binding Wounds, Pushing Boundaries: African Americans in Civil War Medicine*, exhibition, National Institutes of Health, US Department of Health and Human Services, last updated July 15, 2013, www.nlm.nih.gov/exhibition/bindingwounds/pdfs/BioAugustaOB571.pdf.

2. Stauffer, Trodd, and Bernier, *Picturing Frederick Douglass*, 123.

3. Lewis, "Vision & Justice," 11.

4. McPherson, *Negro's Civil War*, 216.

5. Taylor, *Reminiscences of My Life in Camp*, 21, 26.

6. Edwin S. Redkey, introduction to Redkey, *Grand Army of Black Men*, 3.

7. "Photographers and Their Studios," in *The Last Full Measure: Civil War Photographs from the Liljenquist Family Collection*, exhibition, Library of Congress, accessed May 30, 2020, www.loc.gov.

8. Ochs, "Patriot, a Priest and a Prelate," 51.

Chapter One: 1860–61

1. US War Department, *War of the Rebellion*, vol. 1, 31.

2. John David Hoptak, "Nick Biddle: A Forgotten Hero of the Civil War," *Pennsylvania Heritage*, Spring 2010, www.phmc.state.pa.us.

3. US War Department, *War of the Rebellion*, vol. 2, 7–9.

4. James Redpath, editorial, *Boston and New York Pine and Palm*, May 18, 1861, accessed at American Historical Association, "The Pine and Palm," *Sixteen Months to Sumter: Newspaper Editorials on the Path to Secession*, accessed June 3, 2016, www.historians.org/teaching-and-learning/teaching-resources-for-historians/sixteen-months-to-sumter/newspaper-index/boston-and-new-york-pine-and-palm/the-pine-and-palm.

5. John Muller, "Dr. William Henry Johnson: Albany (NY) Correspondent of *The North Star*," *The Lion of Anacostia* (blog), April 16, 2018, https://thelionofanacostia.wordpress.com.

6. William H. Johnson, 2nd Connecticut Infantry, Washington, DC, July 24, 1861, letter 1, in Redkey, *Grand Army of Black Men*, 10–12; *Pine and Palm*, August 3, 1861, 16–17.

7. McPherson, *Negro's Civil War*, 25.

8. Newton, "From Brooklyn to the Civil War," in *Out of the Briars*, viii, 19, 24, and 29. All subsequent quotes from Newton are from this source.

9. Ronald S. Coddington, "Out of the Briars, *New York Times*, April 22, 2011, https://opinionator.blogs.nytimes.com.

10. See John V. Givens to Thomas Hamilton, October 12, 1861, in Yacovone, *Freedom's Journey*, 93–98.

11. The Union League of America (or Loyal League) was the first African American Radical Republican organization in the Southern United States. The league was created in the North during the Civil War as a patriotic club to support the Union. Brittany Rogers, "Union League (1863–)," BlackPast, February 26, 2009, www.blackpast.org.

12. Eric Wills, "The Forgotten: The Contraband of America and the Road to Freedom," *Preservation* (National Trust for Historic Preservation), May–June 2011, https://savingplaces.org.

13. General Benjamin Butler, commanding general of Fort Monroe in Virginia, declared the fugitive slaves who sought refuge in the fort

after escaping the slave masters "contraband of war"—enemy property that was liable to seizure in wartime, just as weapons, ammunition, and food were.

14. Givens to Hamilton, October 12, 1861, 95-97.
15. US War Department, *War of the Rebellion*, vol. 2, 53.
16. US War Department, 649-50. Under the policy then current of the federal government, those loyal citizens of the Union could keep their slaves.
17. US War Department, 650.
18. US War Department, 652.
19. "Letter from John Boston to His Wife Elizabeth," January 12, 1862, enclosed in a letter from Major General George B. McClellan to Hon. Edwin Stanton, January 21, 1862, 783102, National Archives, Washington, DC. The envelope is addressed, in a different handwriting, to "Mrs. Elizabeth Boston. Care Mrs. Prescia Owen, Owensville Post Office, Maryland"; Newkirk, *Letters from Black America.*
20. Wm. A. Jones to Hon. S. Cameron, November 27, 1861, J-52 1861, Letters Received Irregular, Secretary of War, RG 107, National Archives, reprinted in Berlin, Reidy, and Rowland, *Black Military Experience*, 80-81, and in Berlin and Fields, *Free at Last*, 18-19.
21. Ronald S. Coddington, "A Slave's Service in the Confederate Army," *New York Times*, September 24, 2013, http://opinionator.blogs.nytimes.com.
22. Michael E. Ruane, "Library of Congress Acquires Iconic Civil War Image of Master and Slave Headed to War," *Washington Post*, August 24, 2014, www.washingtonpost.com.

Chapter Two: 1861-62

1. General George Brinton McClellan commanded Union forces during the Civil War. President Lincoln removed him from command after he failed to claim Richmond.
2. In September 1861, Burnside was given command of three brigades known as the North Carolina Expeditionary Force to launch an attack against the North Carolina coast. American Battlefield Trust, "Ambrose E. Burnside," accessed May 10, 2018, www.battlefields.org.
3. John Muller, "Dr. William Henry Johnson: Albany (NY) Correspondent of *The North Star*," *The Lion of Anacostia* (blog), April 16, 2018, https://thelionof anacostia.wordpress.com.
4. Williams, *History of the Negro Troops*, 76-77.
5. Williams, 77-78.
6. In 1861, 38,805 lived in Beaufort district at the head of Port Royal, 32,279 were enslaved. "The Slavery Question Necessity for Some Uniform Policy," *New York Times*, November 9, 1861, 4, www.nytimes.com.
7. Willie Lee Rose, *Rehearsal for Reconstruction: The Port Royal Experiment* (Oxford: Oxford University Press, 1964), 15-16.
8. Olmsted and Censer, *Defending the Union*, 276.

9. Charlotte Forten, "Life on the Sea Islands," *Atlantic*, May 1864, www.theatlantic.com/magazine/archive/1864/05/life-on-the-sea-islands/308758/.

10. Higginson, *Black Soldiers/Blue Uniforms*, 2.

11. Higginson, 7, 10–14. The "Hunter Regiment" refers to the First South Carolina Volunteers. This was not the first attempt at a South Carolinian black regiment; Major General David Hunter, who took command of the Union troops in the Department of the South in March 1862, had raised a regiment of five hundred black men, but without the necessary political support, he was forced to disband it in August. At the same time, Robert Smalls, an escaped slave and a Union war hero, traveled to Washington, DC, to request permission for African American men to serve in the Union army. Five days later, on August 25, 1862, and only two weeks after Hunter's regiment was disbanded, Lincoln authorized the creation of a South Carolinian black regiment. Anders Bradley, "The First South Carolina Volunteer Infantry Regiment (1862–1866)," BlackPast, September 9, 2018, www.blackpast.org.

12. Higginson, *Army Life*, 45–48.

Chapter Three: 1863

1. Wilder, *In the Company of Black Men*, 183.

2. Seraile, *Angels of Mercy*; Jeffrey Kraus, "The Burning of the Colored Orphan Asylum, NYC," Jeffrey Kraus Antique Photographics, April 24, 2012, http://antiquephotgraphics.com.

3. Rosenheim, *Photography and the American Civil War*, 163.

4. All of Rogers's letters from "War-Time Letters from Seth Rogers, M.D. Surgeon of the First South Carolina Afterwards the Thirty-third U.S.C.T. 1862–1863," Florida History Online, accessed May 30, 2020, www.unf.edu./floridahistoryonline/Projects/Rogers/index.html.

5. "Letter from Augusta to President Lincoln," in *Binding Wounds, Pushing Boundaries: African Americans in Civil War Medicine*, exhibition, National Institutes of Health, US Department of Health and Human Services, last updated July 15, 2013, www.nlm.nih.gov/exhibition/bindingwounds/pdfs/LetterFromAugustaToPresidentLincoln1863.pdf.

6. Edward Bradley, "Dr. Alexander T. Augusta," *Lincoln Editor* 14, no. 3 (July–September 2014): 5.

7. Ohio Civil War Central, "127th Regiment Ohio Volunteer Infantry (1861–1865)," August 7, 2011, www.ohiocivilwarcentral.com.

8. Shaw, *Blue-Eyed Child of Fortune*, 334–35, 372–75.

9. Forten, *Journal of Charlotte L. Forten*, 191, 194, 196.

10. Adolph J. Gla et al. to Major General Nathaniel P. Banks, April 7, 1863, G-35 1863, Letters Received, series 1920, Civil Affairs, Department of the Gulf, US Army Continental Commands, RG 393, Pt. 1, National Archives; "Black Former Officers in a Louisiana Black Regiment to the Commander of the Department of the Gulf," Freedmen & Southern Society Project,

University of Maryland, last revised February 14, 2020, www.freedmen.umd.edu/Gla.html.

11. Captain Elias D. Strunke to Brigadier General Daniel Ullmann, May 29, 1863, D. Ullmann Papers, Generals' Papers & Books, series 159, Adjutant General's Office, RG 94, National Archives; "Officer in a Louisiana Black Regiment to the Commander of a Louisiana Black Brigade," Freedmen & Southern Society Project, University of Maryland, last revised February 14, 2020, www.freedmen.umd.edu/Strunke.html.

12. Brevet Major General Daniel Ullmann to General Richard C. Drum, April 16, 1887, Generals' Reports of Service, series 160, Adjutant General's Office, RG 94, National Archives.

13. Major General Nathaniel P. Banks to Major General Henry Halleck, May 30, 1863, vol. 26, Union Battle Reports, series 729, War Records Office, Adjutant General's Office, RG 94, National Archives.

14. Hannah Johnson to Hon. Mr. Lincoln, July 31, 1863, J-17 1863, Letters Received, series 360, Colored Troops Division, Adjutant General's Office, RG 94, National Archives; "Mother of a Northern Black Soldier to the President," Freedmen & Southern Society Project, University of Maryland, last revised February 14, 2020, www.freedmen.umd.edu/hjohnsn.htm.

15. Dennis Connors, "Lewis Douglass Fought in the Civil War and Then Married Helen Amelia Loguen," *Syracuse (NY) Post-Standard*, February 29, 2012, www.syracuse.com.

16. Lewis Douglass to Amelia Loguen, July 20, 1863, in Newkirk, *Letters from Black America*, 230.

17. Jean Huets, "A Black Correspondent at the Front," *New York Times*, February 8, 2015, https://opinionator.blogs.nytimes.com.

18. R. J. M. Blackett, preface to Blackett, *Thomas Morris Chester*, xii.

19. Thomas Morris Chester, 1865, in Blackett, 290.

20. Gooding, *On the Altar of Freedom*, 5.

21. Stauffer, Trodd, and Bernier, *Picturing Frederick Douglass*, 124.

22. Jill L. Newmark, "Face to Face with History," *Prologue Magazine* (National Archives), 41, no. 3 (Fall 2009), www.archives.gov.

23. In a review of Reid's book, Steven M. Stowe writes, "Despite the volume's title, Wilder's account is not a diary. As Reid points out, it is based on scores of letters the young surgeon wrote to the woman he would marry in 1868." Stowe, review of *Practicing Medicine in a Black Regiment*, 274.

24. Reid, *Practicing Medicine in a Black Regiment*, 18–19.

25. Reid, 25.

26. Reid, 236–38.

27. Reid, 100.

28. James Henry Gooding to Abraham Lincoln, September 28, 1863, in Aptheker, *Documentary History of the Negro People*, 482–84.

29. Martha to My Dear Husband [Richard Glover], December 30, 1863, enclosed in Brigadier General Wm. A. Pile to Major O. D. Greene, February 11, 1864,

P-91 1864, Letters Received, series 2593, Department of the Missouri, US Army Continental Commands, RG 393, Pt. 1, National Archives; "Missouri Slave Woman to Her Soldier Husband," December 30, 1863, Freedmen & Southern Society Project, University of Maryland, last revised February 14, 2020, www.freedmen.umd.edu/Glover.html.

Chapter Four: 1864

1. Charles Torrey Beman to Amos Beman, June 20, 1864, letter 38, in Redkey, *Grand Army of Black Men*, 98; Amos Beman Scrapbook 2, p. 36, Yale Collection of American Literature, Beinecke Rare Book and Manuscript Library, Yale University Library, New Haven, CT.

2. Rufus Wright to Dear wife, April 2[2], 1864, and Ruphus Wright to dear wife, May 25, 1864, filed with affidavit of Elisabeth Wright, August 21, 1865, Letters & Orders Received, series 4180, Norfolk, VA, Assistant Subassistant Commissioner, Bureau of Refugees, Freedmen, & Abandoned Lands, RG 105, National Archives; "Two Letters from a Black Soldier to His Wife," April and May 1964, Freedmen & Southern Society Project, University of Maryland, last revised February 14, 2020, www.freedmen.umd.edu/RWright.html.

3. Ann Valentine to Andrew Valentine, January 19, 1864, in Newkirk, *Letters from Black America*, 8.

4. Spottswood Rice to his children, September 3, 1864, in Berlin, Reidy, and Rowland, *Black Military Experience*, 690; "Missouri Black Soldier to His Daughters, and to the Owner of One of the Daughters," September 3, 1864, Freedmen & Southern Society Project, University of Maryland, last revised June 19, 2020, www.freedmen.umd.edu/rice.htm. The letter was written from Benton Barracks Hospital, St. Louis, Missouri. The original letter is in RG 393 at the National Archives in Washington, DC.

5. Spottswood Rice to the owner of one of his daughters, September 3, 1864, in Berlin, Reidy, and Rowland, *Black Military Experience*, 689-90; "Missouri Black Soldier to His Daughters, and to the Owner of One of the Daughters."

6. Longacre, *Regiment of Slaves*, 20.

7. Christian A. Fleetwood, "Diary of Sergeant Major Christian A. Fleetwood, US Colored Infantry Fourth Regiment, Company G, 1864," in *The Making of African American Identity*, vol. 1, *1500-1865* (Research Triangle Park, NC: National Humanities Center Toolbox Library, March 2007), 2, http://nationalhumanitiescenter.org/pds/maai/identity/text7/fleetwooddiary.pdf.

8. Michael O. Hughes, "Eyes That Do Not See: Eye Loss and Prosthetic Restoration during the American Civil War Years," *Journal of Ophthalmic Prosthetics* 13, no. 1 (Fall 2008): 1.

9. James W. Grace to the *Mercury*, February 25, 1864, in Gooding, *On the Altar of Freedom*, 114.

10. African Americans celebrated August 1 to commemorate the day in 1833 when Great Britain freed slaves throughout its empire.

11. James Gordon Bennett, publisher of the *New York Herald*, criticized the efforts of black soldiers.

12. Garland H. White to the *Christian Recorder*, August 8, 1864, letter 43, in Redkey, *Grand Army of Black Men*, 110.

13. James H. Payne to the *Christian Recorder*, August 12, 1864, letter 44, in Redkey, 113.

14. "Nursing the Wounded," in *Binding Wounds, Pushing Boundaries: African Americans in Civil War Medicine*, exhibition, National Institutes of Health, US Department of Health and Human Services, last updated July 15, 2013, www.nlm.nih.gov.

15. Moorland Spingarn Research Center, Howard University, "Rapier Family" (paper 164, Manuscript Division, 2015), http://dh.howard.edu.

16. John H. Rapier Jr. to James P. Thomas, Esq., August 19, 1864, in *Binding Wounds, Pushing Boundaries: African Americans in Civil War Medicine*, exhibition, US National Library of Medicine, last updated July 15, 2013, www.nlm.nih.gov/exhibition/bindingwounds/pdfs/rapierletter.pdf.

17. G. H. Freeman to Madam, August 19, 1864, enclosed in Rebecca Guy to the Adjutant General of the Army, March 11, 1865, G-42 1865, Letters Received Relating to Recruiting, series 366, Colored Troops Division, Adjutant General's Office, RG 94, National Archives; "Maryland Black Soldier to the Mother of a Dead Comrade," August 19, 1864, Freedmen & Southern Society Project, University of Maryland, last updated February 14, 2020, www.freedmen.umd.edu/Freeman.html.

18. Jane Welcome to Abraham Lincoln, November 21, 1864, and C. W. Foster, Bureau of Colored Troops, to Mrs. Jane Welcome, December 2, 1864, W-934 1864, Letters Received, series 360, Colored Troops Division, Adjutant General's Office, RG 94, National Archives; "Mother of a Pennsylvania Black Soldier to the President," Freedmen & Southern Society Project, University of Maryland, last updated February 14, 2020, www.freedmen.umd.edu/JWelcome.html.

19. Ramona Rand-Caplan, "Williams, Cathay (1850-)," BlackPast, January 30, 2007, www.blackpast.org.

20. An example of this uniform is in the collections of the National Museum of American History, Smithsonian Institution: "The uniform of the Fifth New York Volunteer Infantry (Duryée's Zouaves), 1861, consisted of a distinctive jacket, vest, sash, baggy trousers, and fez. The Zouave uniform, adopted on both sides by many volunteer units during the first year of the Civil War, was based on that of the elite Zouave battalion of the French Army, whose dashing appearance matched its fighting abilities. In their turn, the French Zouaves modeled their uniform and drill after the native dress and fearless tactics of their former Algerian opponents, encountered in the course of the colonial war of the 1830s." "Soldiering," CivilWar@Smithsonian (National Portrait Gallery), accessed May 30, 2020, www.civilwar.si.edu.

21. "Female Buffalo Soldier—With Documents: Cathay Williams or William Cathay (Cathey)," Buffalo Soldier, 2002, www.buffalosoldier.net/CathayWilliamsFemaleBuffaloSoldierWithDocuments.htm.

22. A sutler is a person who followed an army and sold provisions to the soldiers.

23. In the 1830s, the Cherokee Indians of eastern Tennessee and the Carolinas were forced by the federal government to move to Oklahoma.

24. James H. Payne to the *Christian Recorder*, December 21, 1864, letter 49, in Redkey, *Grand Army of Black Men*, 123.

25. Reid, *Practicing Medicine*, 28; letter to the *Christian Recorder*, April 1864, in Trudeau, *Voices of the 55th*, 93–94.

26. Coddington, *African American Faces*, 153.

27. Milton M. Holland to the *Messenger*, January 19, 1864; "Holland Letter 1," Richmond National Battlefield Park, Virginia, National Park Service, 2015, www.nps.gov/rich/learn/historyculture/mhletter1.htm.

28. Milton M. Holland to the *Messenger*, January 24, 1864, letter 41, in Redkey, *Grand Army of Black Men*, 103; Holland's letter was published in the *Messenger*, February 4, 1864, and reprinted in *Civil War Times Illustrated*, November 1972, 10–15.

29. William McCoslin to the *Christian Recorder*, July 26, 1864, letter 42, in Redkey, *Grand Army of Black Men*, 107.

30. At Fort Pillow, Tennessee, Union troops, especially black soldiers, were shot by Confederate troops while trying to surrender.

31. George W. Reed to the *Christian Recorder*, May 14, 1864, letter 121, in Redkey, *Grand Army of Black Men*, 272.

32. Redkey, *Grand Army of Black Men*, 269.

33. Isaac Van Loon to the *New York Weekly Anglo-African*, August 1864, in Yacovone, *Freedom's Journey*, 149–50. Published in the *New York Weekly Anglo-African*, September 3, 1864.

34. "Bay State" to the *New York Weekly Anglo-African*, April 10, 1864, in Yacovone, 156–59. Published in the *New York Weekly Anglo-African*, April 30, 1864.

Chapter Five: 1865–66

1. H.S.H. Sergeant to the *Christian Recorder*, April 3, 1865, letter 22, in Redkey, *Grand Army of Black Men*, 56.

2. The album is a unique group of thirty-one individual portraits of officers, noncommissioned officers, and enlisted men of Company F, 108th United States Colored Infantry, Randolph Linsly Simpson African-American Collection, JWJ MSS 54, Beinecke Rare Book and Manuscript Library, Yale University, http://hdl.handle.net/10079/fa/beinecke.pubsim.

3. W. B. Johnson, to the *Christian Recorder*, April 28, 1865, letter 23, in Redkey, *Grand Army of Black Men*, 59.

4. Chaplain Garland H. White to the *Christian Recorder*, April 12, 1865, letter 71, in Redkey, *Grand Army of Black Men*, 175–78. Published in the *Christian*

Recorder, April 22, 1865; and *Washington National Republican*, April 3, 1865, evening extra; "Richmond, VA, 1865: 'This is your mother, Garland, who has spent 20 years of grief about her son," CivilWarTalk, July 18, 2014, https://civilwartalk.com/threads/richmond-va-1865-this-is-your-mother-garland-who-has-spent-20-years-of-grief-about-her-son.

5. Affidavit of Patsey Leach, March 25, 1865, filed with H-8 1865, Registered Letters Received, series 3379, TN Assistant Commissioner, Bureau of Refugees, Freedmen, & Abandoned Lands, RG 105, National Archives; "Affidavit of a Kentucky Black Soldier's Widow," Freedmen & Southern Society Project, University of Maryland, last revised February 14, 2020, www.freedmen.umd.edu/Leach.html.

6. George Buck Hanon to "Genel thoms," November 19, 1865, and Col. F. W. Lister to Brigadier General W. D. Whipple, December 14, 1865, Letters Received, 40th USCI, Regimental Books & Papers USCT, Adjutant General's Office, RG 94, National Archives, Endorsements; "Tennessee Black Soldier to the Commander of the Military Division of the Tennessee, and Commander of a Tennessee Black Regiment to Division Headquarters," November 19, 1865, and December 14, 1865, Freedmen & Southern Society Project, University of Maryland, last revised February 14, 2020, www.freedmen.umd.edu/Buck%20Hanon-Lister.html.

7. Theodore Hodgkins to E. M. Stanton, April 18, 1864, H-868 1864, Letters Received, Secretary of War, RG 107, National Archives.

8. Benjamin, *Light after Darkness*, 22, African American Perspectives: Pamphlets from the Daniel A. P. Murray Collection, 1818–1907, Library of Congress, Rare Book and Special Collections Division.

9. Keith F. Davis, "A 'Terrible Distinctness': Photography of the Civil War Era," in Sandweiss, *Photography in Nineteenth-Century America*, 143.

10. Affidavit of Roda Ann Childs, September 25, 1866, vol. 270, 41–42, Register of Complaints, series 893, Griffin, GA, Subassistant Commissioner, Bureau of Refugees, Freedmen, & Abandoned Lands, RG 105, National Archives; "Affidavit of the Wife of a Discharged Georgia Black Soldier," September 25, 1866, Freedmen & Southern Society Project, University of Maryland, last revised February 14, 2020, www.freedmen.umd.edu/Childs.html.

11. 1st Sergeant John Sweeny to Brigadier General Clinton H. Fisk, October 8, 1865, S-82 1866, Registered Letters Received, series 3379, Tennessee Assistant Commissioner, Bureau of Refugees, Freedmen, & Abandoned Lands, RG 105, National Archives; "Kentucky Black Sergeant to the Tennessee Freedmen's Bureau Assistant Commissioner," October 8, 1865, Freedmen & Southern Society Project, University of Maryland, last revised February 14, 2020, www.freedmen.umd.edu/Sweeny.html.

12. Thomas J. Calloway, "International Exposition in Paris," in *United States Congressional Serial Set* (Washington, DC: Government Printing Office, 1901), 463, 466.

13. W. E. B. Du Bois, "The American Negro at Paris," in *Reviews and World's Work*, ed. Albert Shaw, vol. 22 (New York: Review of Reviews, 1900), 577.

14. Blake was the first African American to actually *receive* a Medal of Honor, which was presented to him in 1864. Carney did not receive his until 1900. But because Carney's action occurred first, he usually is credited with being the first African American Medal of Honor recipient.

15. Lindsay Harris, "Before the Eyes of Thousands: The 54th Massachusetts Regiment and the Shaw Memorial in Twentieth-Century Art," in Greenough and Anderson, *Tell It with Pride*, 97.

16. Alan Trachtenberg, "Unsung Heroes: History in the Making," in *A Stirring Song Sung Heroic: African Americans from Slavery to Freedom, 1619 to 1865*, ed. William Williams (Haverford, PA: Cantor Fitzgerald Gallery, Haverford College, and Lehigh University Art Galleries, 2013), 8.

17. Lewis Douglass to Amelia Loguen, July 20, 1863, in Newkirk, *Letters from Black America*, 230.

SELECTED BIBLIOGRAPHY

Alexander, Adele Logan. *Homelands and Waterways: The American Journey of the Bond Family, 1846–1926*. New York: Vintage Books, 1999.

Aptheker, Herbert, ed. *A Documentary History of the Negro People in the United States*. New York: Citadel, 1951.

Benjamin, R. C. O. *Light after Darkness: Being an Up-to-Date History of the American Negro*. Xenia, OH: Marshall and Beveridge, 1896.

Berlin, Ira, and Barbara J. Fields. *Free at Last: A Documentary History of Slavery, Freedom, and the Civil War*. New York: New Press, 1992.

Berlin, Ira, Joseph P. Reidy, and Leslie S. Rowland, eds. *The Black Military Experience*. New York: Cambridge University Press, 1982.

———, eds. *Freedom's Soldiers: The Black Military Experience in the Civil War*. New York: Cambridge University Press, 1998.

Bernier, Celeste-Marie, and Andrew Taylor. *If I Survive: Frederick Douglass and Family in the Walter O. Evans Collection*. Edinburgh: Edinburgh University Press, 2018.

Blackett, R. J. M., ed., *Thomas Morris Chester: Black Civil War Correspondent*. Boston: Da Capo, 1991.

Brown, Christopher Leslie, and Philip D. Morgan, eds. *Arming Slaves: From Classical Times to the Modern Age*. New Haven, CT: Yale University Press, 2006.

Cecelski, David S. *The Fire of Freedom: Abraham Galloway and the Slaves' Civil War*. Chapel Hill: University of North Carolina Press, 2012.

Coddington, Ronald S. *African American Faces of the Civil War: An Album*. Baltimore: Johns Hopkins University Press, 2012.

Cornish, Dudley Taylor. *The Sable Arm: Black Troops in the Union Army, 1861–1865*. Lawrence: University Press of Kansas, 1987.

Forten, Charlotte L. *The Journal of Charlotte L. Forten*. New York: Dryden, 1953.

Glymph, Thavolia, *Out of the House of Bondage: The Transformation of the Plantation Household.* New York: Cambridge University Press, 2008.

Gooding, James Henry. *On the Altar of Freedom: A Black Soldier's Civil War Letters from the Front: Corporal James Henry Gooding.* Edited by Virginia M. Adams. Boston: University of Massachusetts Press, 1991.

Greenough, Sarah, and Nancy K. Anderson, eds. *Tell It with Pride: The 54th Massachusetts Regiment and Augustus Saint-Gaudens' Shaw Memorial.* Washington, DC: National Gallery of Art, 2013.

Harvey, Eleanor Jones. *The Civil War and American Art.* New Haven, CT: Yale University Press and Smithsonian American Art Museum, 2012.

Higginson, Thomas Wentworth. *Black Soldiers/Blue Uniforms: The Story of the First South Carolina Volunteers.* Tucson, AZ: Fireship, 2009.

Holland, Frederic May. *Frederick Douglass: The Colored Orator.* 1891. Reprint, New York: Haskell House, 1969.

Holzer, Harold, and Craig L. Symonds, eds. *The "New York Times" Complete Civil War 1861-1865.* New York: Black Dog and Leventhal, 2010.

Hunter, Tera W. *Bound in Wedlock: Slave and Free Black Marriage in the Nineteenth Century.* Cambridge, MA: Harvard University Press, 2017.

Jones, Jacqueline, "Wartime Workers, Moneymakers: Black Labor in Civil War-Era Savannah." In *Slavery and Freedom in Savannah*, ed. Leslie M. Harris and Daina Ramey Berry, 141. Athens: University of Georgia Press, 2014.

Kelbaugh, Ross J., *Introduction to African American Photographs, 1840-1950: Identification, Research, Care, and Collecting.* Gettysburg, PA: Thomas, 2005.

Krauthamer, Barbara, and Deborah Willis. *Envisioning Emancipation: Black Americans and the End of Slavery.* Philadelphia: Temple University Press, 2013.

LaBarre, Steven M. *The Fifth Massachusetts Colored Cavalry in the Civil War.* Jefferson, NC: McFarland, 2016.

Lewis, Sarah. "Vision & Justice." *Aperture* 223 (Summer 2016): 11.

Litwack, Leon F., *Trouble in Mind: Black Southerners in the Age of Jim Crow.* New York: Knopf, 1998.

Long, Gretchen. *Doctoring Freedom: The Politics of African American Medical Care in Slavery and Emancipation.* Chapel Hill: University of North Carolina Press, 2012.

Longacre, Edward G. *A Regiment of Slaves: The 4th United States Colored Infantry, 1863-1866.* Mechanicsburg, PA: Stackpole Books, 2003.

Lowry, Beverly, *Harriet Tubman: Imagining a Life.* New York: Doubleday, 2007.

McPherson, James M. *The Negro's Civil War: How American Blacks Felt and Acted During the War for the Union.* Rev. ed. New York: Vintage Books, 2003.

Mitchell, Mary Niall. *Raising Freedom's Child.* New York: NYU Press, 2008.

Newkirk, Pamela, ed. *Letters from Black America: Intimate Portraits of the African American Experience*. Boston: Beacon, 2009.

Newton, Alexander Herritage. *Out of the Briars: An Autobiography and Sketch of the Twenty-Ninth Regiment Connecticut Volunteers*. Philadelphia: A.M.E. Book Concern, 1910.

Ochs, Stephen J. "A Patriot, a Priest and a Prelate: Black Catholic Activism in Civil War New Orleans." *US Catholic Historian* 12, no. 1 (Winter 1994): 49–75.

Olmsted, Frederick Law, and Jane Turner Censer. *Defending the Union: The Civil War and the U.S. Sanitary Commission, 1861–1863*. Baltimore: Johns Hopkins University Press, 1986.

Painter, Nell Irvin. *Sojourner Truth: A Life, a Symbol*. New York: Norton, 1996.

Prince, Bryan, *My Brother's Keeper: African Canadians and the American Civil War*. Toronto: Dundurn, 2015.

Redkey, Edwin S., ed. *A Grand Army of Black Men: Letters from African-American Soldiers in the Union Army, 1861–1865*. Cambridge: Cambridge University Press, 1992.

Reef, Catherine. *African Americans in the Military*. New York: Infobase, 2014.

Reid, Richard. *Practicing Medicine in a Black Regiment: The Civil War Diary of Burt G. Wilder, 55th Massachusetts*. Amherst: University of Massachusetts Press, 2010.

Rosenheim, Jeff L. *Photography and the American Civil War*. Exhibition catalogue. New York: Metropolitan Museum of Art, 2013.

Samito, Christian G. *Becoming American under Fire: Irish Americans, African Americans, and the Politics of Citizenship during the Civil War Era*. Ithaca, NY: Cornell University Press, 2009.

Sandweiss, Martha A., ed. *Photography in Nineteenth-Century America*. Fort Worth, TX: Amon Carter Museum; New York: Harry N. Abrams, 1991.

Seraile, William. *Angels of Mercy: White Women and the History of New York's Colored Orphan Asylum*. New York: Fordham University Press, 2013.

Shaw, Robert Gould. *Blue-Eyed Child of Fortune: The Civil War Letters of Colonel Robert Gould Shaw*. Edited by Russell Duncan and William McFeeling. Athens: University of Georgia Press, 1999.

Stauffer, John, Zoe Trodd, and Celester-Marie Bernier. *Picturing Frederick Douglass: An Illustrated Biography of the Nineteenth Century's Most Photographed American*. New York: Liveright, 2015.

Sterling, Dorothy, ed. *Speak Out in Thunder Tones: Letters and Other Writings by Black Northerners, 1787–1865*. New York: Da Capo, 1998.

——, ed. *We Are Your Sisters: Black Women in the Nineteenth Century*. New York: Norton, 1984.

Stowe, Steven M. Review of *Practicing Medicine in a Black Regiment: The Civil War Diary of Burt G. Wilder, 55th Massachusetts*, by Richard Reid. *Journal of the Civil War Era* 2, no. 2 (2012): 274–76.

Taylor, Susie King. *Reminiscences of My Life in Camp with the 33d United States Colored Troops: Late 1st S.C. Volunteers*. Boston, 1902.

Trudeau, Noah Andre, ed. *Voices of the 55th: Letters from the 55th Massachusetts Volunteers, 1861–1865*. Dayton, OH: Morningside, 1996.

US War Department. *The War of the Rebellion: A Compilation of the Official Records of the Union and Confederate Armies*. Series 1, vols. 1–2. Washington, DC: Government Printing Office, 1880.

Wilder, Craig Steven. *In the Company of Black Men: The African Influence on African American Culture*. New York: NYU Press, 2001.

Williams, George Washington. *A History of the Negro Troops in the War of the Rebellion, 1861–1865*. New York: Harper and Bros., 1887.

Yacovone, Donald, ed. *Freedom's Journey: African American Voices of the Civil War*. Chicago: Lawrence Hill Books, 2004.

INDEX

Page numbers in *italics* indicate figures.

A

Abbott, Anderson R., 147, *147*

abolitionism, 20, 32, 57; Douglass, F., and, 1, 58, *83*; of freed slaves, 99; of Higginson, 68; of Redpath, 26-27

Adams, Emmit, 177, *177*

Adams, Scout, *22*

African American children, 127, 187-88, 198; education of, 64, 67-68; enslaved, *45*, 123-24, 128-30; orphaned, 75, *80*; of soldiers, 128-29

African American Civil War Memorial, *204*

African American men, *47*; complexion of, 60, 70, 71, 72, 142, 177; medical education of, 84, 138, 147; military uniforms of, vii, 7, 13, 23, 25, 26, *51*, 60, *61*, 114, 130, 137-38, 144, 149, *153*, *179*, *192*, 202, 221n20; photographs of, 26, 126, 152, 202; as prisoners of war, 195-96; Union army enlisting, 58, 60, 76, 125, 132, 166; Union army excluding, 19-20, 25, 27, 31-32, 41, 122; as Union army soldiers, 86, 101, 105-6, 107-8, 116, 123, 125-26, 192-96; as war correspondents, 27,

29, 51-52, 76, 113-14, *115*, 116. *See also* black Civil War soldiers

African American women, *5, 59, 61, 170*; clothing of, 13, 18; daughters, 9, 128-30, 198, *199*; letters to and from, 40-41, 108-10, 113, 123-24, 126-27, 147-48, 167; mothers, 108-10, 123-24, 187-89, 198; as nurses, *47*, 138, 150-52; as teachers, *8, 9, 63, 65*, 67-68, 77, 142; Union army enlisting, 148-50; Union role of, ix-x, 77, 138, 148, 150-52; wives, viii-x, *15, 43*, 110, *112*, 113, 123-24, 127-28, 189-91, 192-94, 197-98

African Americans, enslaved, *56*, 99, 108, 127, 154, 175; buying and selling, 29, 188; children, *45*, 123-24, 128-30; *Christian Recorder* (newspaper) on, 180-81, 187-89; Confederate army using, 28, 29-31, 38, 44, *45, 46*, 55; Emancipation Proclamation and, 30, 44, 77-78, 110; freedom bought for, 32, 75, 128-30; fugitive, 30, 34-35, 37-41, *43*, 57, 58, 60, *61*, 150-51, 216n13; as property, 38-40, 60, 62-63, 129-30;

ABOUT THE AUTHOR

Deborah Willis is University Professor and Chair of the Department of Photography and Imaging at the Tisch School of the Arts at New York University and has an affiliated appointment with the College of Arts and Sciences, Departments of Social and Cultural Analysis and Africana Studies, where she teaches courses on photography and imaging, iconicity, and cultural histories visualizing the black body, women, and gender. She is Director of the NYU Institute for African American Affairs and the Center for Black Visual Culture. Her research examines photography's multifaceted histories, visual culture, the photographic history of slavery and emancipation, migration, contemporary women photographers and beauty. Among many other accolades, she is the recipient of the John D. and Catherine T. MacArthur Fellowship, the Richard D. Cohen Fellowship in African American Art, Hutchins Center, Harvard University, the John Simon Guggenheim Fellowship, and the Alphonse Fletcher Jr. Fellowship. She is the author of over eight books including *Posing Beauty: African American Images from the 1890s to the Present* and *Reflections in Black: A History of Black Photographers—1840 to the Present* and a practicing art photographer whose work has appeared in exhibits at the African American Museum Philadelphia, Gantt Center, Wallach Gallery, Columbia University, Light Work at Syracuse University, and many others.

NYU SERIES IN SOCIAL AND CULTURAL ANALYSIS
General Editor: Phillip Brian Harper